Natural Fashion
Tribal Decoration from Africa

Hans Silvester

D0884746

Thames & Hudson

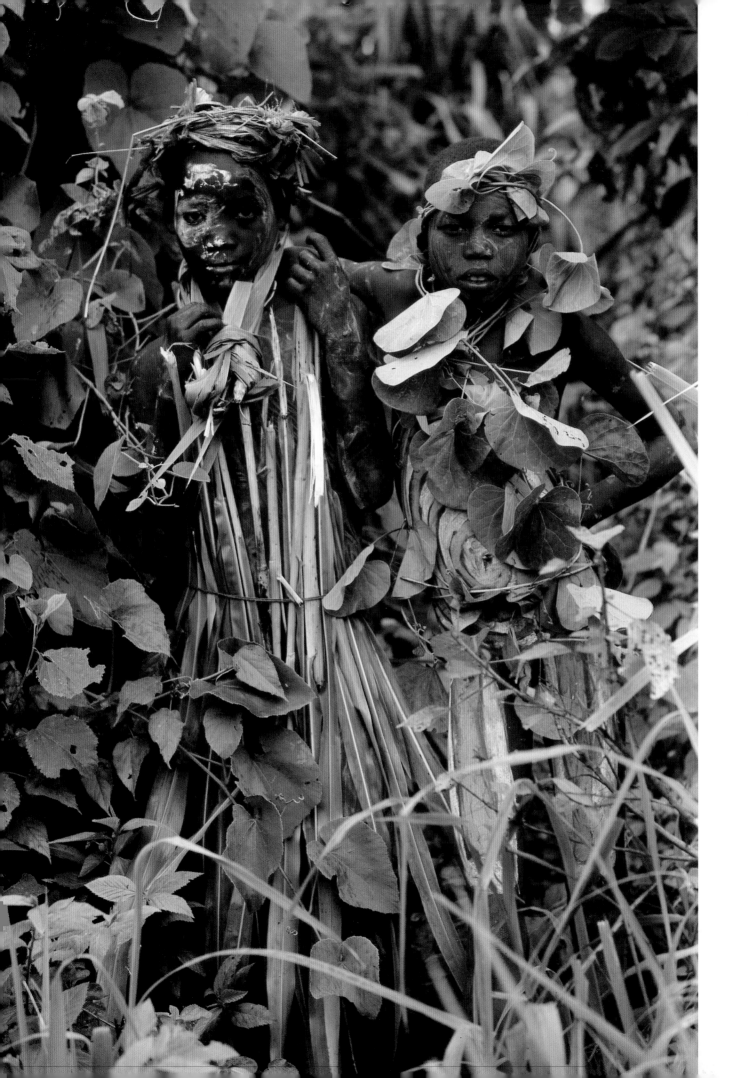

Hans Silvester
Art and the Body

An arena of incessant tribal and guerrilla warfare, and a hotbed for the arms and ivory trades, the Omo Valley nevertheless plays host – when the Kalashnikovs fall silent – to some astonishing events of a much more peaceful nature. Among the fifteen tribes that have lived in this Rift region since time immemorial, the Surma and the Mursi, two tribes that get on well together, share a taste for body painting and extravagant decorations borrowed from nature. The former is done mainly with materials from the plant world, whereas the latter predominantly comprises products of the hunt – all kinds of trophies, including buffalo horns, warthog tusks, monkey skins and more.

These displays often have a practical origin, such as protection against the sun. Thus when women walk from one village to another, they frequently carry a branch to provide themselves with some shade. Afterwards, they paint, decorate and embellish themselves with ingredients drawn from the vast store cupboard of Mother Nature. Renewed every day, these wonderfully inventive changes of appearance form a parade of African fashion that is as rich as it is ephemeral. A little lump of clay stuck on top of the head and pierced with feathers becomes a masterpiece of the milliner's art. Zebu skin sheathing the shins is transformed into an original pair of bush leggings. Snail shells strung on plant fibre make a superb necklace. Shells, nuts, gourds, flowers, woven grass are all used for decoration. A scattering of non-natural items – rifle cartridges, the tops of ballpoint pens, pieces of Italian glass jewelry – sometimes supplement these ornaments, as a reminder that Western civilization, even in the deepest depths of Africa, is never far away. As for copper bracelets, the last word in luxury, these come from Uganda and are acquired for the price of so many goats.

Generally naked – only the women wear a tiny G-string – the bodies are smooth and supple, providing an extraordinary sculptural surface that is ideal for these works of art. Flesh becomes a raw material on which decorative fantasies can be played out. Heads are almost completely shaven, and this creates a minimalistic effect, with just a few discreet elements of decoration: a tiny circle, triangle or tuft – each motif representing a sign specific to one family, much like our own coats-of-arms. For the most part, the Surma and Mursi use Indian-made razor blades to shape their geometric hairstyles. Failing these, they make do with leaf springs from Land Rovers which they take to pieces and sharpen.

The ear lobes of boys as well as girls are usually pierced, and the holes are gradually enlarged with slivers of wood, each one bigger than the last – a technique similar to that used by the womenfolk with their discs (see below). These piercings hold various decorations, like fruits, snail shells, pieces of pottery and other trinkets. There is, however, nothing obligatory in this practice, and some people prefer to leave their ears intact. Families are free to do what they want, and the only compulsory mark comes later and applies to girls of marriageable age. When they reach about twenty, they have to undergo an incision of the lower lip, into which is inserted a 'disc' – a tradition which has unfortunately persisted right through to the present. It is an extremely brutal custom, but is all the more entrenched because of the fact that a girl bearing this token will earn a great deal more for her father, since her bridal price may even double – fifty cows instead of the twenty or twenty-five normally paid by the prospective husband.

The landscape of the body

This decorative focus on the body, and its pre-eminence over the spatial environment and the surrounding world of objects, is strongly connected with nomadic lifestyles. The body is seen almost as a piece of territory, with skin and flesh replacing the stone, ceramics and textiles typical of other cultures. Nomads always have the ability to leave everything behind and travel. Except for their livestock – the only wealth they own – their possessions are limited to what they can carry on their backs or shoulders. The inventory is short: a few plain pots of clay, some gourds, things to eat and drink, skins to lay out on the ground, and weapons – knives for the women and children, Kalashnikovs for the men. Their homes are very simple and made exclusively of plant materials. They do not use mud or clay, but only branches. The one item that is sometimes ornate is the headrest which old people use and which also serves as a stool. Shaped from a piece of white wood, it is decorated with a sort of rudimentary pokerwork: cow dung is smeared on it to form different motifs, lines or dots. Live embers are then applied and the uncovered surfaces of the wood blacken, while the rest retains the bright colour of the original.

An infinite wardrobe

It is right beside the river, the lifeline of the region, that these decorative arts are at their most expressive. At the peak of the dry season, during the weeks that precede the arrival of the rains, the weather in these latitudes becomes extremely heavy, with temperatures around 45° C. The sky turns a whitish grey, almost leaden. At this time, much of village life takes place by the river, which is the only source of water for humans as well as animals. It is quite shallow, unlike the Omo, which is dangerous and infested with crocodiles, not to mention

various species of lizard that sometimes haunt its little tributaries. People come to draw water, or bring their cattle to drink; they also fish there in somewhat primitive fashion for catfish, to supplement their stocks of grain, sorghum and maize, which dwindle fast at this time of year. And they bathe there too, looking to escape from the intense heat. Children, youths and adults all come together where the water has dug out shallow coves, never more than two metres in depth, for them to swim in.

In this region of East Africa, the savannah landscape presents a picture of large, scattered trees and bushes, and tall dry grasses. In contrast, the vegetation near the water is almost lush – papyrus, flowers, and wild fruit trees. This luxuriance is like an incitement to self-expression, to putting on a show. Within easy reach is a multitude of plants, each one an invitation to indulge in all kinds of imaginative decoration. A tuft of grass serves as a hat, and banana leaves, woven tendrils or flowers are knotted together like a scarf or neckerchief. For Westerners, any such activity might demand great intellectual effort – which branch, what colour, how and where should they be arranged? – and the whole process could seem laborious, but here the people make their choices spontaneously but firmly, and with a particular instinct for what will work. They do not spend any time thinking about it. They live so close to nature that they also act naturally, and at quite astonishing speed. They take a branch, strip it, adroitly turn it into a string, and weave that into a crown or some other form, to be finished off with a shell as its centrepiece.

The final effect, while not sophisticated, is by no means crude. There is a fascinating dimension of mystery here that is almost magical. Anyone who has observed these people for any length of time will see that they are remarkably talented: they can take any material from the plant world – leaf, stem, flower, grass, root – and instantly transform it into an accessory that has come straight from a fantasy or fairy tale, without the slightest tinge of absurdity. This skill is an integral feature of those human societies that live in symbiosis with nature. For them, she provides an infinite wardrobe – the most amazing accessory shop you can imagine.

Pigments and complexions

Attractive though they are, these plant decorations might be nothing but somewhat extravagant accoutrements, were they not accompanied by body paintings which create a kind of decorative counterbalance. Done with the aid of natural pigments, these constitute the abstract element in this style of physical adornment.

The geological structure of the volcanic Rift Valley is quite remarkable. Some rock faces reveal strata of red, ochre, yellow, all shades of white, pure white and light grey. This mixture of pigments dating from aeons ago offers a vast palette of colours, with the single exception of blue. They are very concentrated and pure. A small piece of ochre crushed with a pebble will yield a quantity of pale colour when diluted with plenty of water, whereas just a few drops will create a darker shade. Green is obtained from a crumbly stone found on the river bed; this must be broken and then crushed into a powder.

The richness and beauty of these pigments are seen at their brightest and best when combined with the individual colour and texture of the skin. This is linked to the reflection of light. Further to the south, very dark-skinned people – the Sudanese, Kenyans and Ugandans – absorb light, but the Omo tribes, native Ethiopians from the mountains, have a complexion that is redder, more copper-coloured. They do not consider themselves to be black, and they do not have negroid features. Their skin reflects the light very well, and so provides a wonderful background for the various pigments.

The absent mirror

These body paintings are totally free, and yet they never repeat themselves, and there is no underlying system. Each one is extraordinarily fresh. The technique and the skill of body decoration, with its infinite variations, is learned at a very early age, with mothers painting their babies. But it is adolescents who devote themselves most avidly to this activity. Some of them are immensely talented. They have a highly original sense of colour and form, whereas others can be clumsy and need to start all over again. In the case of any second thoughts, a dive into the river will provide a fresh start, although the process cannot of course be reversed.

Most of the painting is done by hand. Cruder motifs are drawn very quickly with a finger, but details are executed with the aid of a piece of reed. This is split between two stones. One end serves as a sort of swab, and its splayed fibres can draw things like stars or birds' footprints. A sharpened piece is used to draw dots and spots.

The absence of mirrors – until recently, these were completely unknown to the tribes – may have contributed to the absolute freedom of this art. Without a mirror or even a natural equivalent (the silty water is always cloudy in the valley), the only way one can see oneself is through other people's reactions. Reflections, or narcissistic images in the mythical sense, do not exist. An image of oneself, if we can talk of such a thing, can therefore only be constructed through the eyes of others. And also, to a certain degree, through the lens of the camera. Might not this situation make people invent something crazy, something extreme, in order to create a reaction, whereas a mirror is merely a mirror? For this very reason, body painting is not done in isolation. For it to be effective, the presence of a second person is indispensable, at least as far as the face and back are concerned. But often you will find five or even ten people together by the water. Body painting is thus very much a team sport.

Between Noh theatre and mimicry

Quite apart from the playful pleasures of the activity, the young painters are also very proud of their art. They are aware that they are doing something important, as is evident from their intense concentration. When they paint one another, their faces are very serious. One is reminded in certain respects of Japanese Noh theatre. This is marked by a complete absence of visible expression. But do not be misled – there is nothing clown-like about Mursi and Surma body painting, and there is no sense of dressing up either, as in the carnival tradition, in which people change their appearance or their role. What we have here is a skill and an art form that is an integral element of the culture. The very fact that a painting may be erased in the waters of the river if it does not fulfil the artist's intention, so that he or she can start all over again, confirms that there is a concept of failure or success, and it greatly enhances the value of a tradition that has been passed down from generation to generation. As a cultural manifestation, the act of painting and decorating oneself is of almost religious importance, despite its ephemeral and apparently anecdotal character.

Aside from the ashes with which shepherds sometimes smear their bodies to protect themselves against the sun and the flies that swarm round their flocks, it would be difficult to find any occasions, whether functional, festive or ritual, that specifically demand these body paintings, even among adults. People simply paint themselves for no particular reason and at no particular time.

The only hint of religious significance that I myself observed was the day after an incredible storm, which lit up the night with its bolts of lightning. After the deluge, which carried away tents and huts and trees, everyone in the village displayed three streaks of green on their foreheads, put on brusquely with three fingers. I was told by the interpreters that these signs were meant to appease the malevolent god of the storm and calm his destructive powers. But there does seem to be a strong link between the paintings and the deities, although the tribes themselves have very little to say about such questions and, in this particular case, very little to show – just three simple lines. It is true to say, however, that coded practices of this kind greatly reduce freedom of expression.

If one really has to find a reference for this art form, it would have to be in its mimicry of nature and of animals. One man might paint his own face in a manner clearly inspired by that of a monkey; someone else will colour his torso like an animal skin; another will make his legs look like the hanging tree roots of plants such as mangroves. Each artist reproduces the things he has seen through his close proximity to nature. Perhaps underlying it all is the spirit of the hunter, accustomed to the art of camouflage, or the warrior merging with nature as he confronts his enemy. Or perhaps it is simply an unconscious homage to Mother Earth.

Speed and motion

If you ask these young people for the meaning of their truly magnificent designs, which in our eyes are very reminiscent of contemporary art, they cannot tell you. They simply enjoy them, are happy to have made them, and are even happier to have them praised. But why and how the ideas come to them is beyond their ability to explain. One would really like to know more – our sense of reason demands an explanation – but they smile and say nothing, and their silence sends us back to our own void, our own culture with all its uncertainties.

Their manner of painting, on the other hand, is extremely eloquent and expressive. A great deal of its attractiveness lies in its movement. These body paintings are always done at great speed. A painting never takes more than a minute. Speed is unquestionably a basic factor in all sensory perception. A similar artwork created with painstaking meticulousness would not convey the same modernist immediacy that is so pleasing to the eye. Another factor is that the diluted pigments dry very quickly on the skin because of the heat, so every artist has to work with great rapidity in order to retain the brilliance of the colours and the continuity of the lines, without which the result would be disappointing. Modern artists like Picasso, Matisse and others, in the course of a long period of development, eventually recaptured the spontaneity that comes close to childhood. It is this that marks the work of these African tribes – movement without self-consciousness or inhibition, doing what comes naturally, determined by things that are ephemeral and, perhaps even more importantly, brief: they know the right moment at which to stop. It is the same spontaneity we see when young children begin to draw something, break off, grab another sheet, draw something else, and then start all over again. As they grow older, they become preoccupied with finishing touches: tiles on the roof, a fireplace, birds in the sky, clouds and so on. They find it almost impossible to stop, and the more they persist, the more cluttered the drawing becomes, lost in a welter of higgledy-piggledy detail.

The double face is a popular motif among the Surma, and is very evocative. But instead of tracing a central line from the forehead, down over the bridge of the nose, and dividing the lips and chin in two, they tend to overshoot or accentuate or distort these natural markers. The line with which they divide the face is drawn with little attention to evenness or symmetry. There is no doubt that they could draw it very precisely if they wanted to, but then the effect would be far less interesting. Precision and symmetry are not their aim, for graphically they achieve something much more expressive and more subtle than a rigorous division of the face. Some face painting is done with very strong, highly contrasting marks, rather like one of Andy Warhol's silkscreen prints, suggesting the idea of a face through a few patches of colour.

Artists and models

Seduction is an ever-present factor underlying the decoration of the body, and it involves a sometimes surprising reciprocity between the sexes. Just as the girls highlight their breasts, there are boys who take a pride in painting the penis. It is all part of a game. But even here, pleasing the eye takes second place to the pleasure of painting and being painted. There is a very special and very sensitive relationship between painter and model, based on physical contact through touch, and the exploration of the body. The hand runs over the skin, explores its forms, and traces motifs that follow the specific curves and hollows of each individual. Everything is bound up with what one sees – the attitude, appearance and self-expression of the body. There are some photographs that capture this expression, this profoundly intimate movement that characterizes the relationship between painter and model. Generally, boys paint boys and girls paint girls, but sometimes they have themselves painted by the opposite sex. Quite apart from the obvious sexual pleasure, these movements seem to hark back to something from the dim and distant past – a kind of lost sensuality.

A question of survival

The more I see of this region – and I have already been there twelve times – the more I am struck by its absolute uniqueness. Body painting, as practised here in East Africa, the cradle of humanity, seems to me to represent a way of life that dates from prehistory and once enabled humankind to overcome the hostility of nature. Art was then a means of survival. Faced with animals, a man needed to be creative in order to prove his manhood. What we have here may even be one of the earliest forms of art, and it is almost certainly older than cave art, of which there are no traces in this region. The rock paintings of Lascaux, Chauvet and Altamira is less than 30,000 years old, whereas the human species has been around for hundreds of thousands of years. Long, long ago in the Rift Valley, I can picture in my mind's eye the spectacle of human beings using the ochre and the pigments in just the same way, to change their appearance by decorating themselves, thereby giving birth to what we know as art. But this region, which brings us so close to our own origins, has now become a very fragile place.

Paradoxically, encounters with outsiders have intensified the practice of body painting, at the risk of rendering it unnatural. The paintings have become a source of income for some of the tribes. Tourism advances, subverting and destroying the lives of the local people even more irrevocably than civil or tribal wars, trade and the vagaries of the climate. Just four years ago, when I first visited the Omo Valley, it was a very dangerous area. Almost every night you could hear the sound of the Kalashnikovs. The tension was palpable, and you ventured forth at your own peril. Within a very short time, things have changed drastically. Once the juggernaut of tourism starts moving, it seems impossible to stop. Kenyan tour operators, ever in search of 'exotic' attractions – which have largely disappeared from their own country – have cast their net further afield to relatively unexplored regions like the Omo Valley. And the phenomenon is gradually spreading, although so far it has only made itself felt in the areas bordering on this unique part of the world.

There is one particular Mursi village which is already a fixed point on the itinerary and regularly plays host to tourists. Its people have adapted themselves perfectly to the rhythm of the tours, which for them seem like manna from heaven. When the 4x4s arrive, at about 10 a.m., the natives are ready to welcome them, sporting their accessories and bodies painted for the occasion. This somewhat surreal show lasts until around midday, and then the tourists depart and things return to normal until the next day and the next group. These 'performers' are paid in local currency according to a set tariff: two *birs* for allowing themselves to be photographed (eleven *birs* are worth about a dollar). The money is immediately converted into alcohol or weapons, two flourishing trades. The whole business reeks of tragedy.

Originally, however, the Mursi were the most warlike of all the tribes. The aggressive conduct of their warriors, and their highly impressive regalia, made from warthog tusks, horns and other animal trophies, made a major contribution to this reputation – certainly much more than their body paintings. Indeed there have sometimes been serious incidents with tourists who have refused to pay them. In such cases, weapons are never too far away.

The Surma and the Mursi cannot see the future, but they know that an era is coming to an end. The days of their independence are numbered. These secular nomads will have to learn to respect borders; these intrepid hunters will have to learn not to kill wild animals; these free spirits will have to learn to obey laws contrary to those laid down by the elders of the village; and these people whose language has been passed down orally since time immemorial will have to learn to speak Amharic. Just like the Native Americans, the Nuba, the Masai and many other minorities who live in close proximity to nature, they will in due course have to resign themselves to living in reservations.

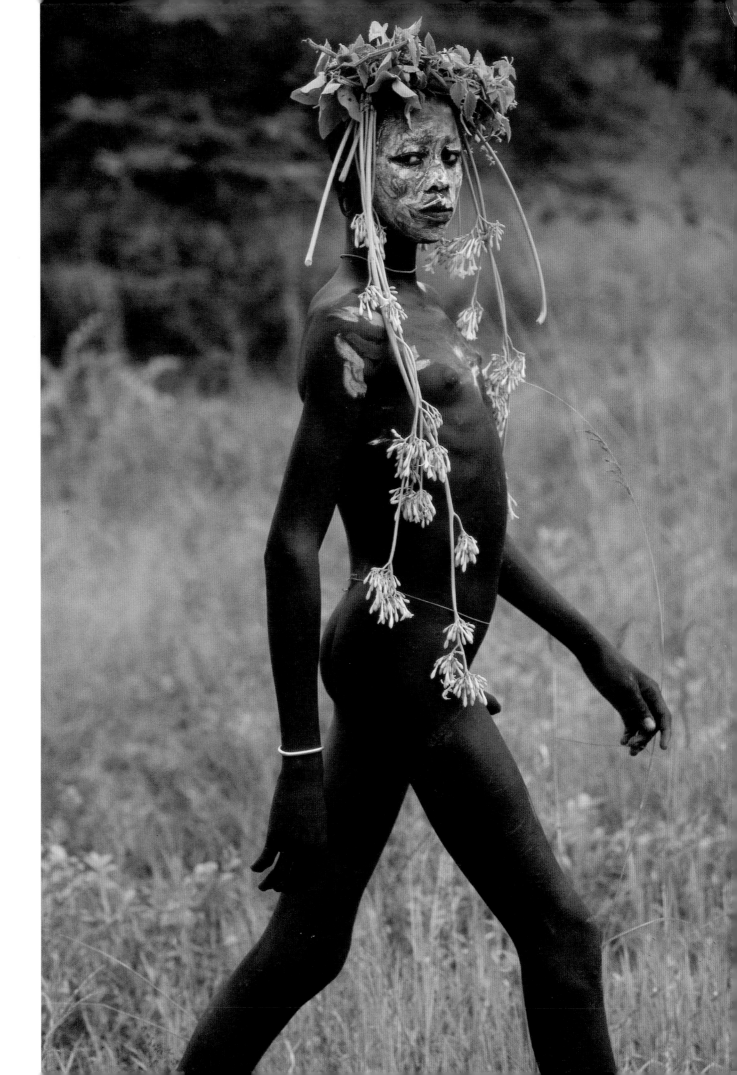

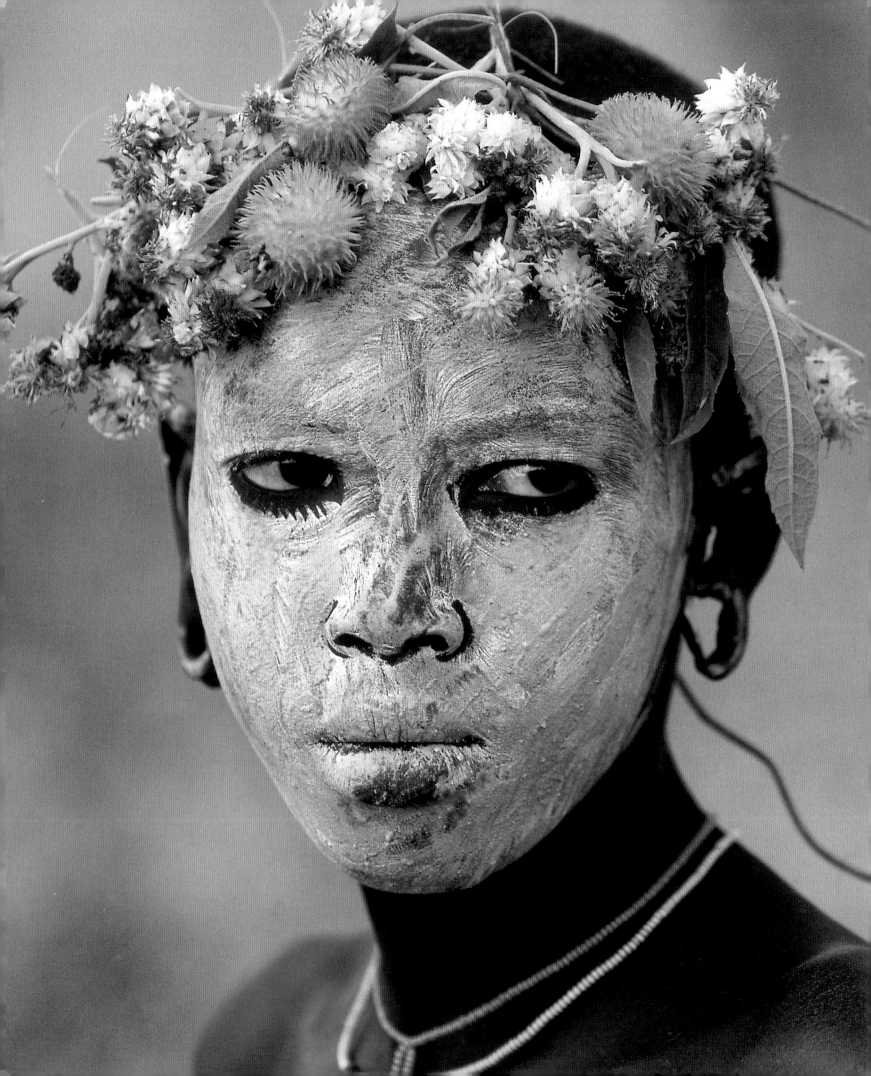

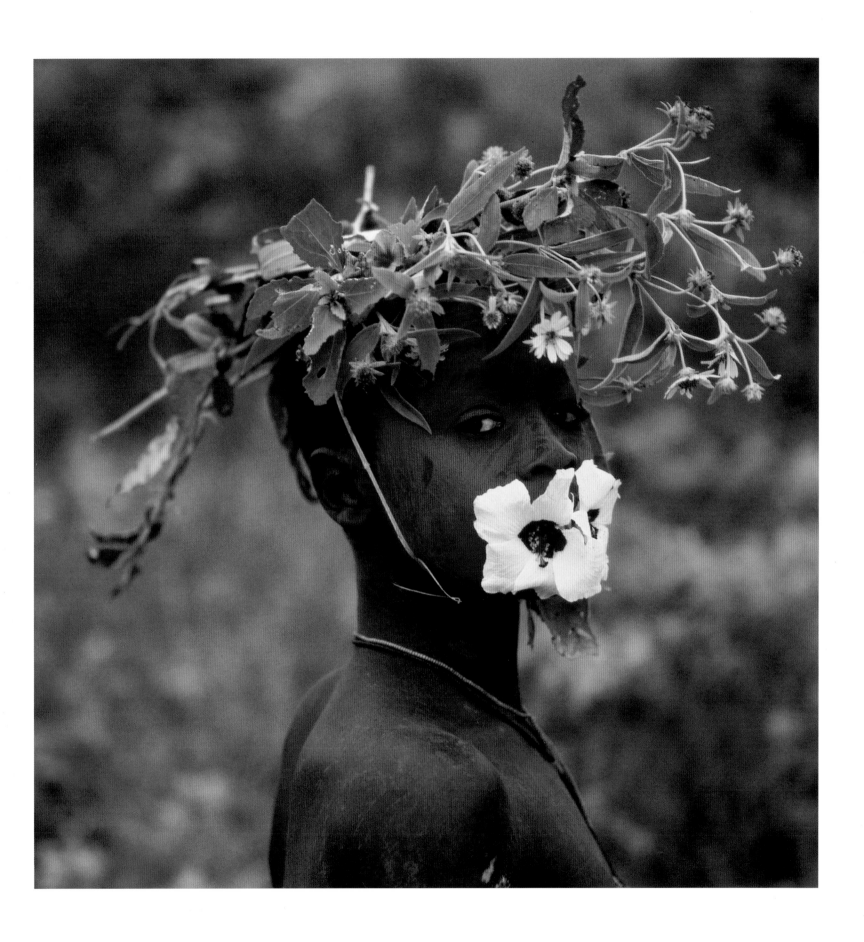

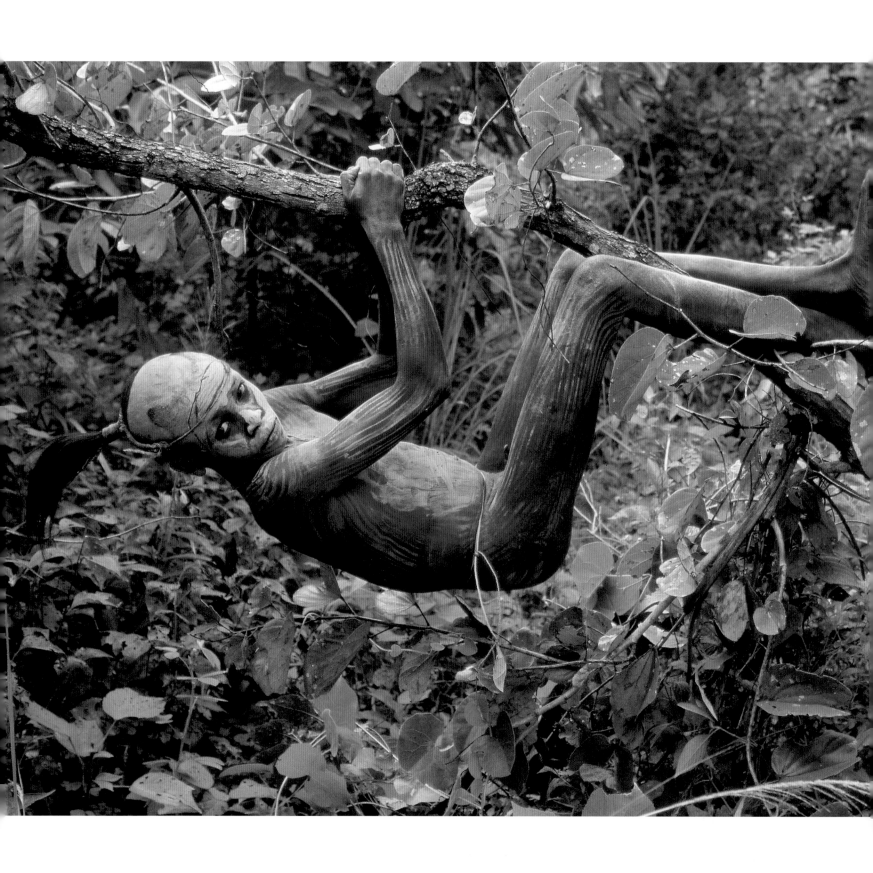

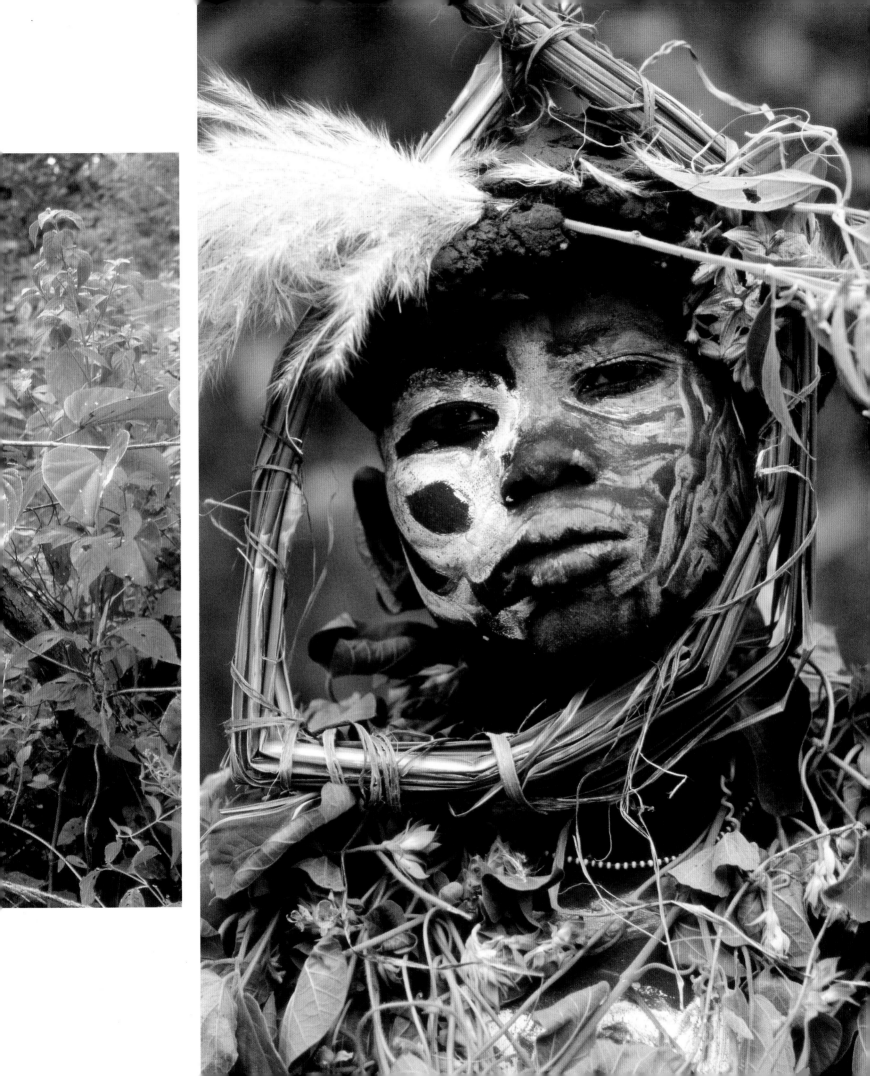

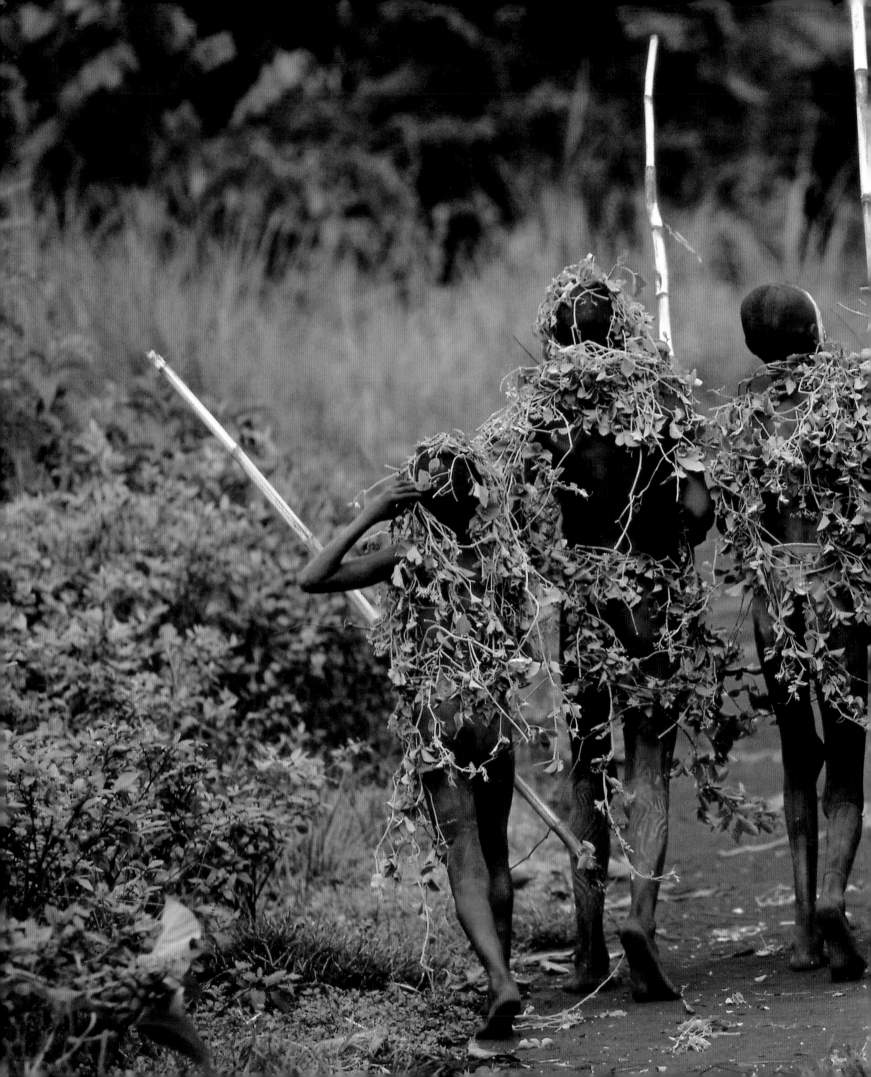

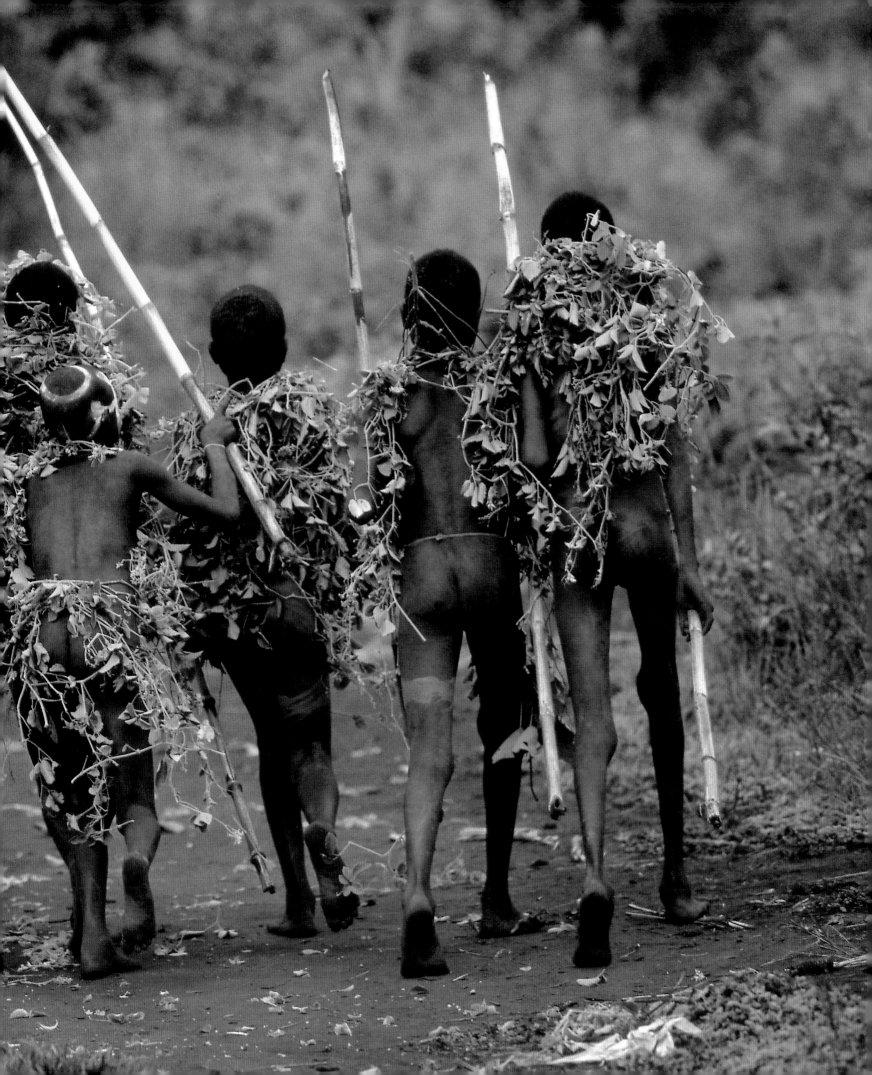

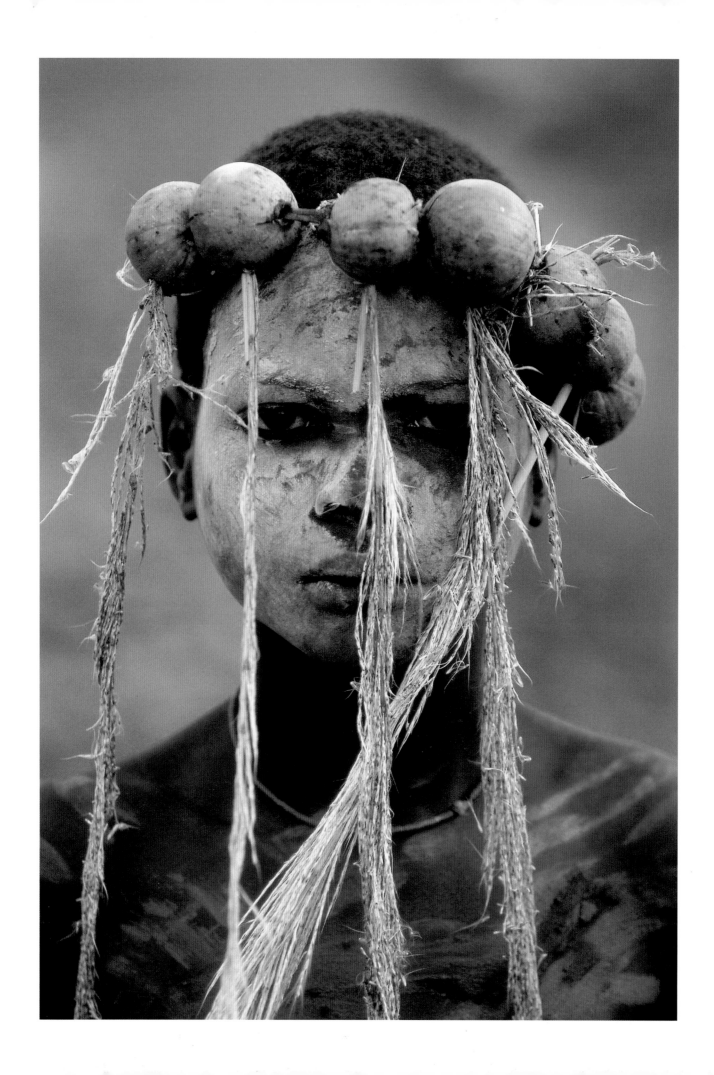

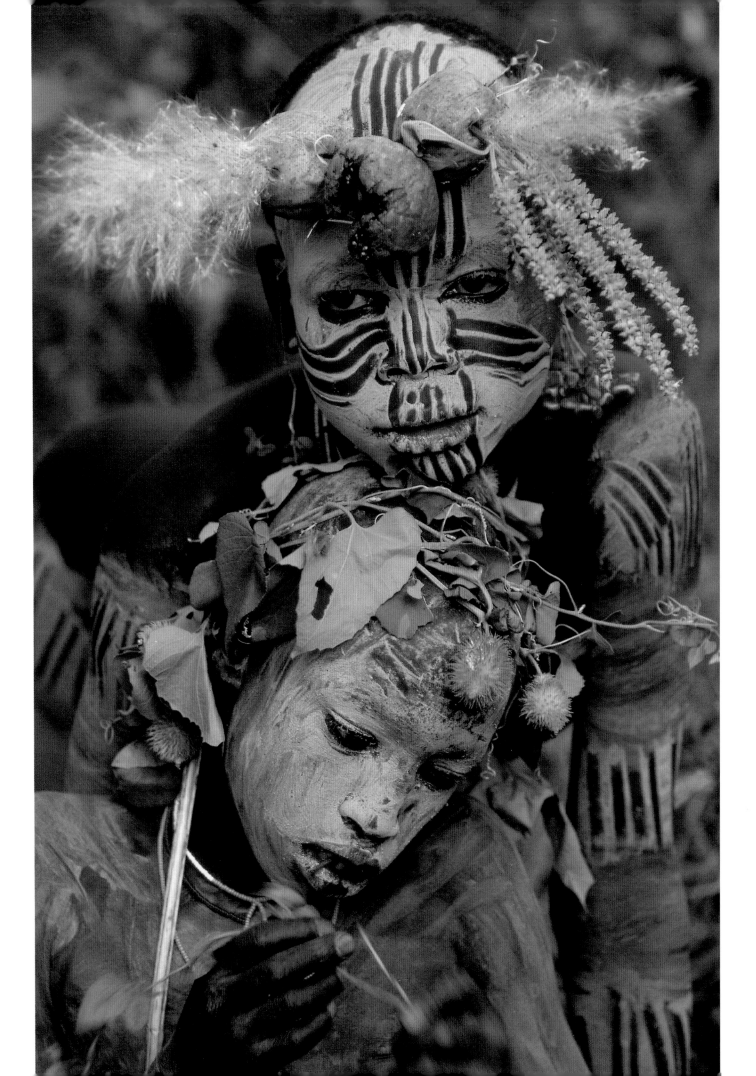

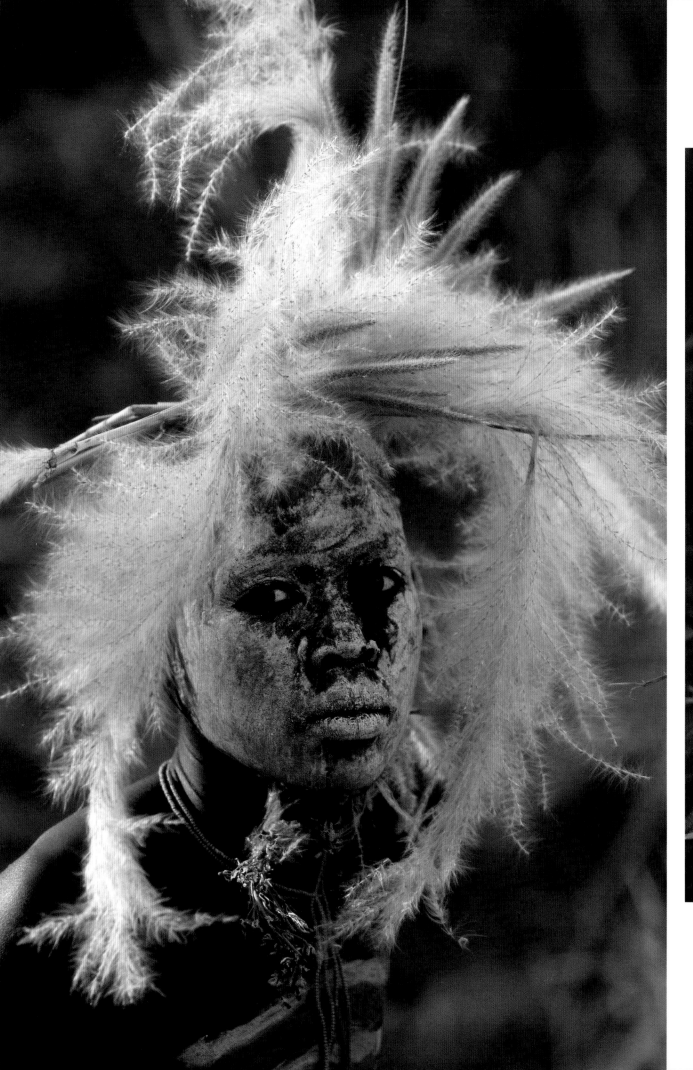

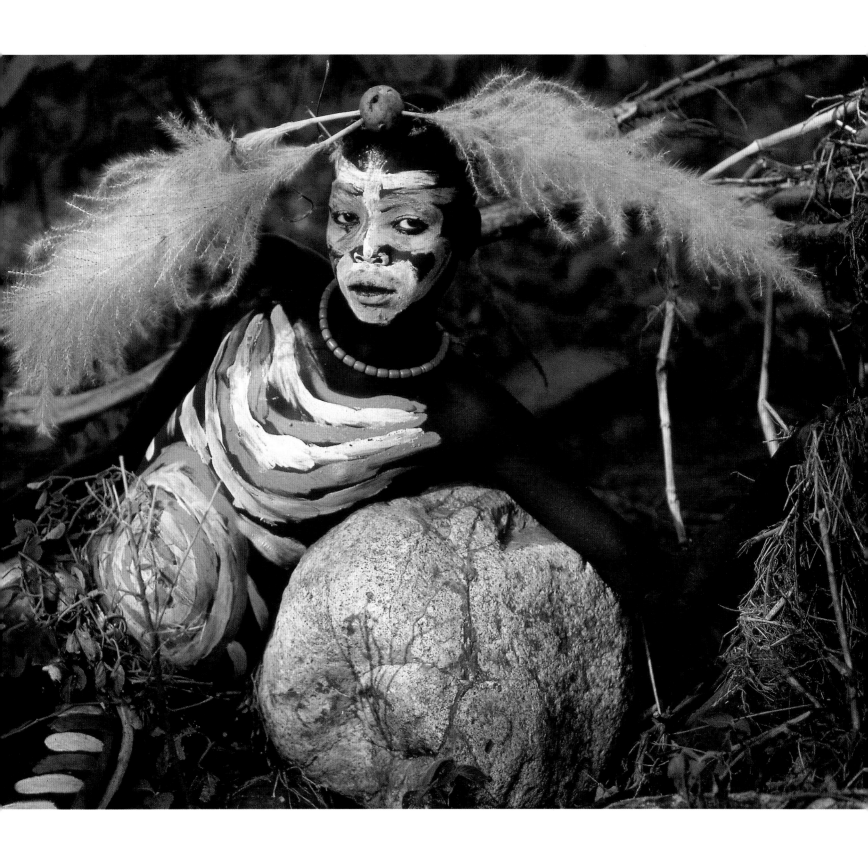

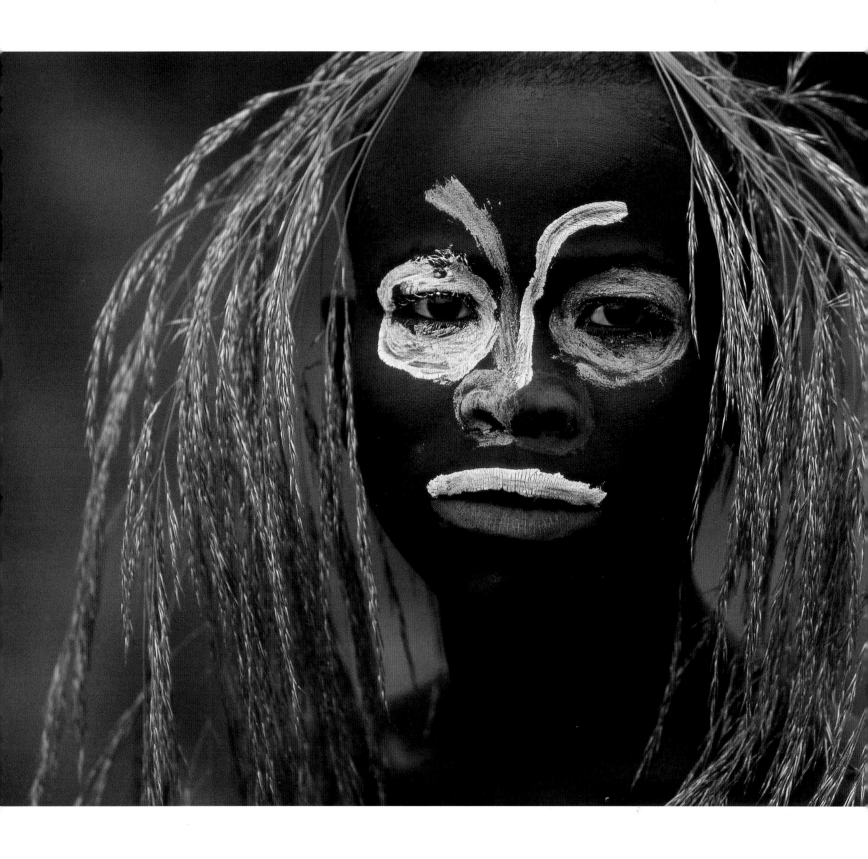

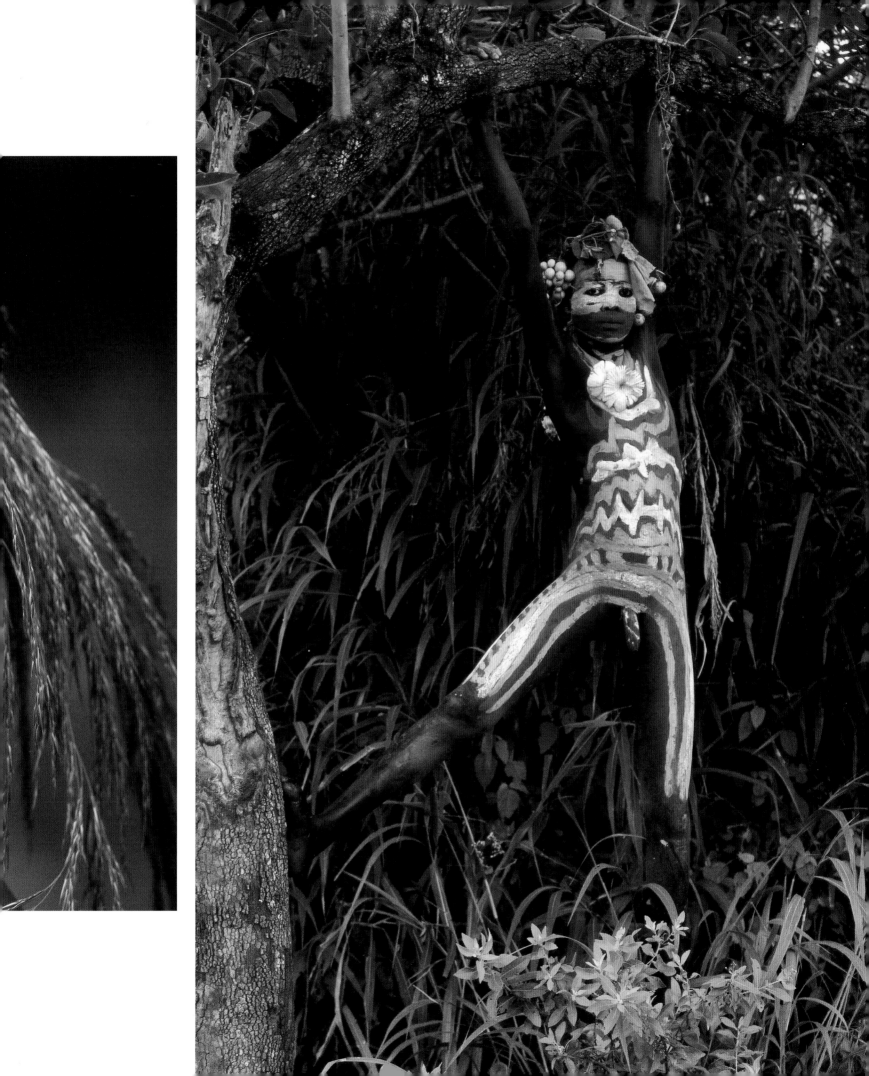

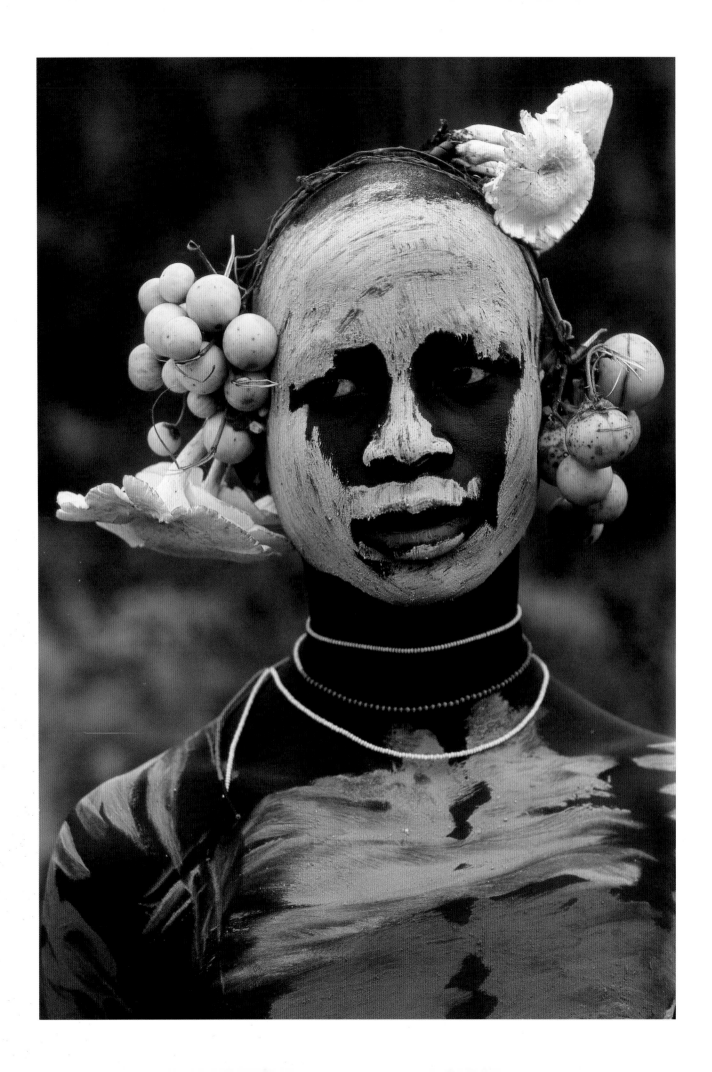

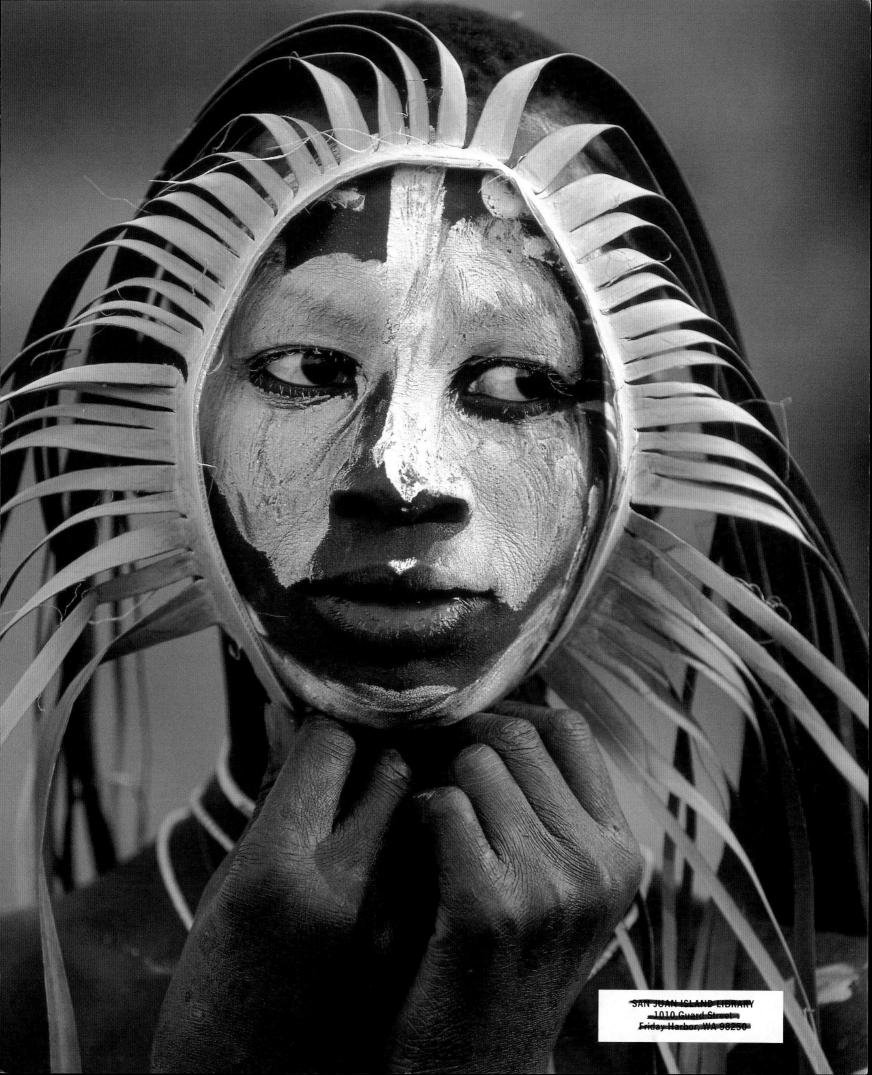

SAN JUAN ISLAND LIBRARY
1010 Guard Street
Friday Harbor, WA 98250

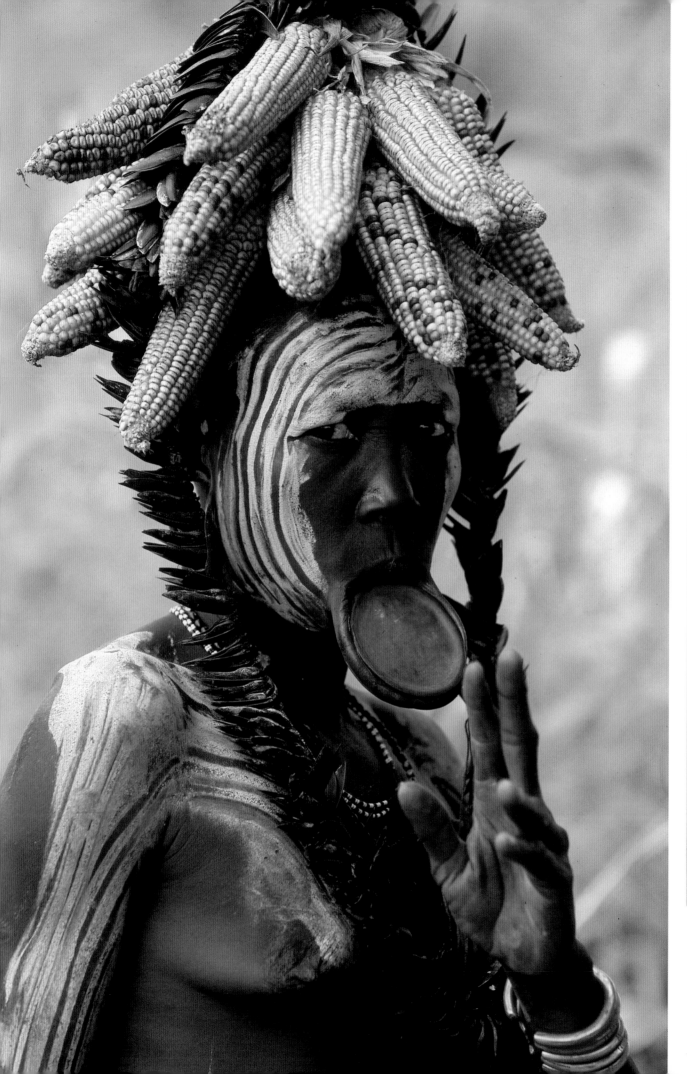

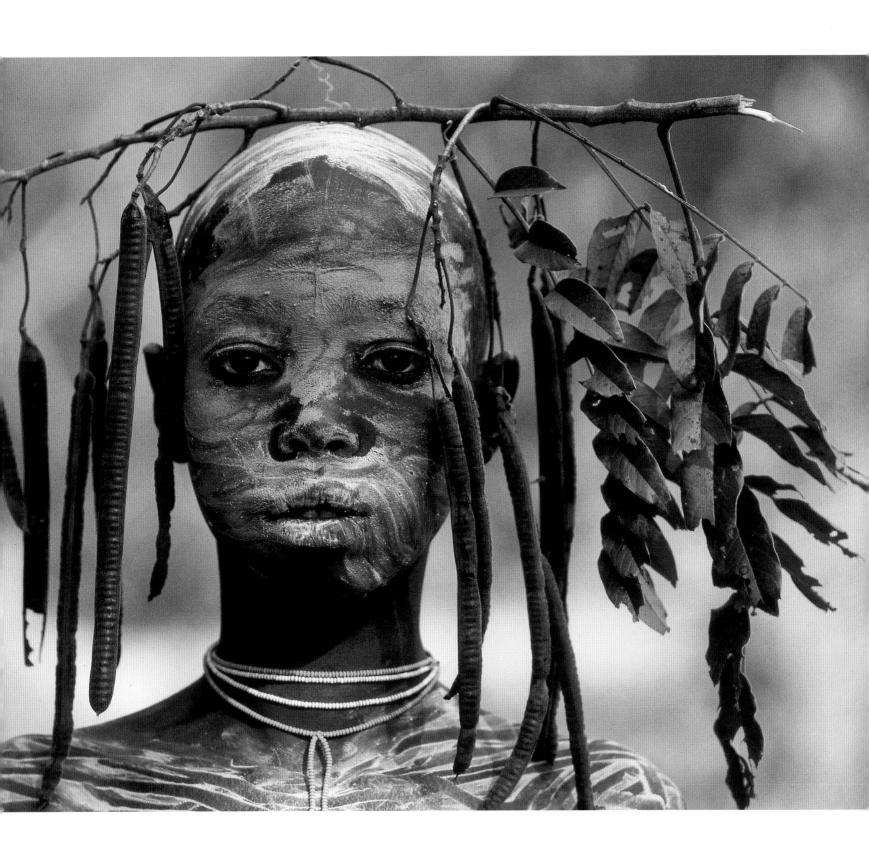

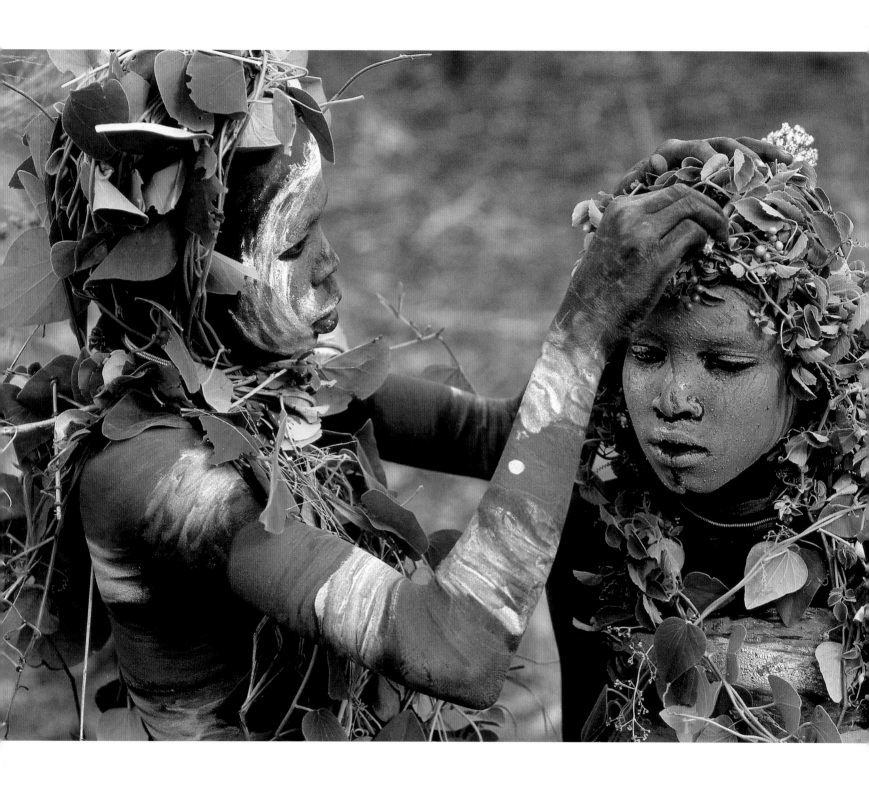

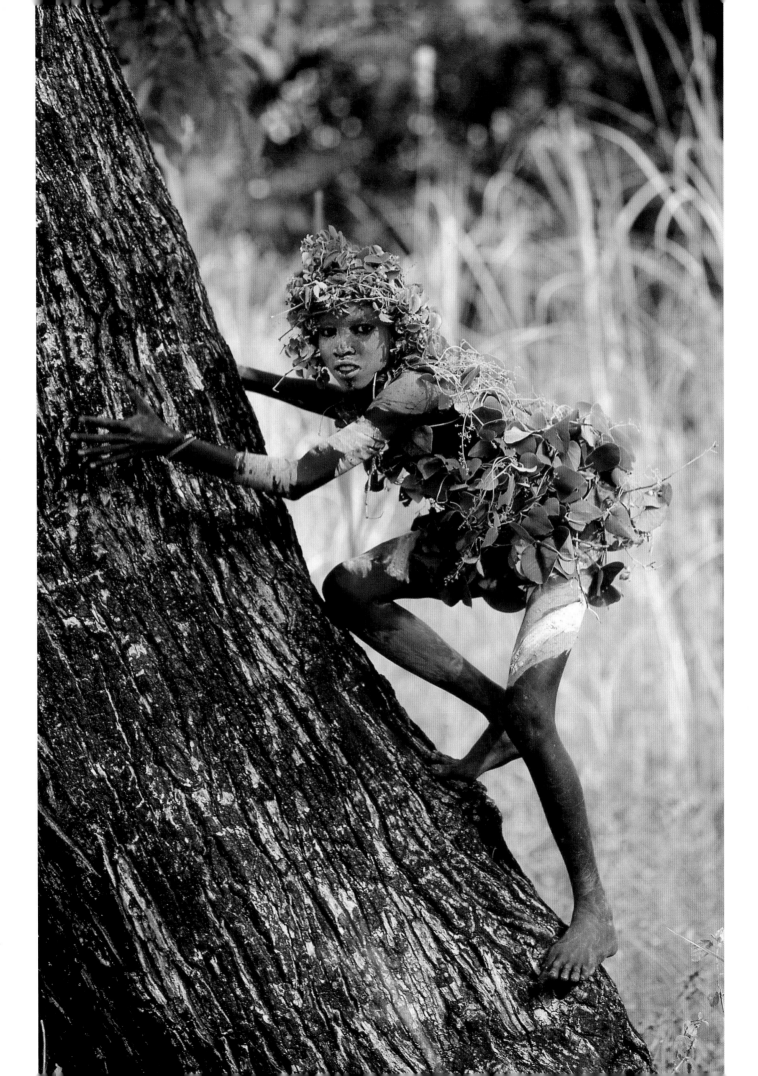

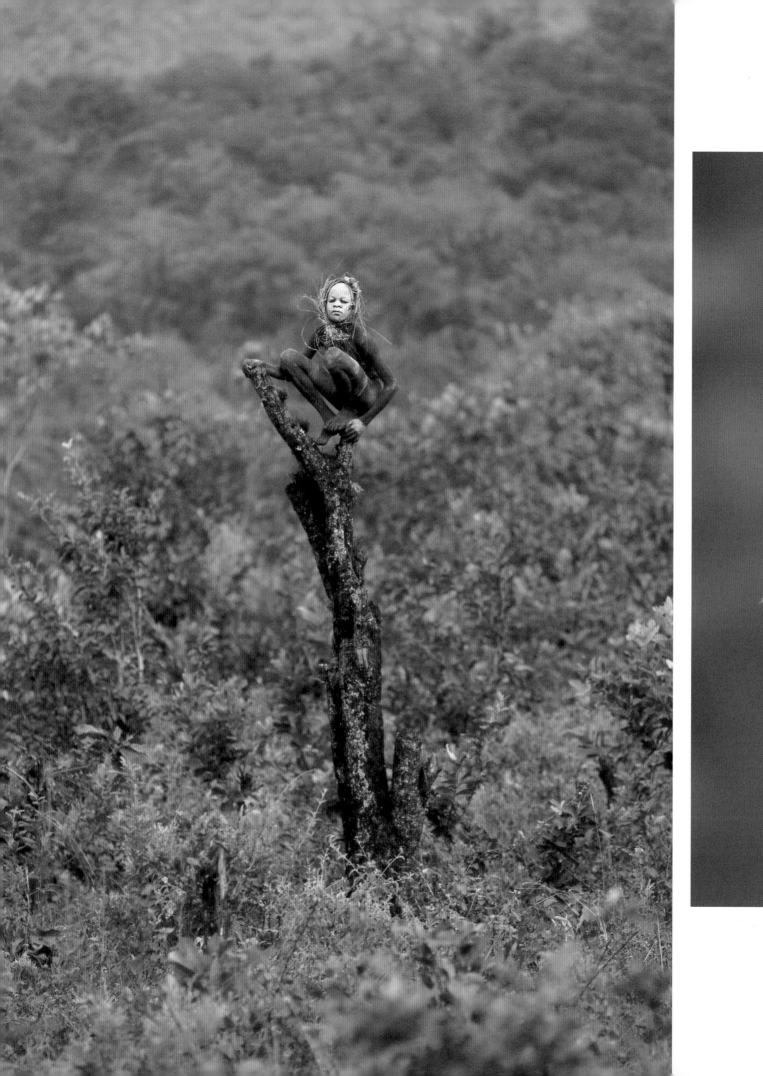

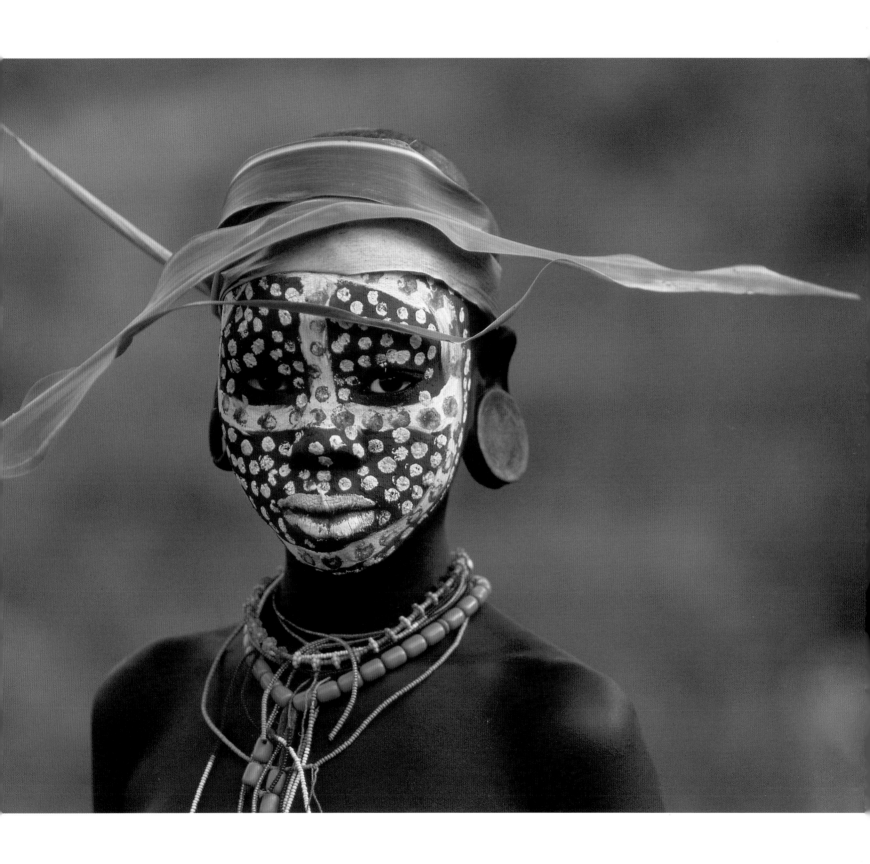

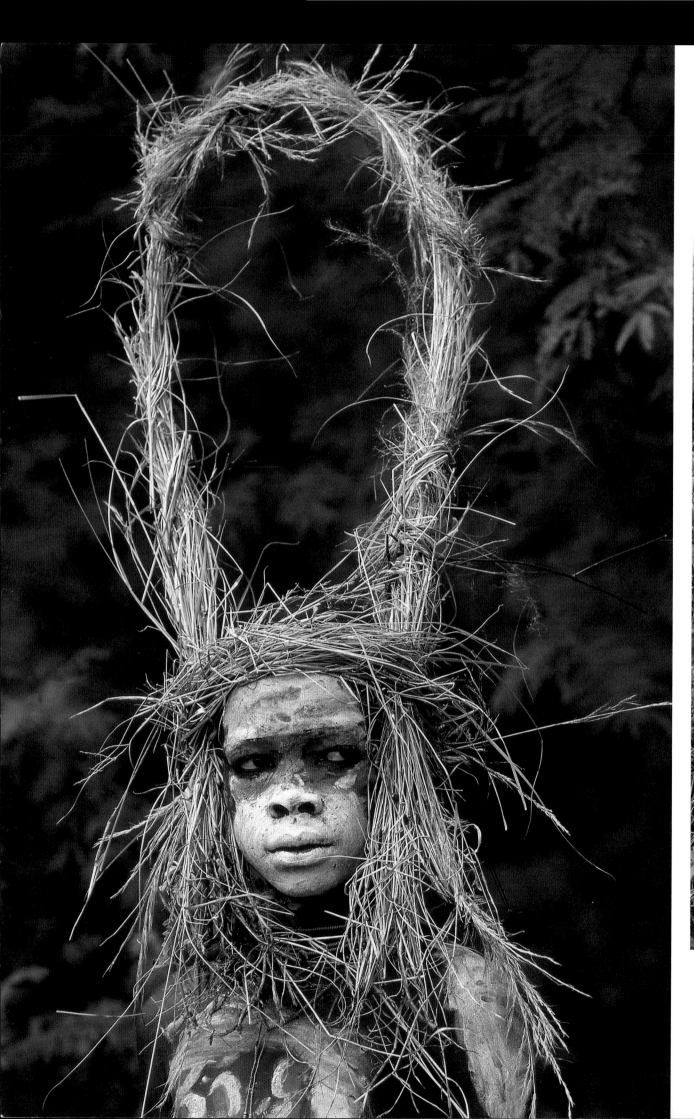

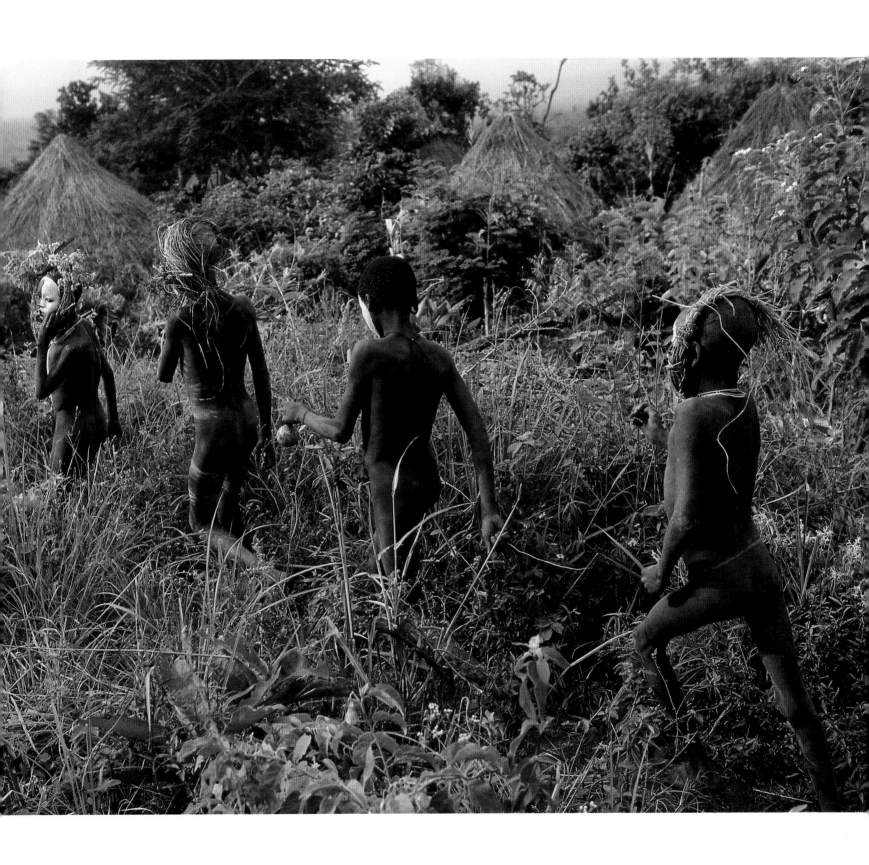

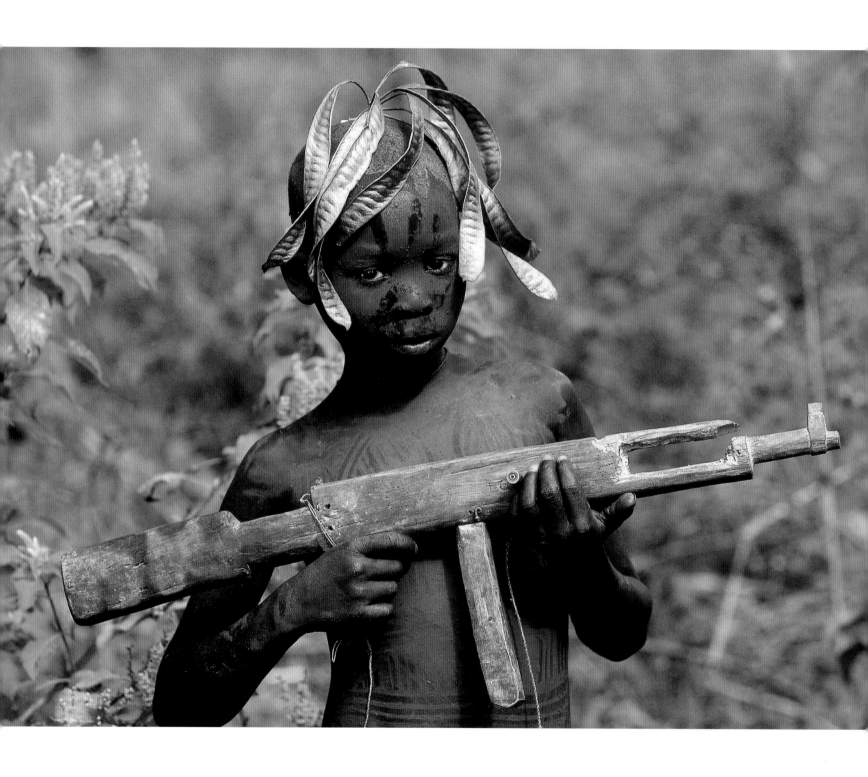

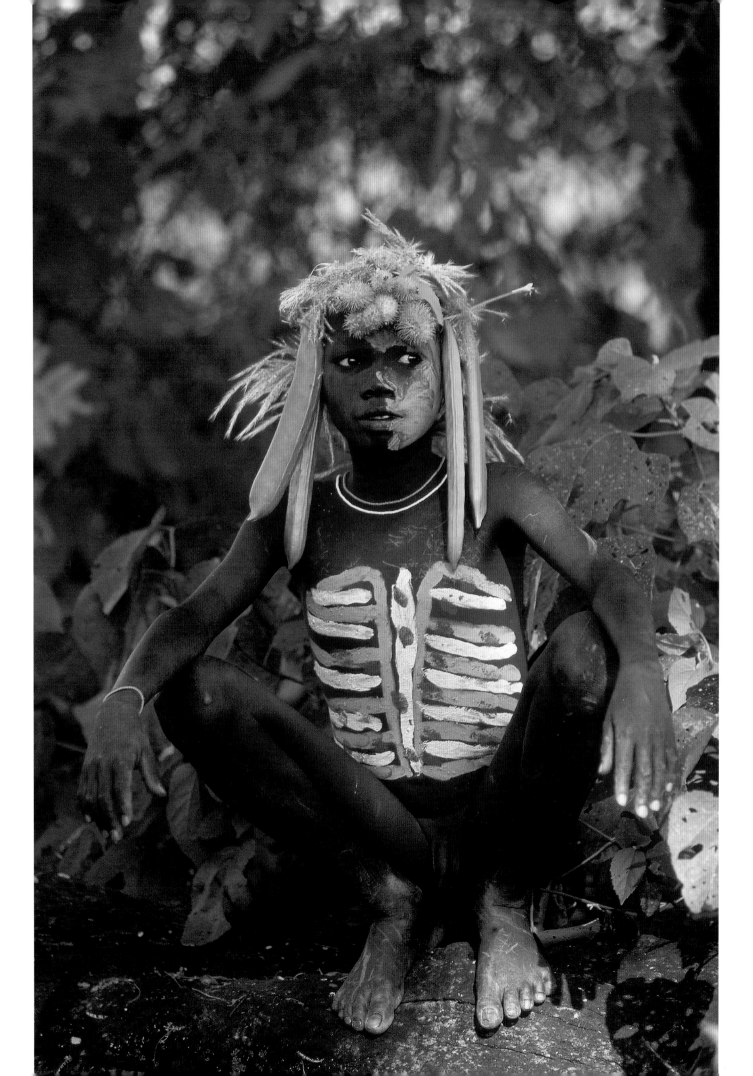

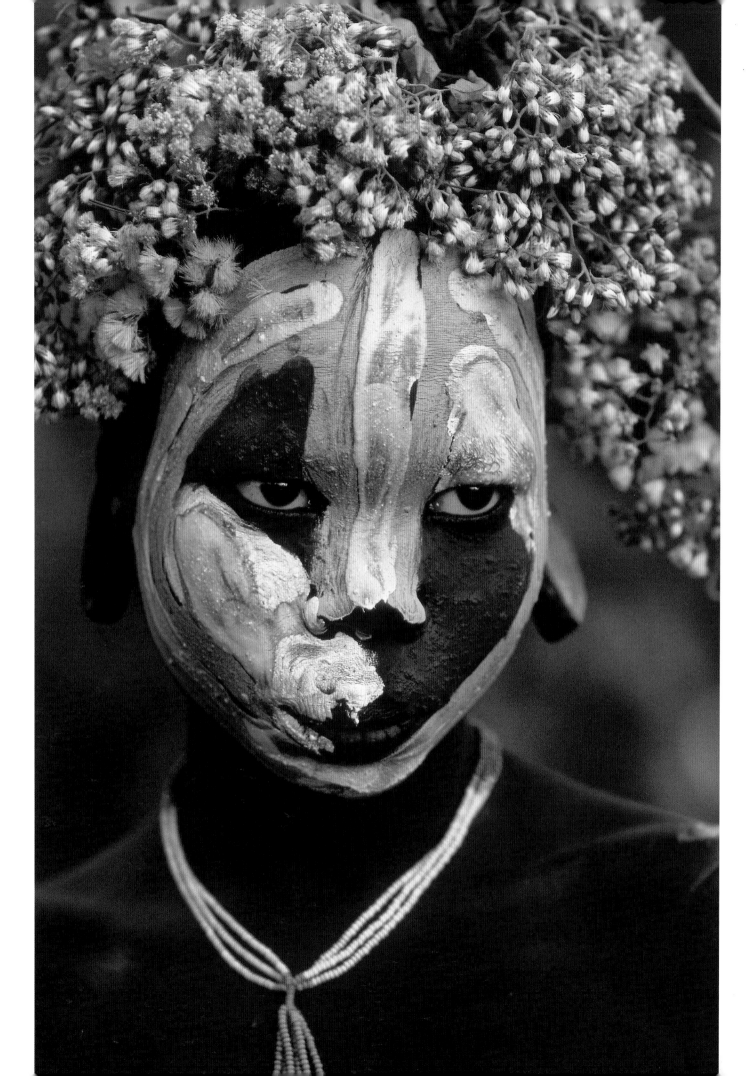

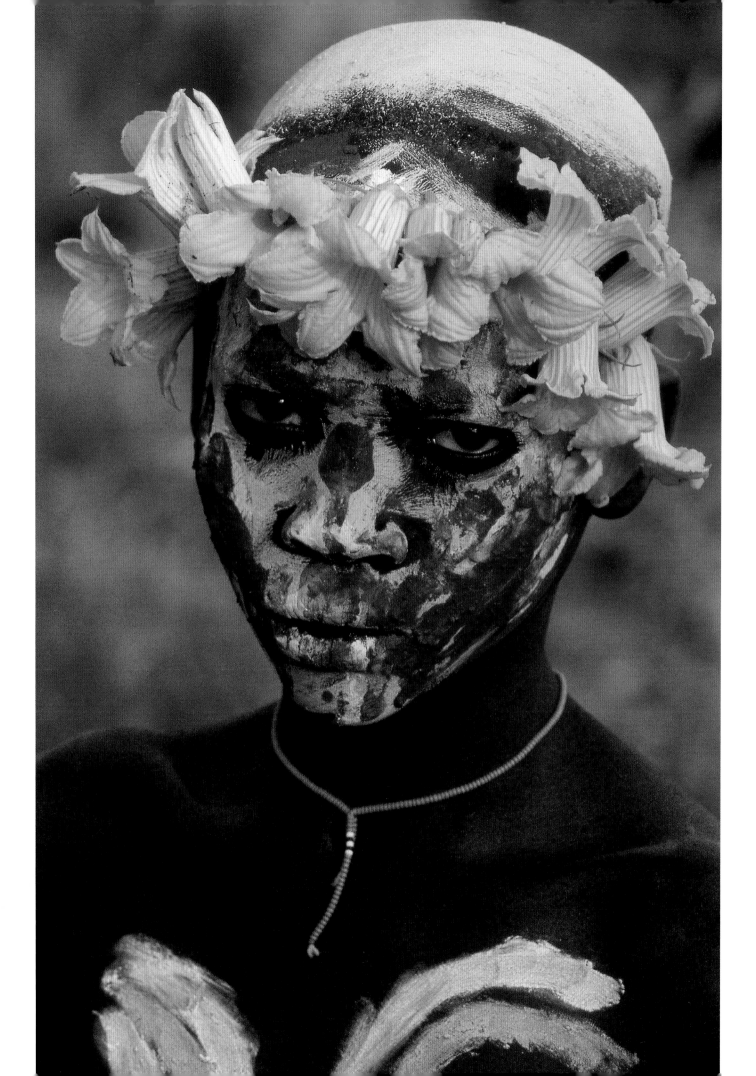

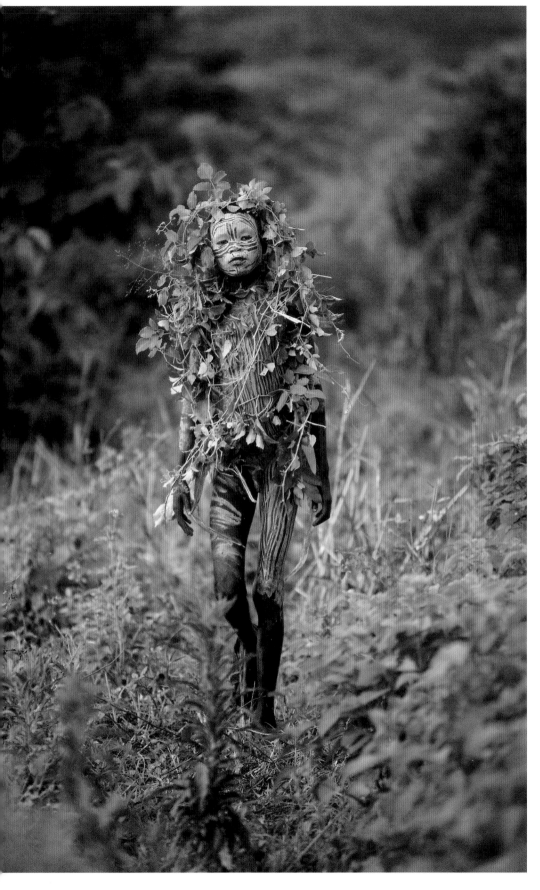

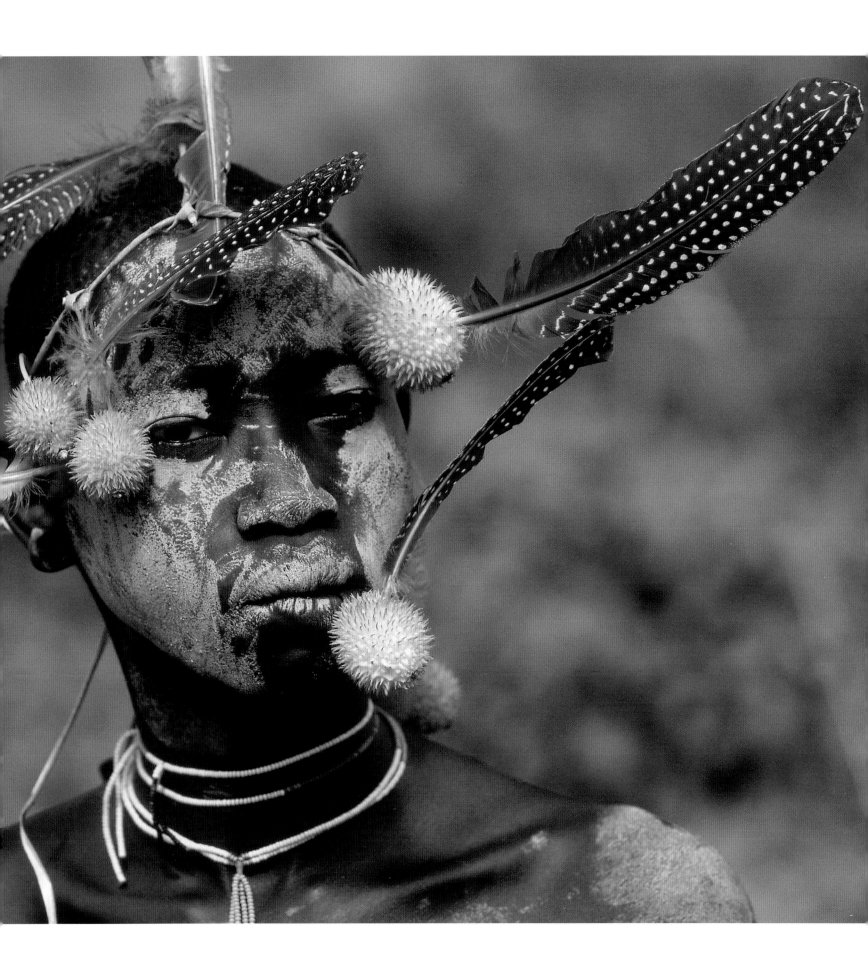

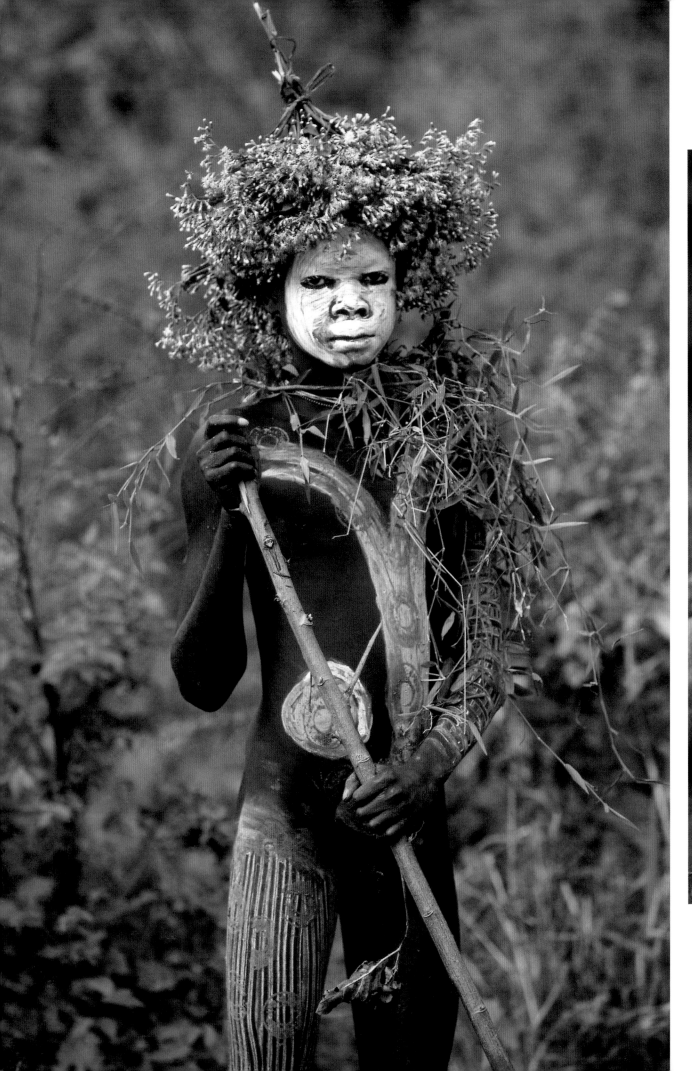

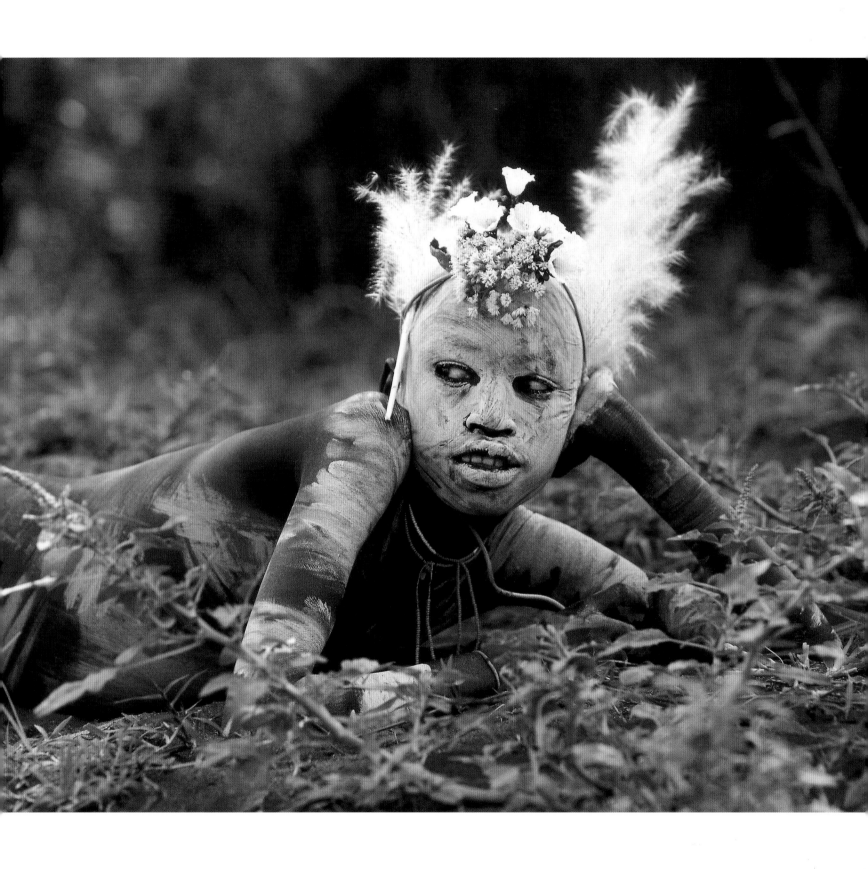

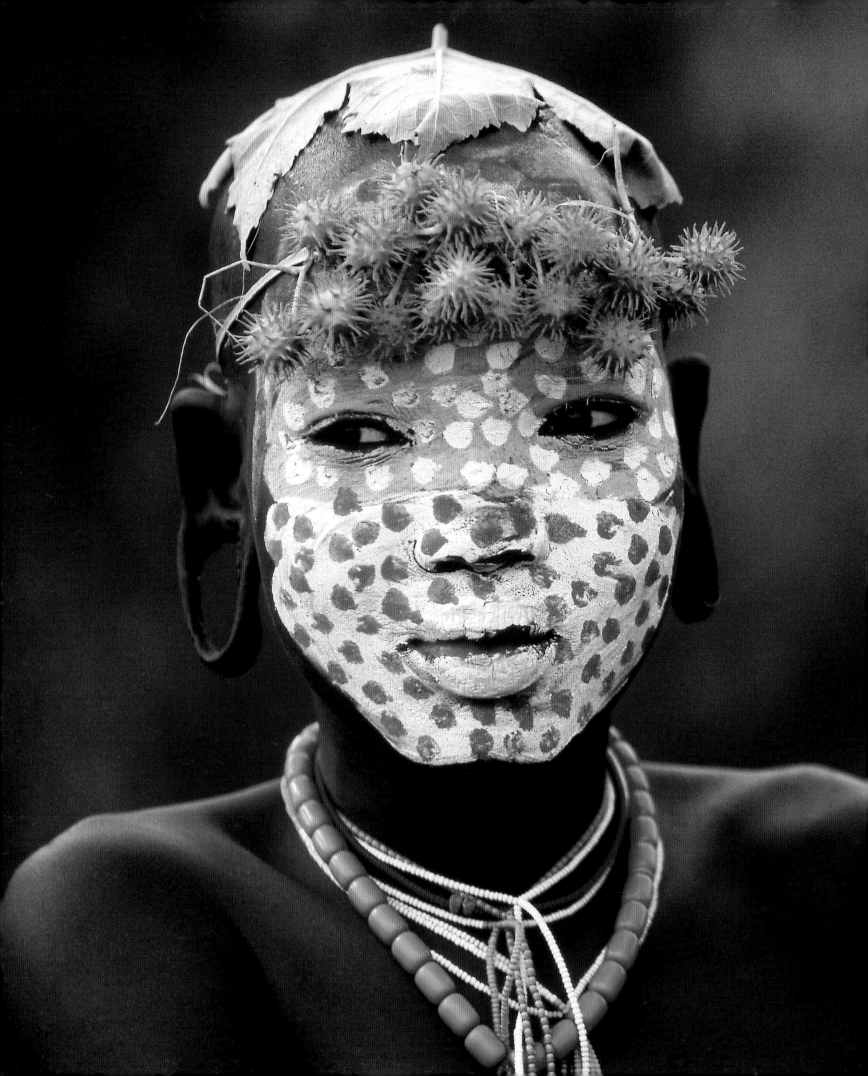

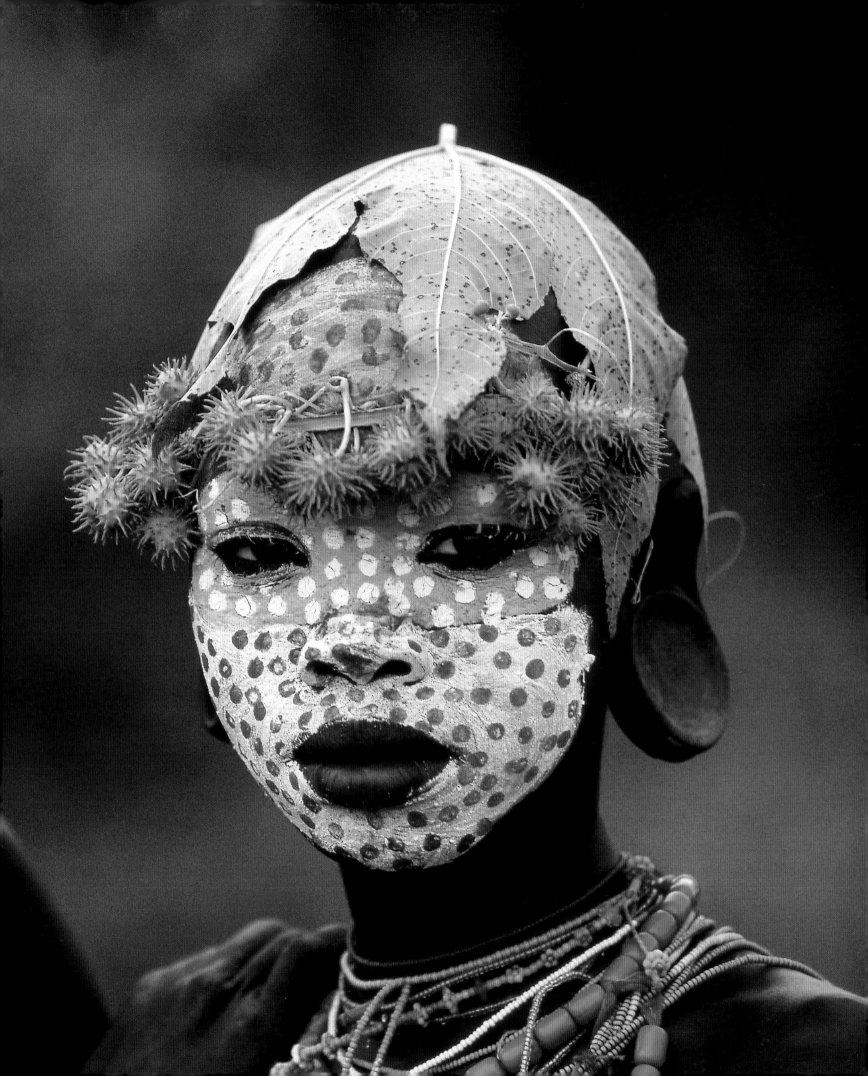

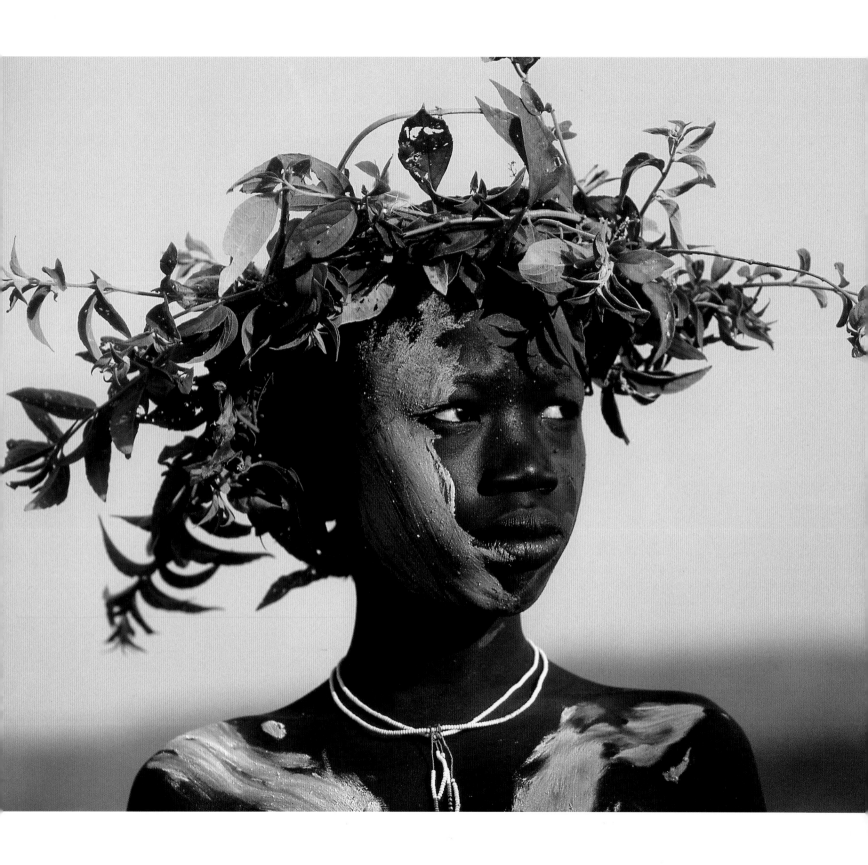

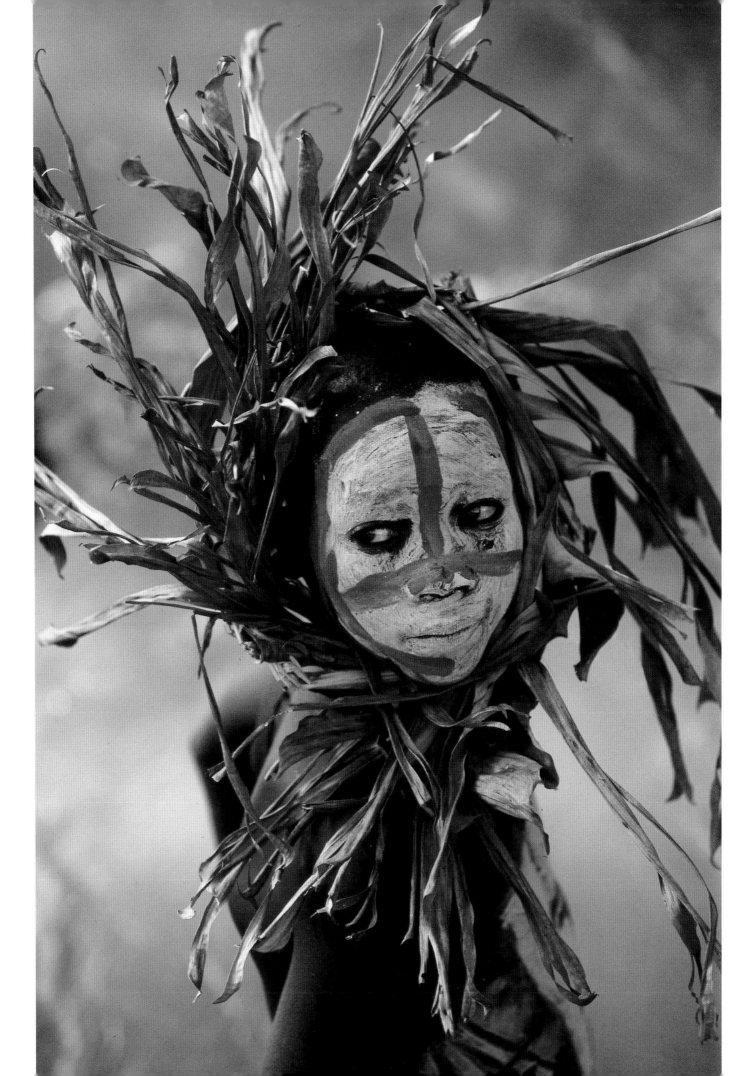

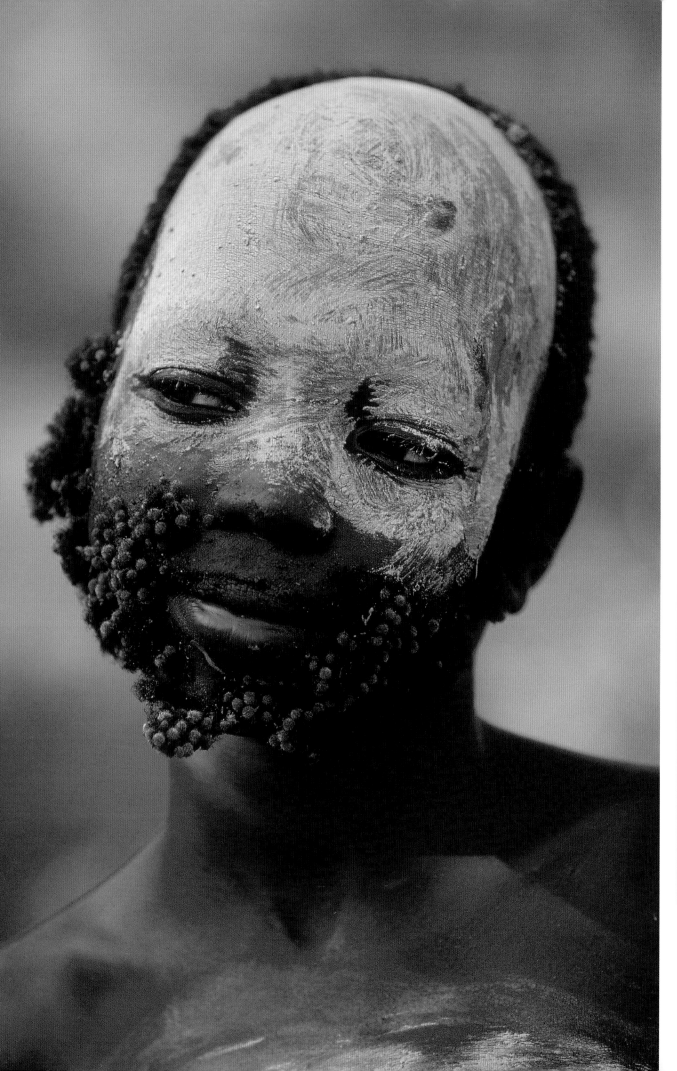

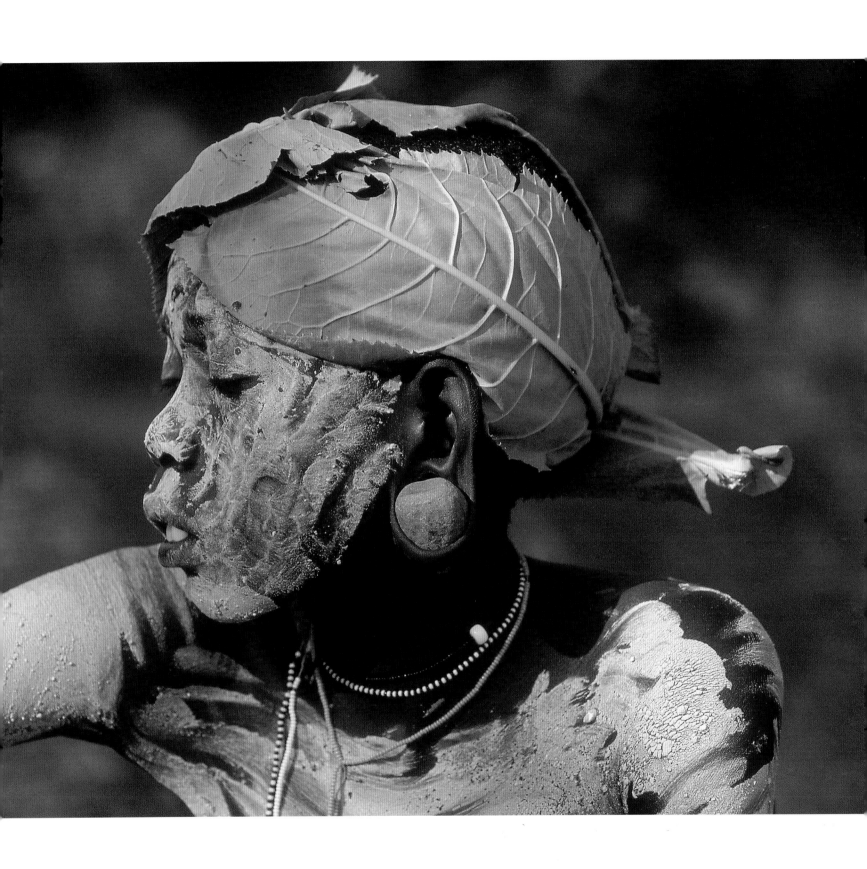

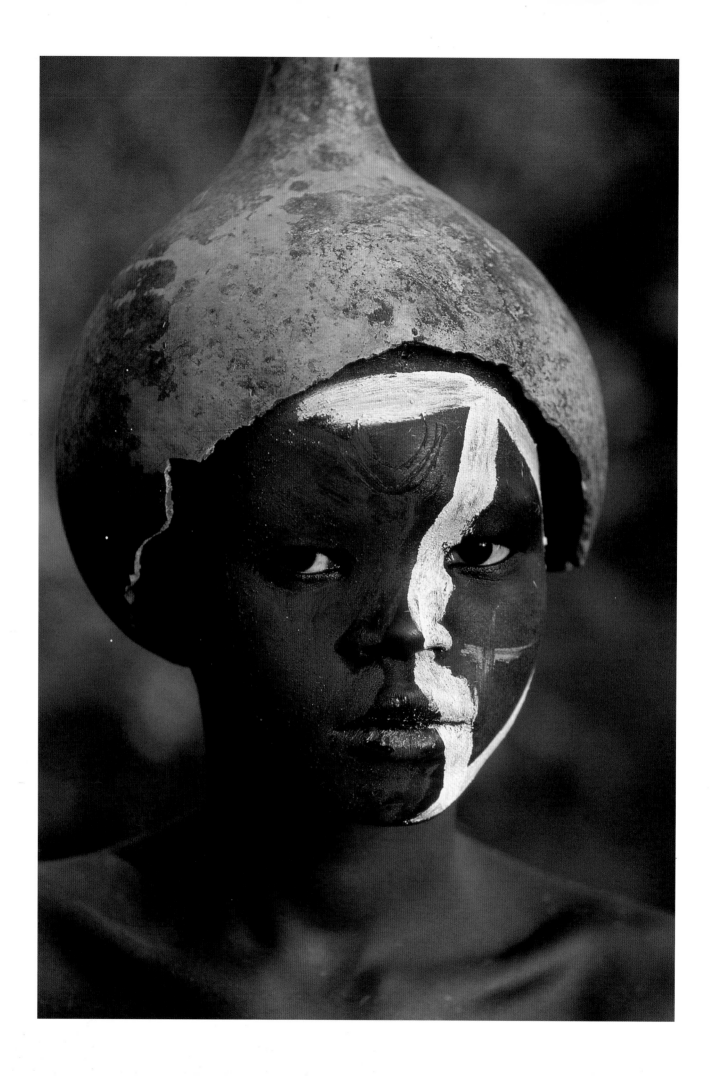

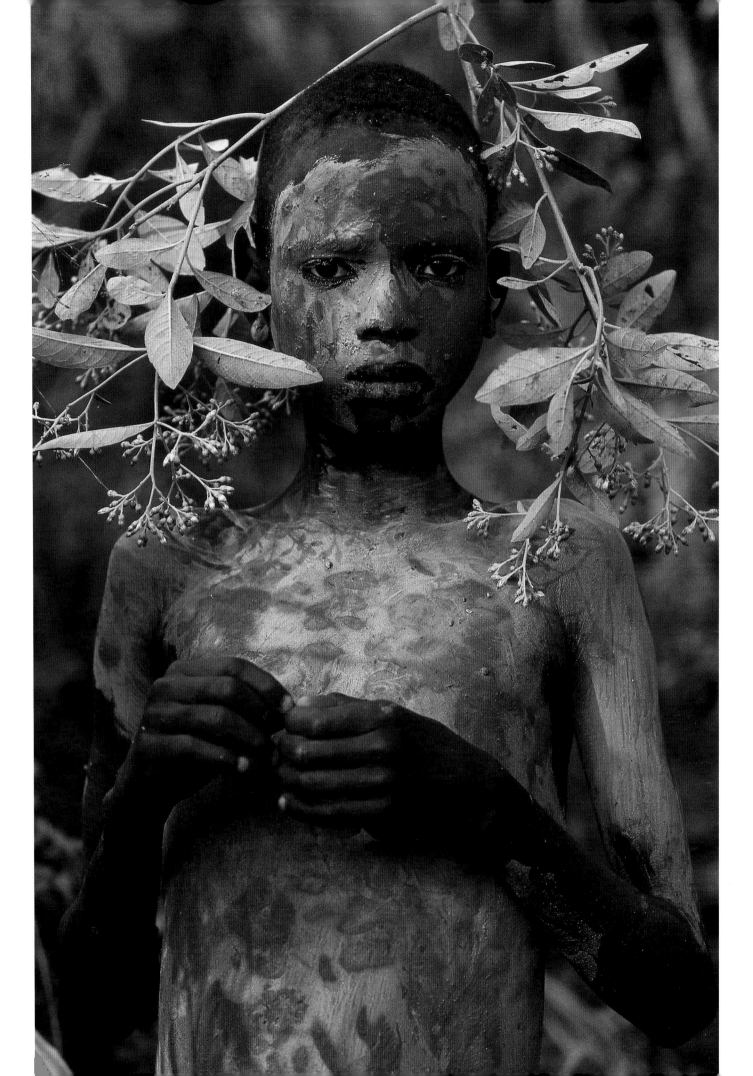

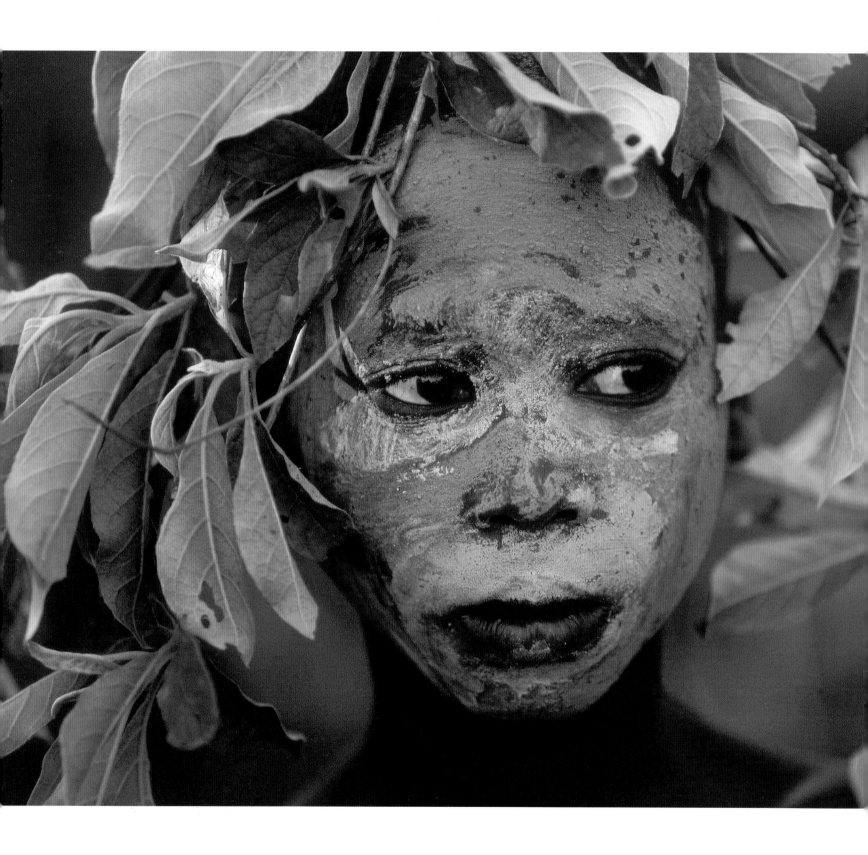

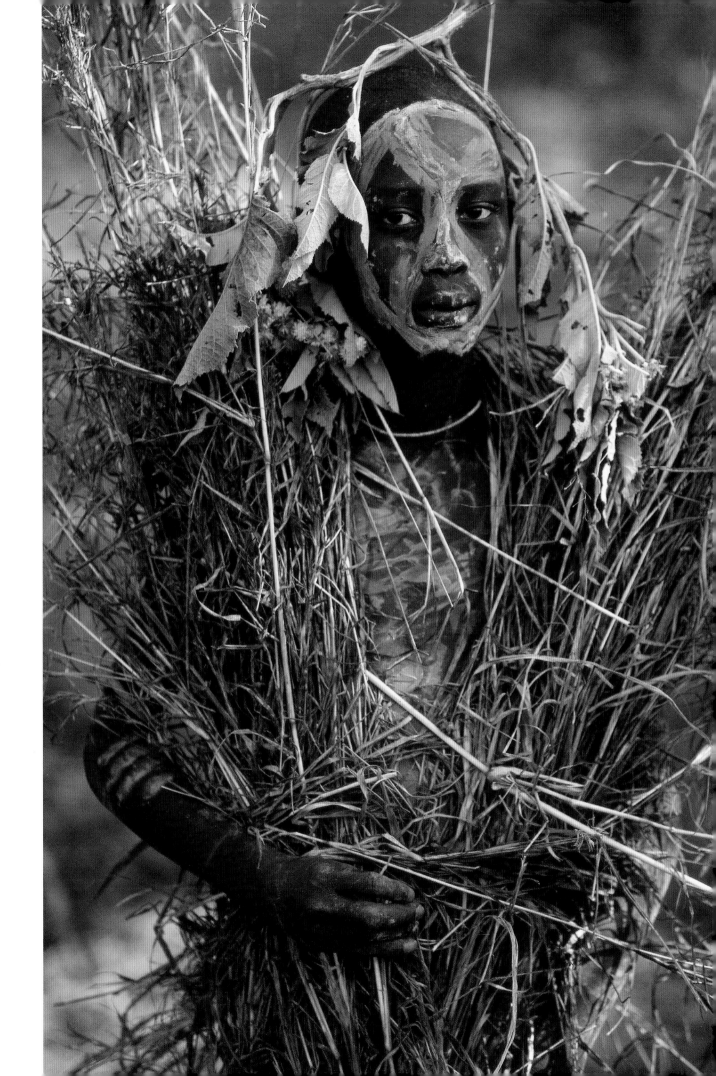

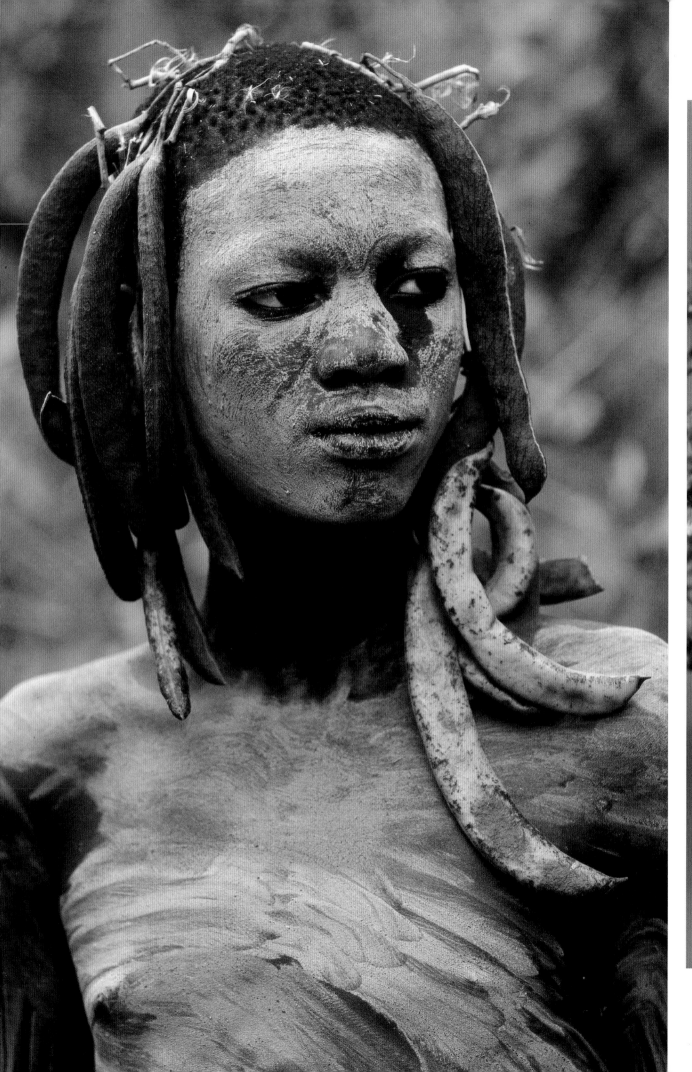

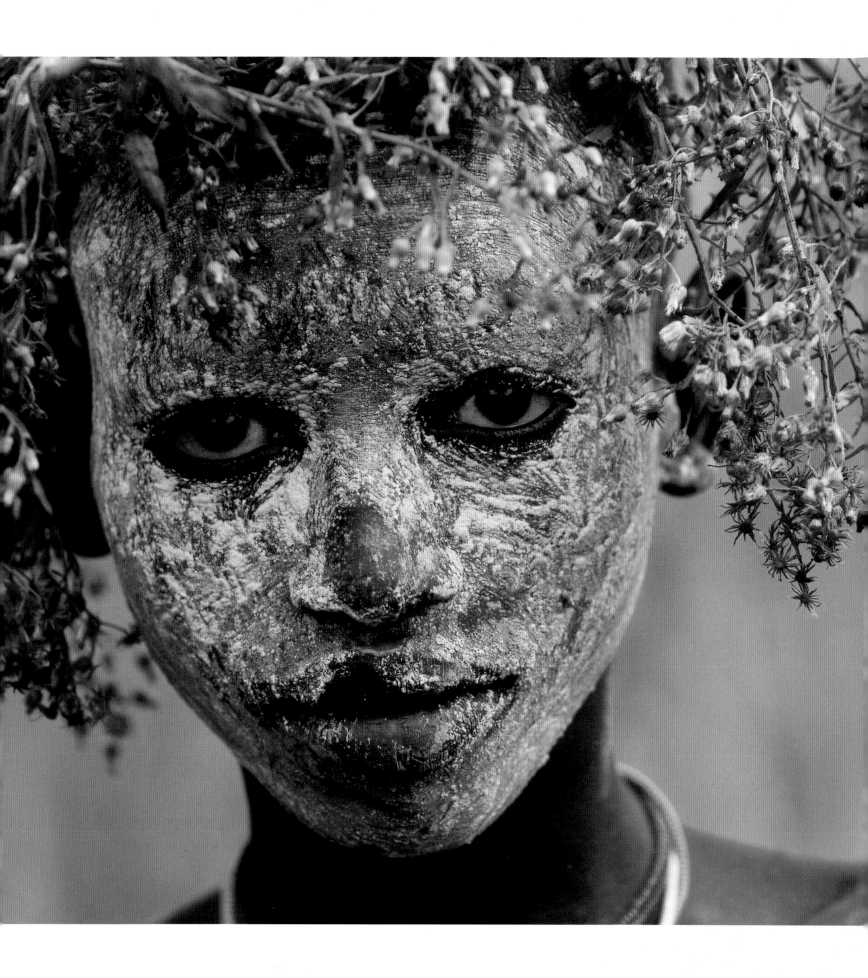

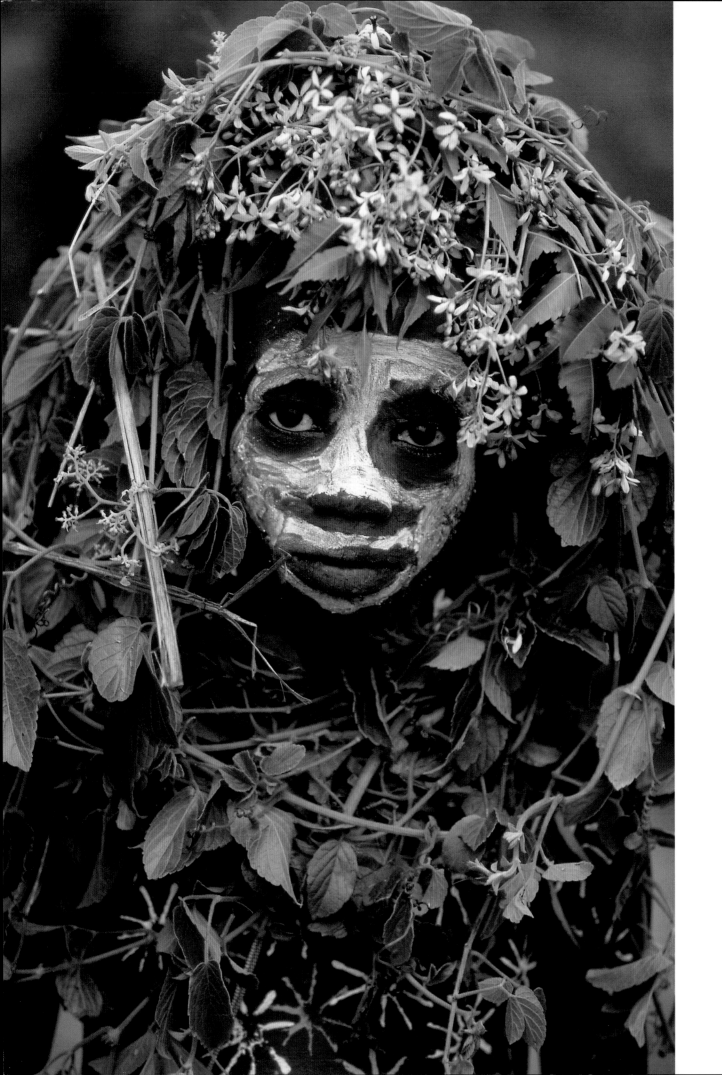

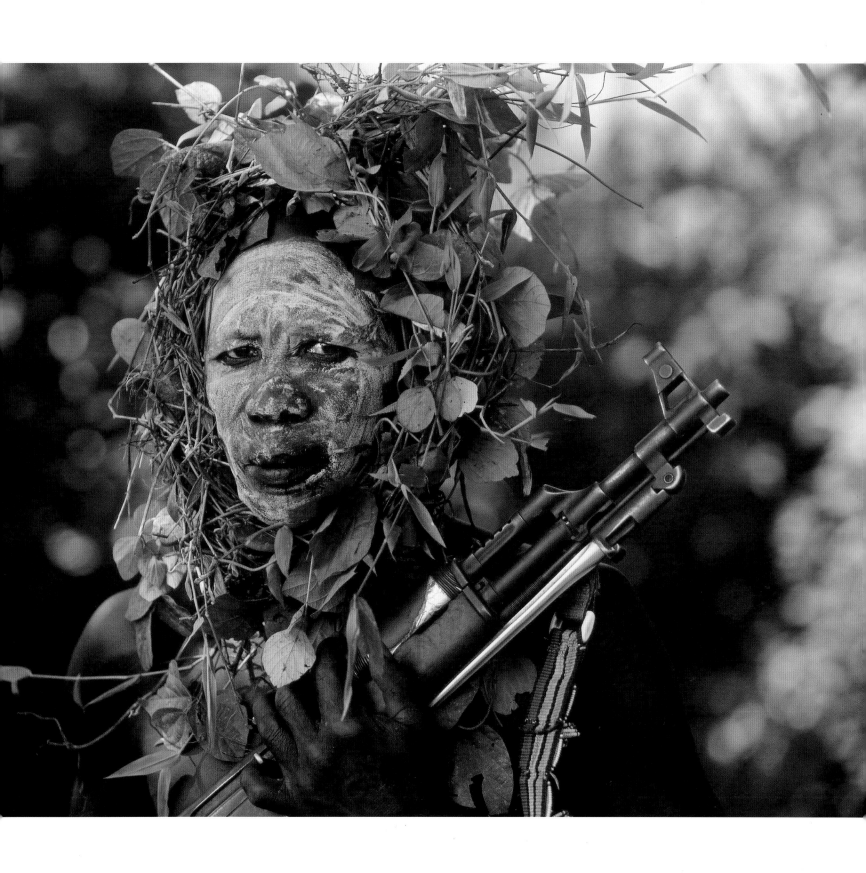

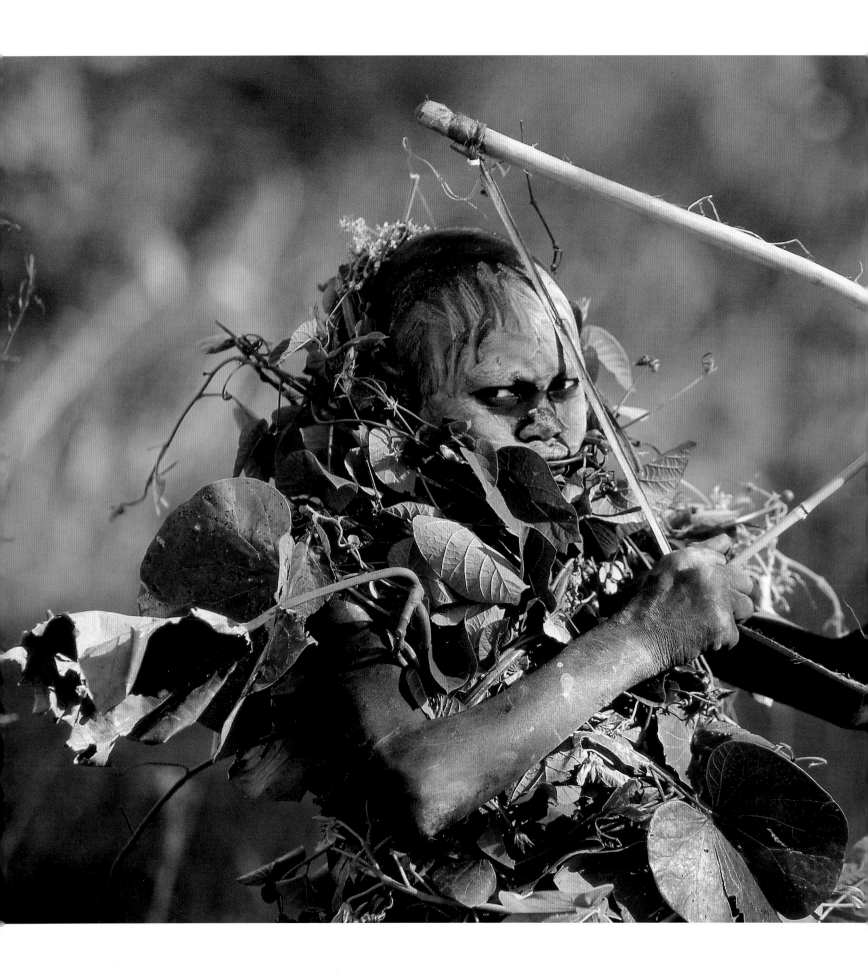

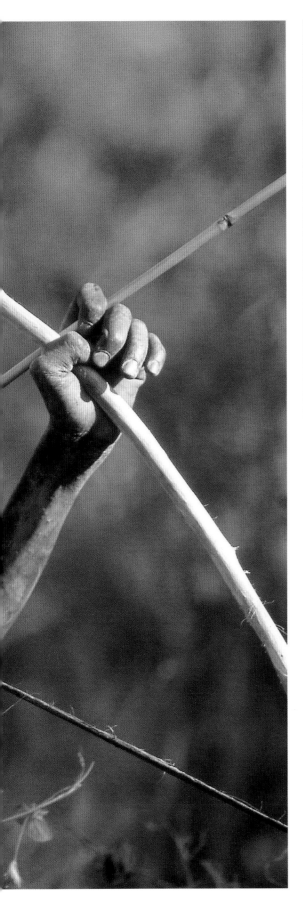
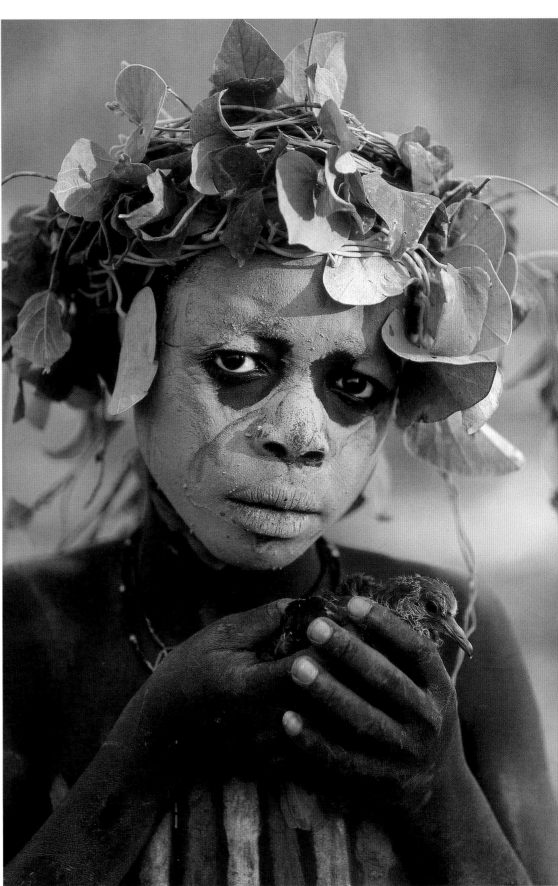

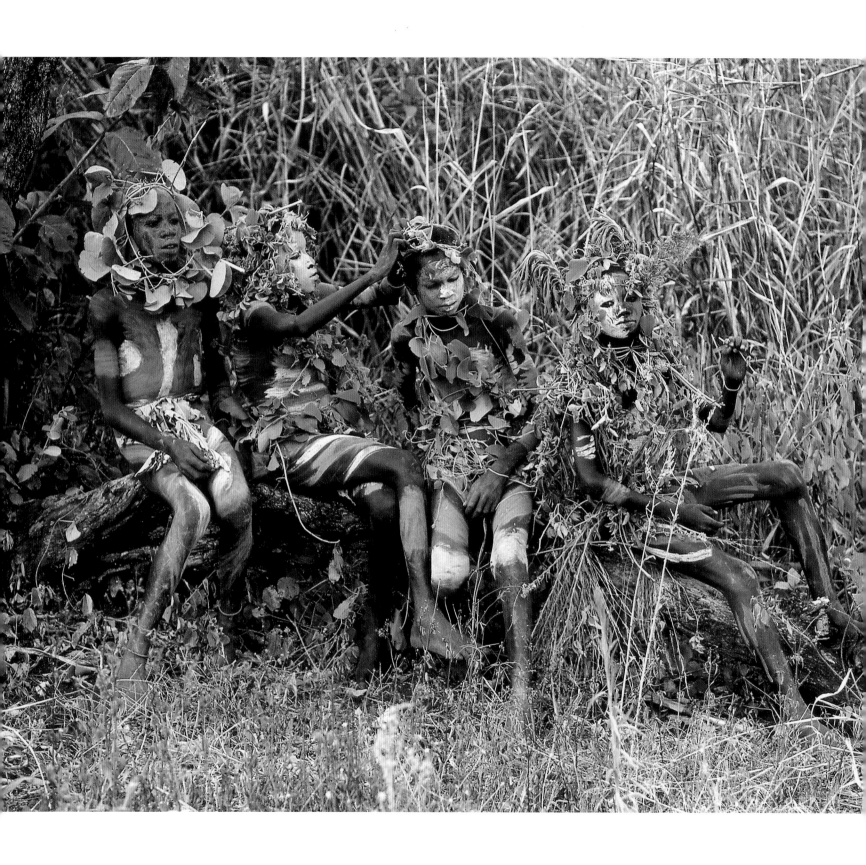

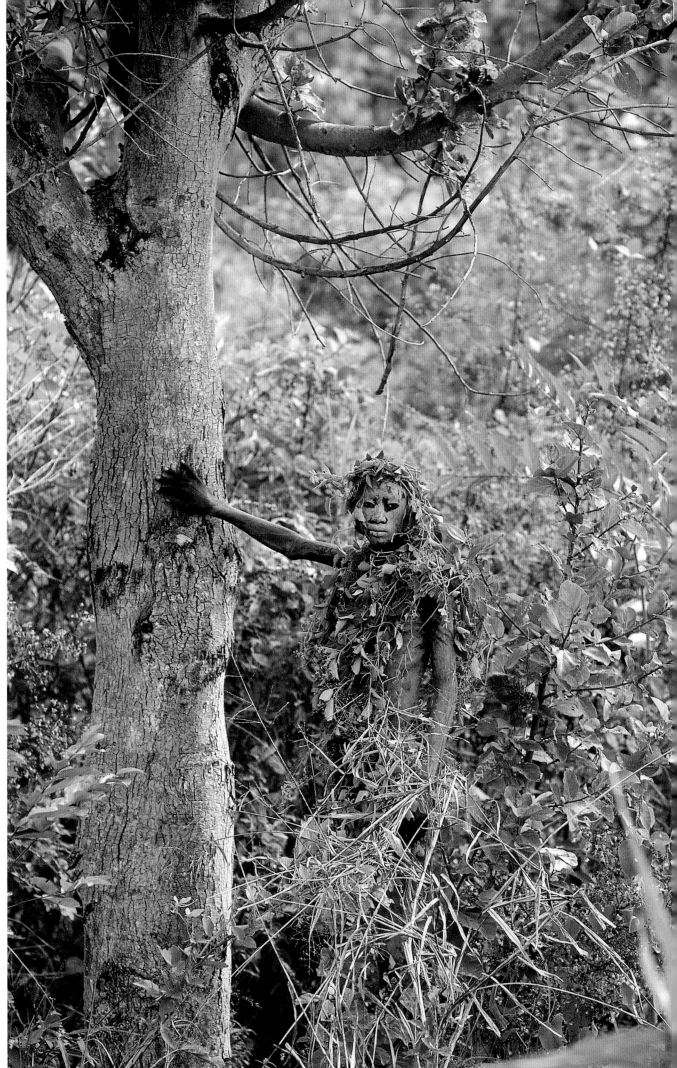

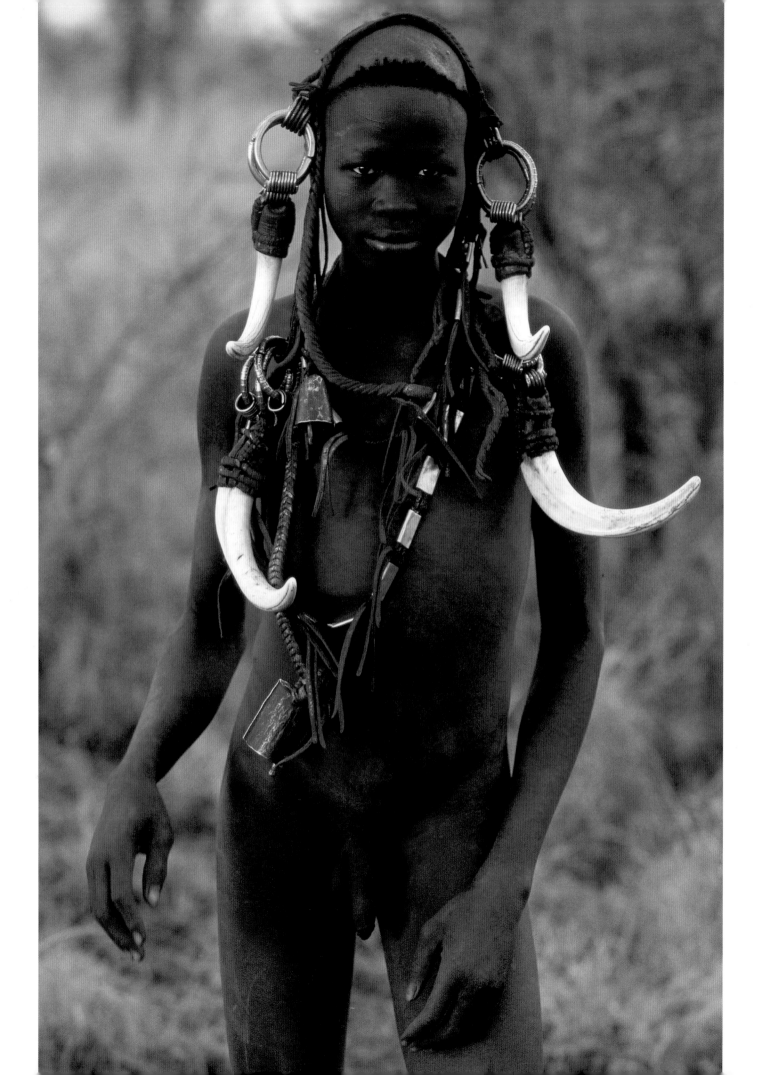

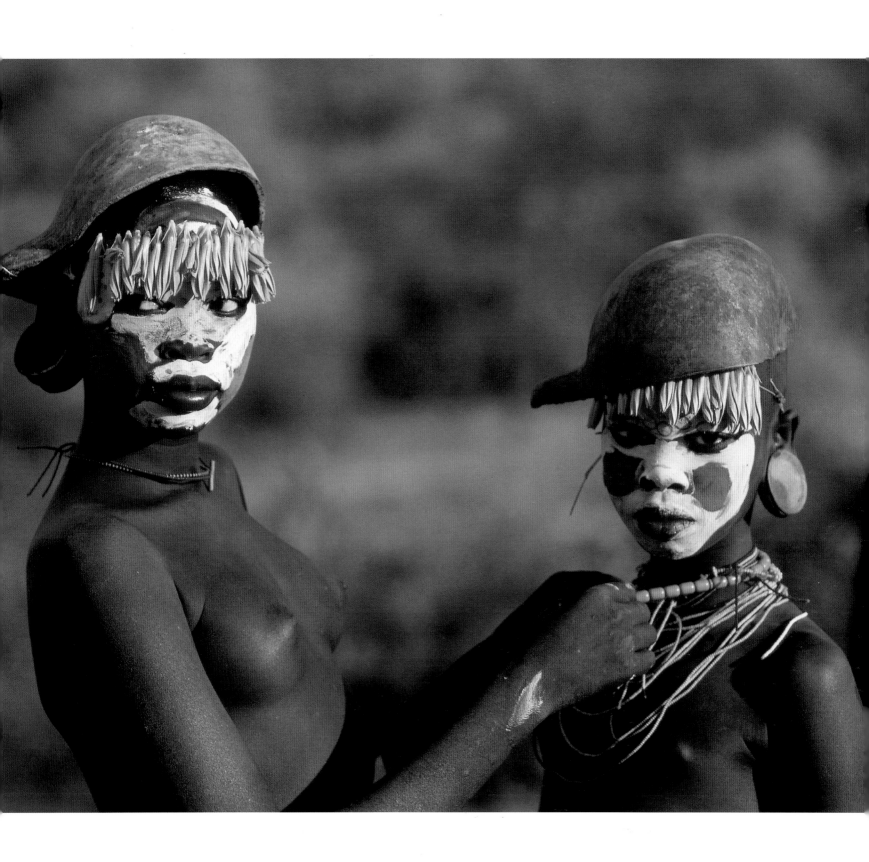

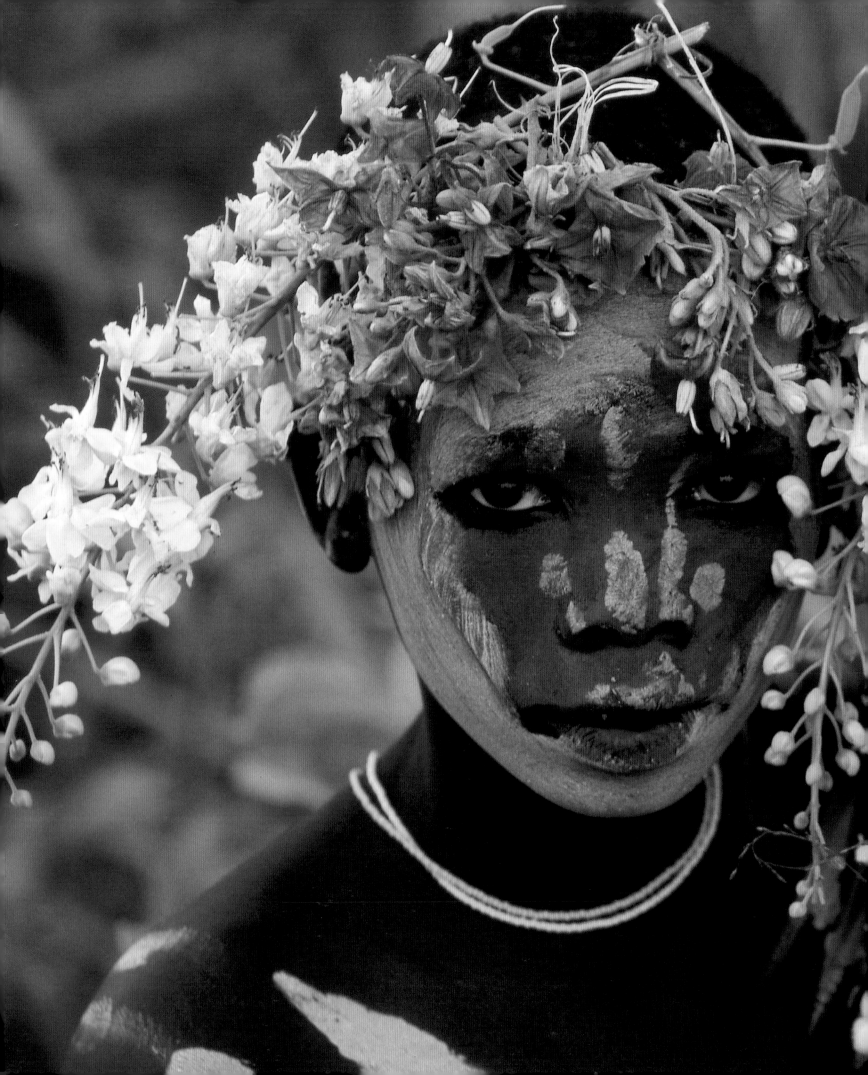

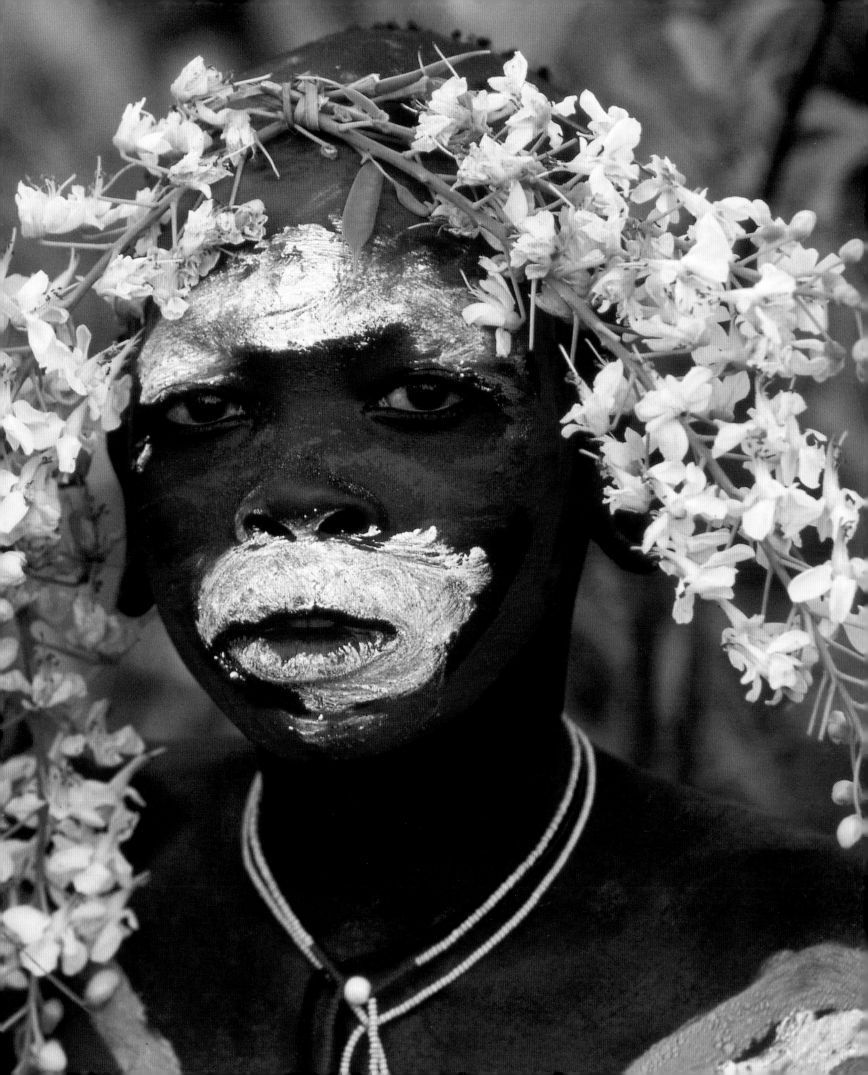

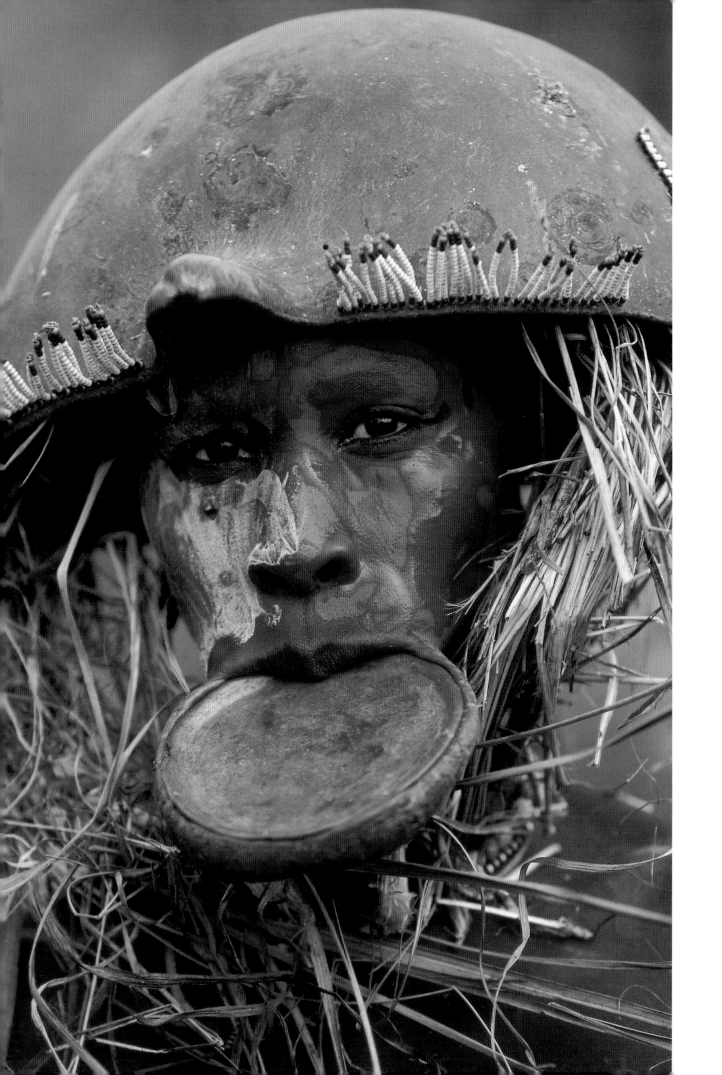

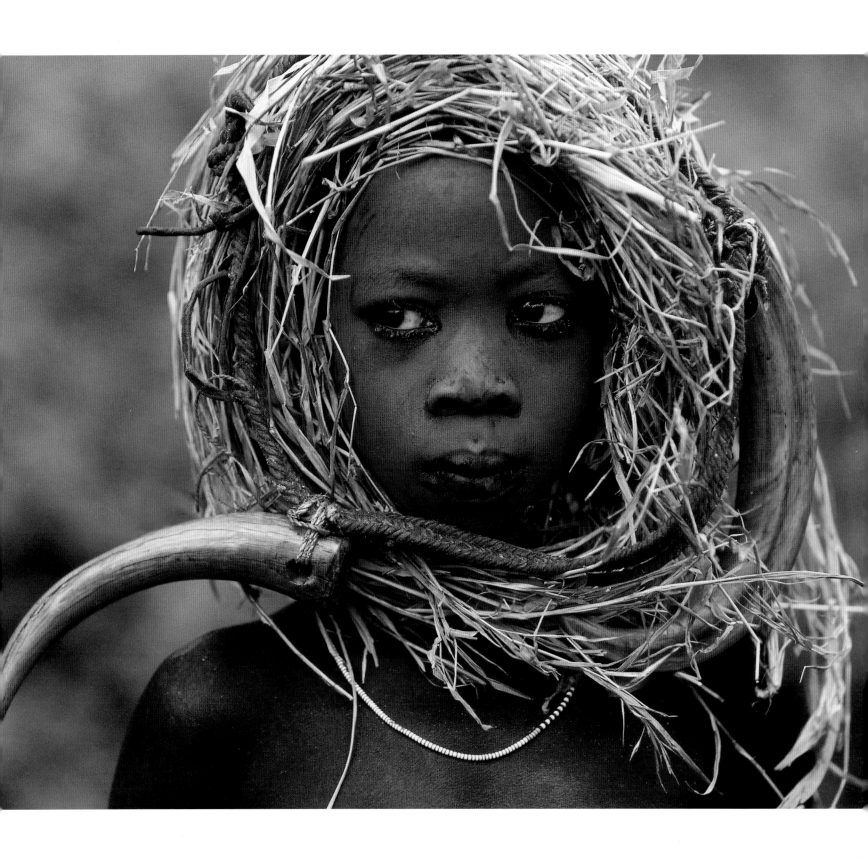

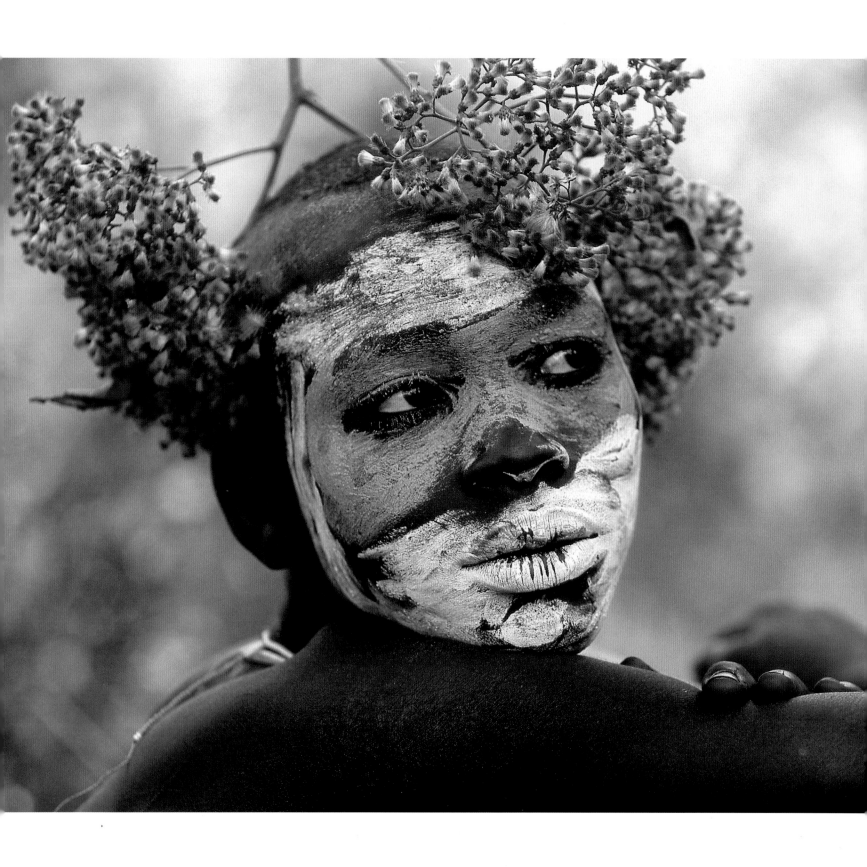

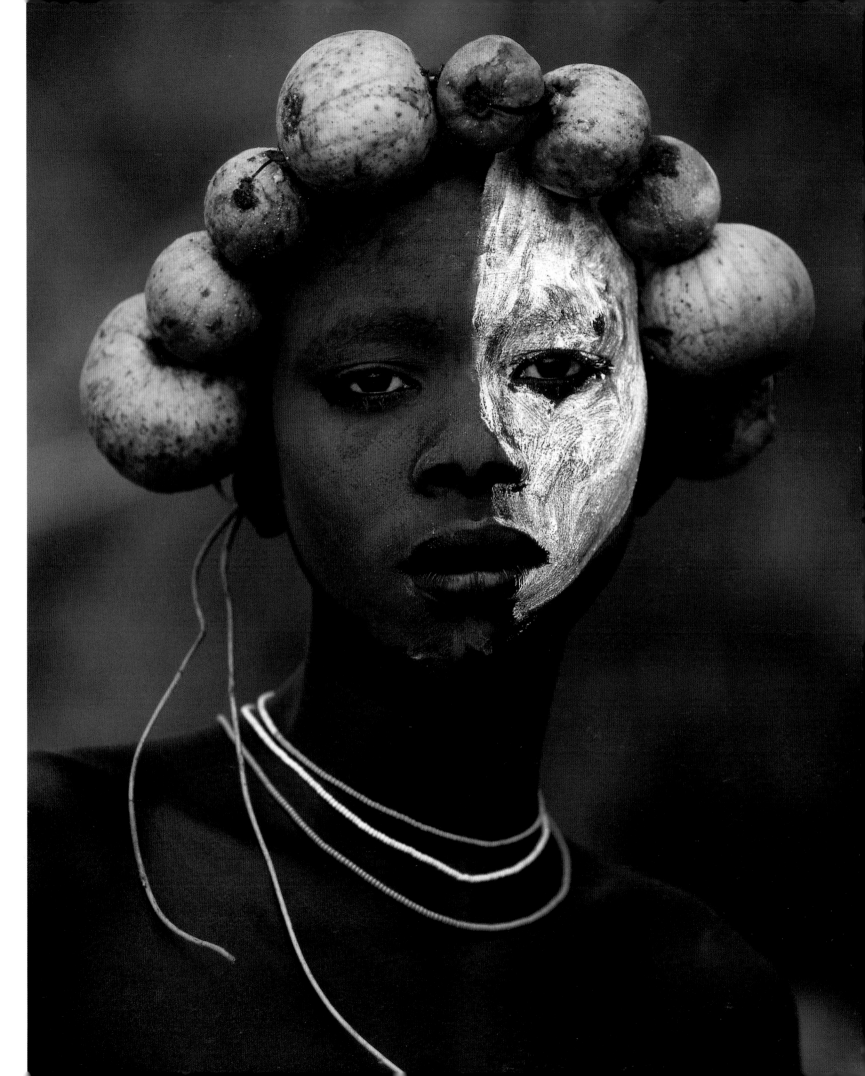

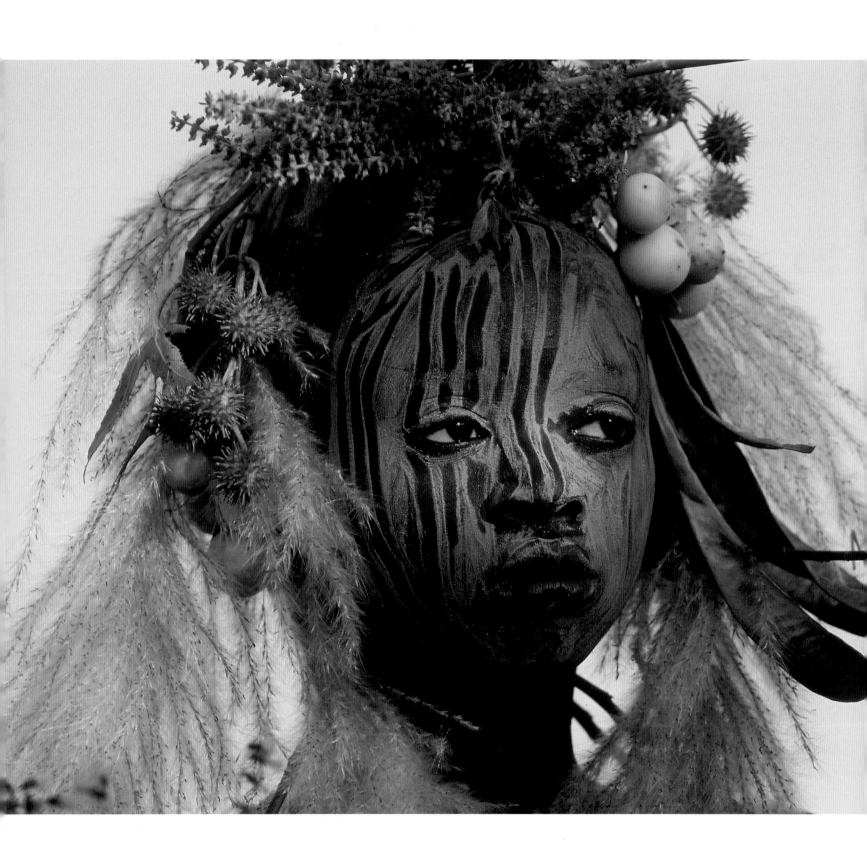

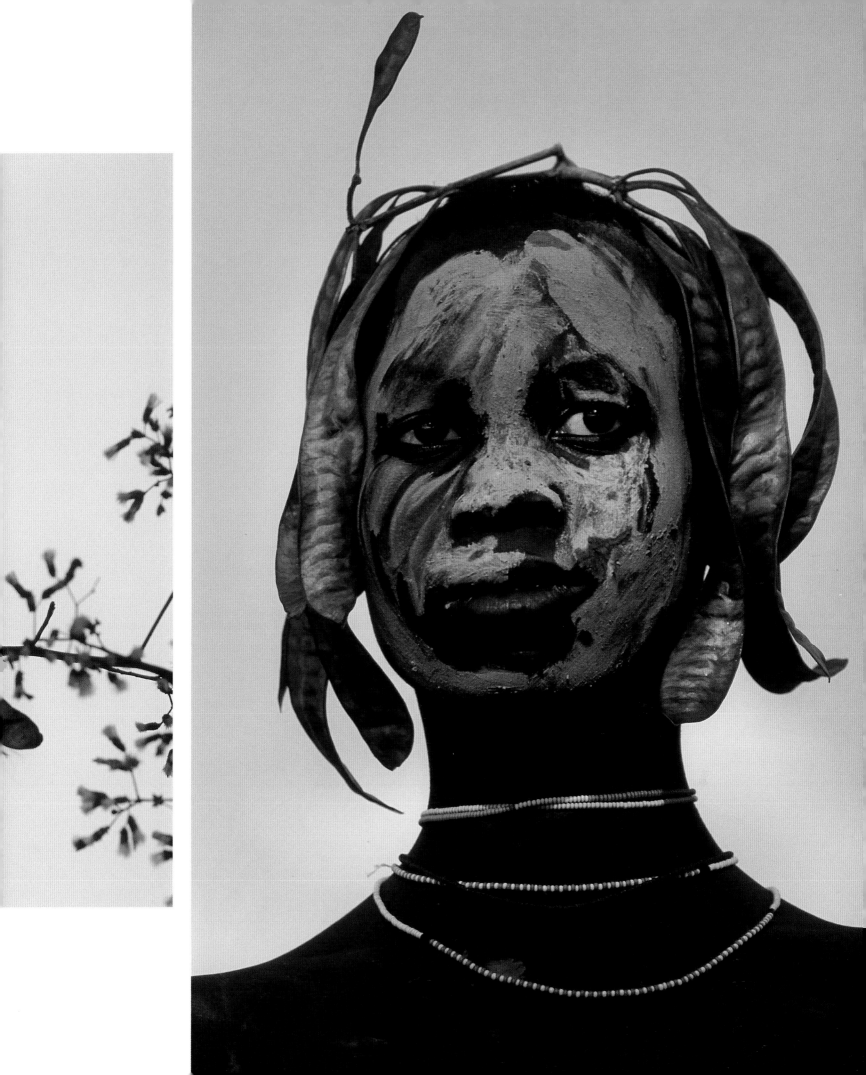

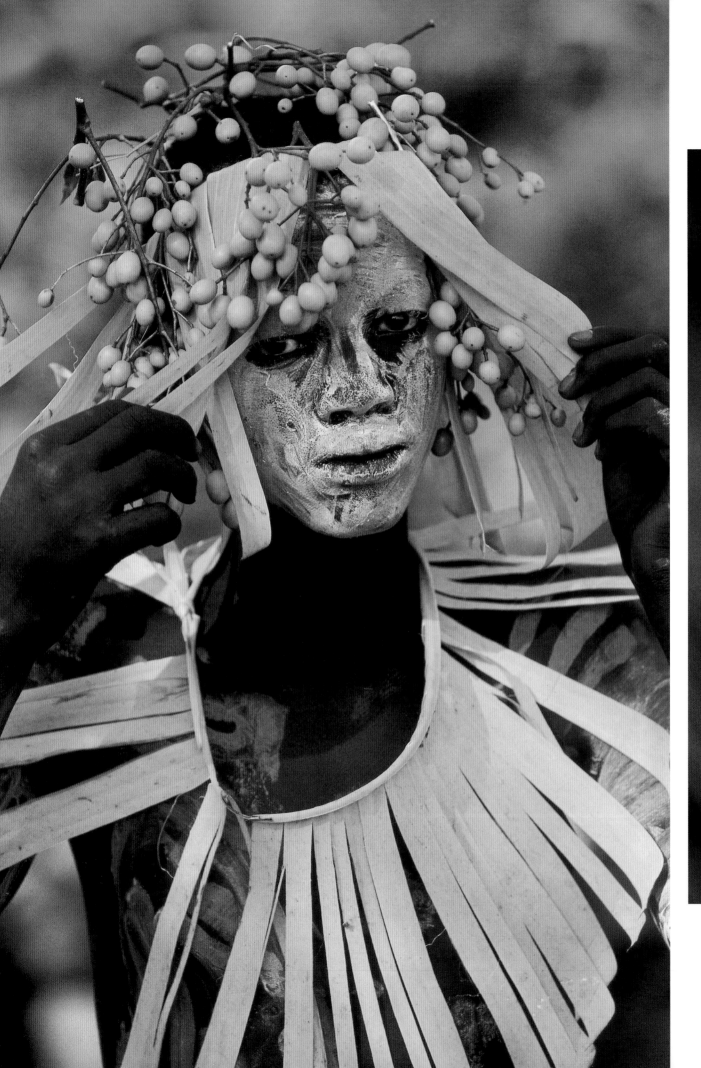

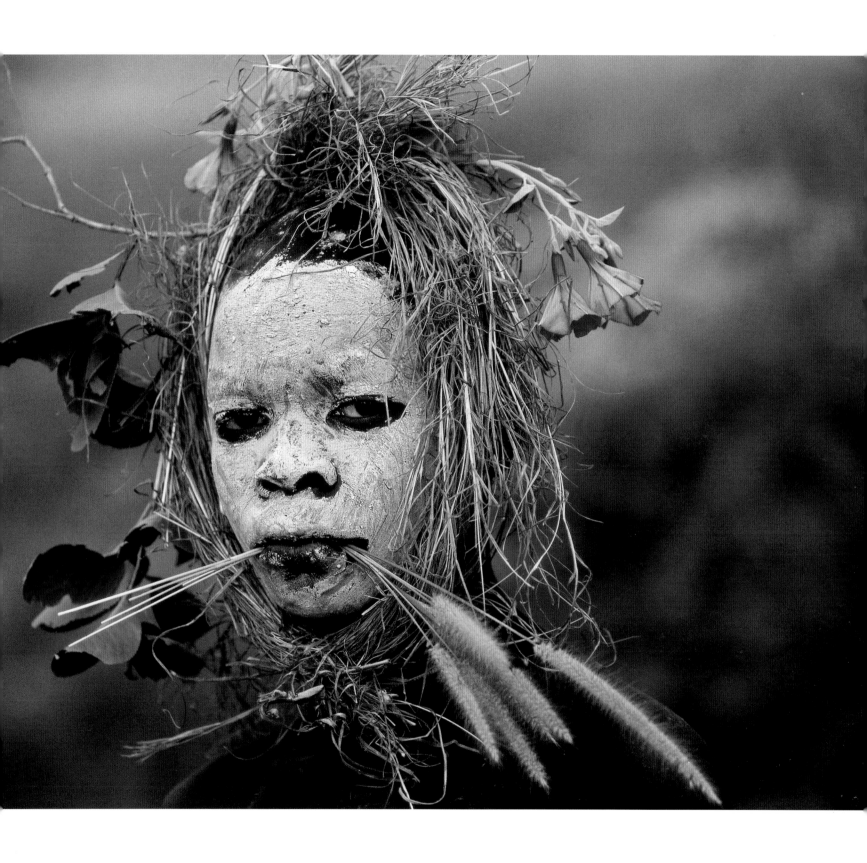

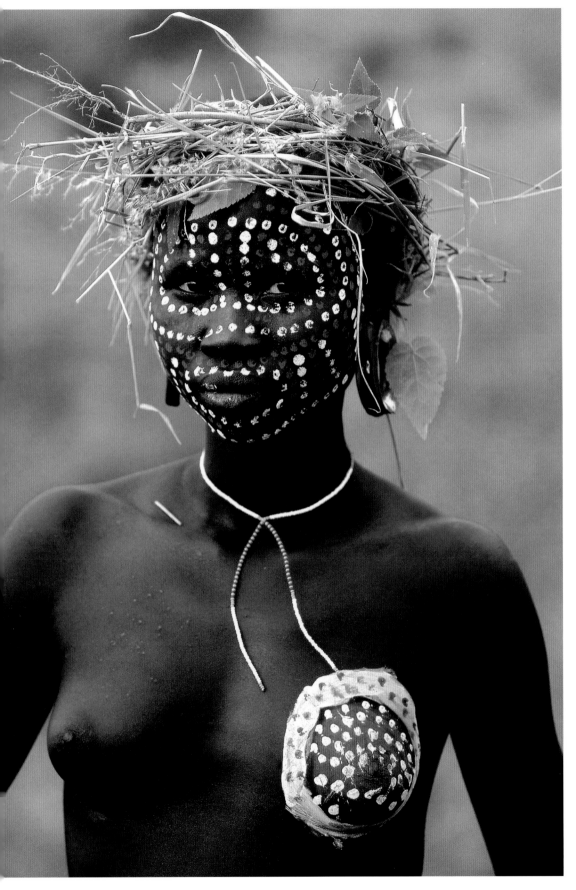

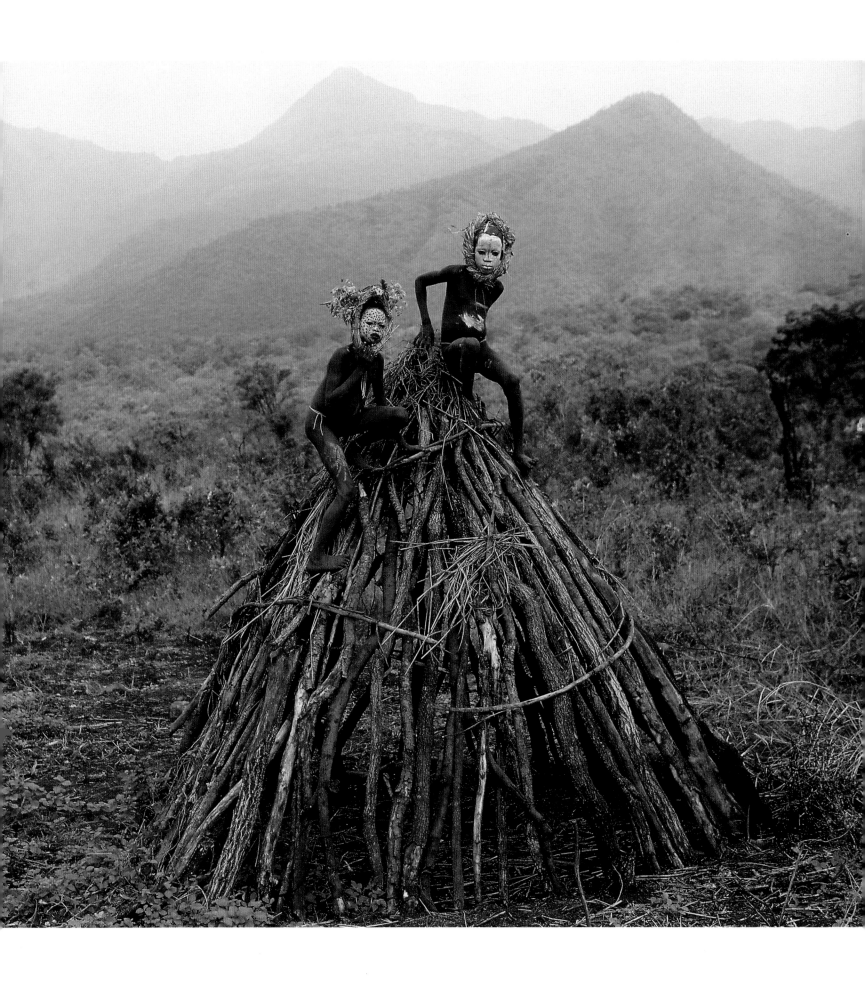

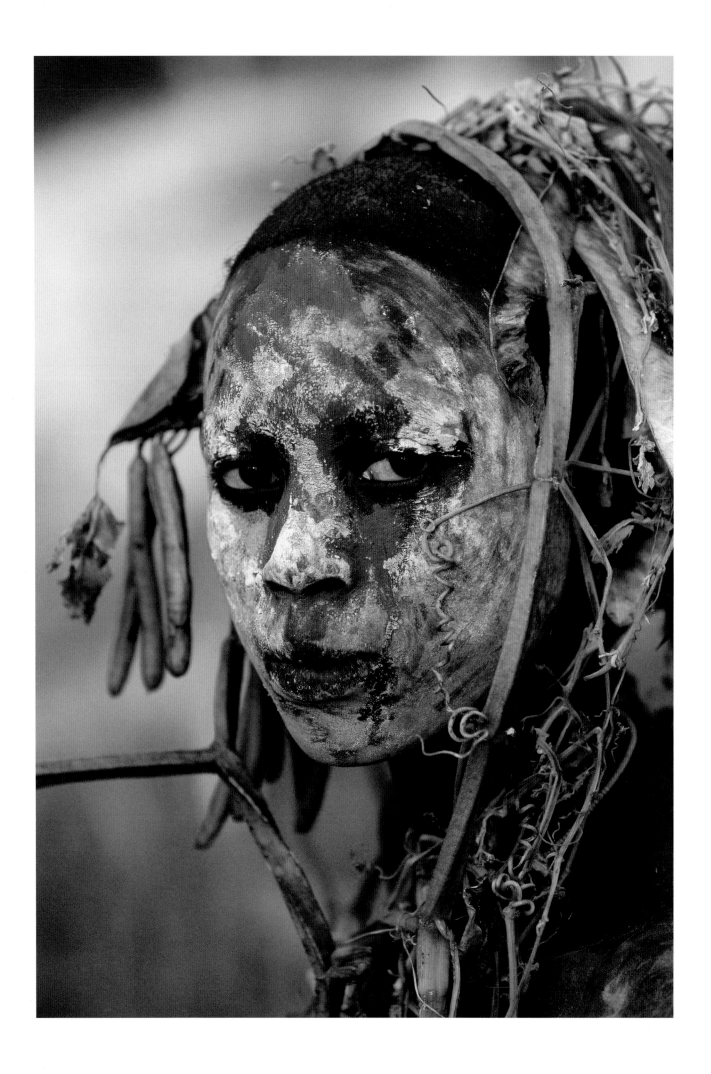

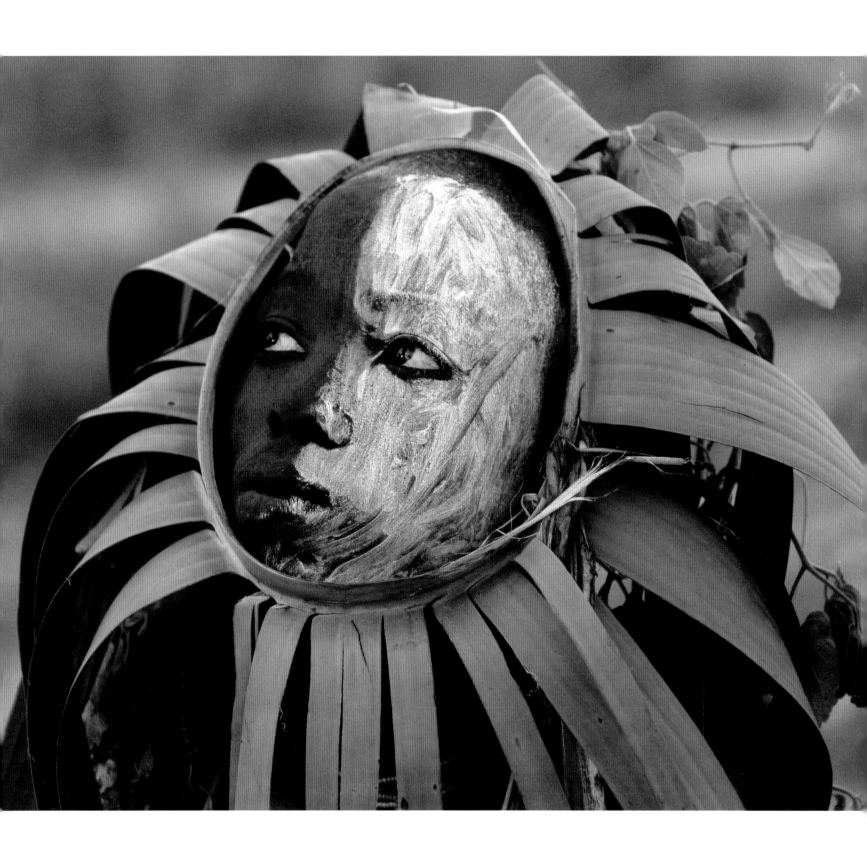

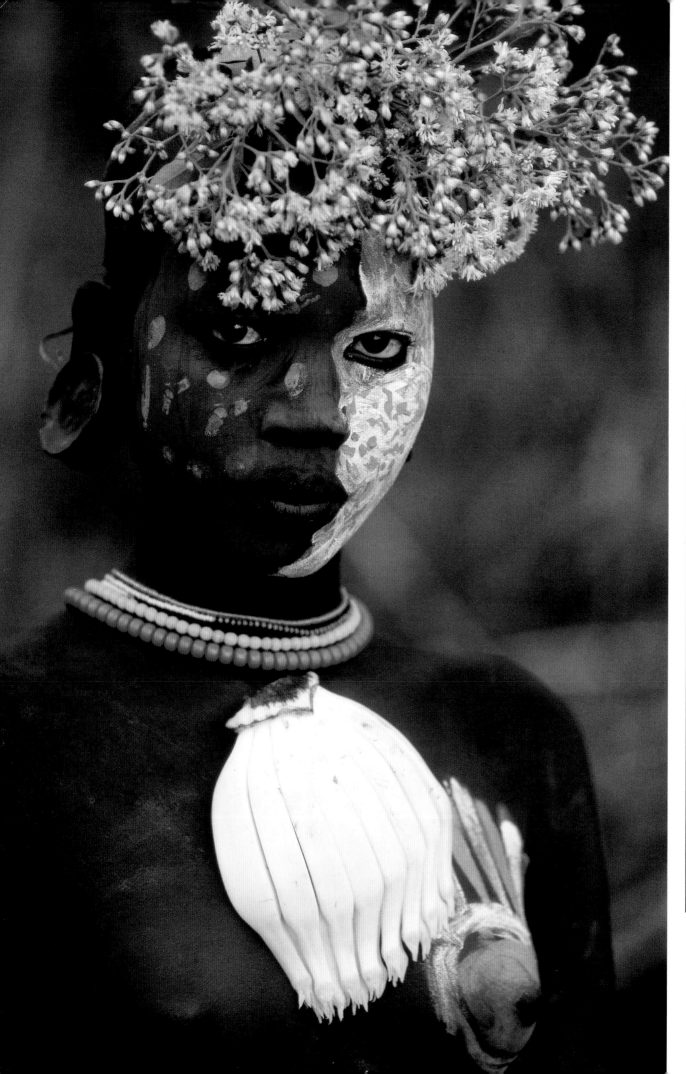

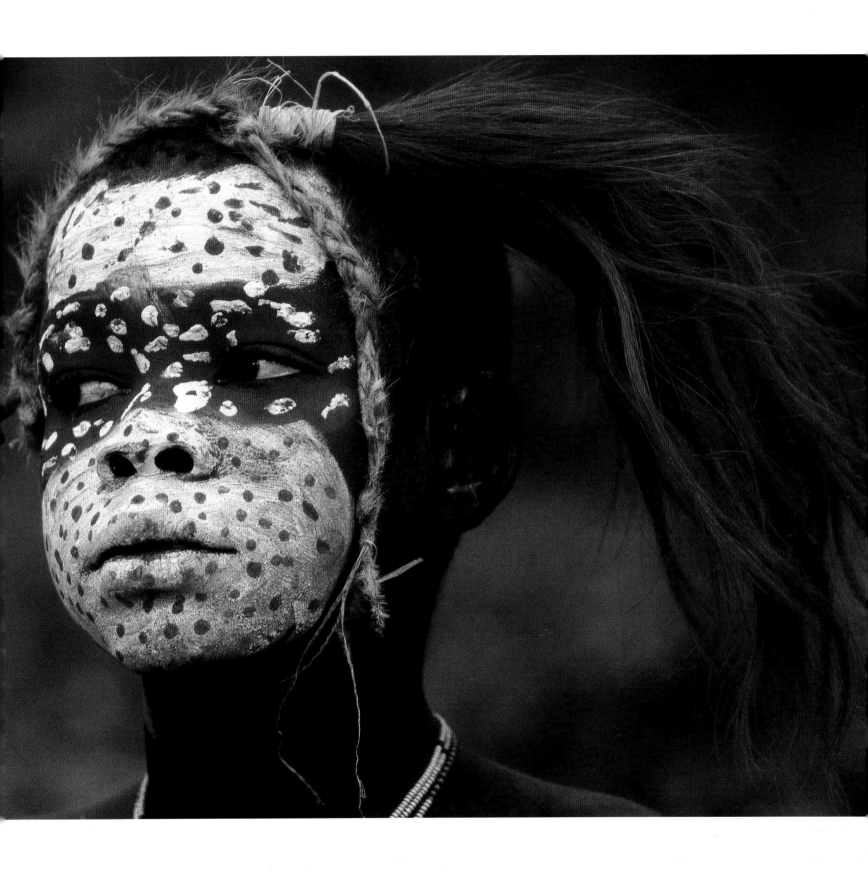

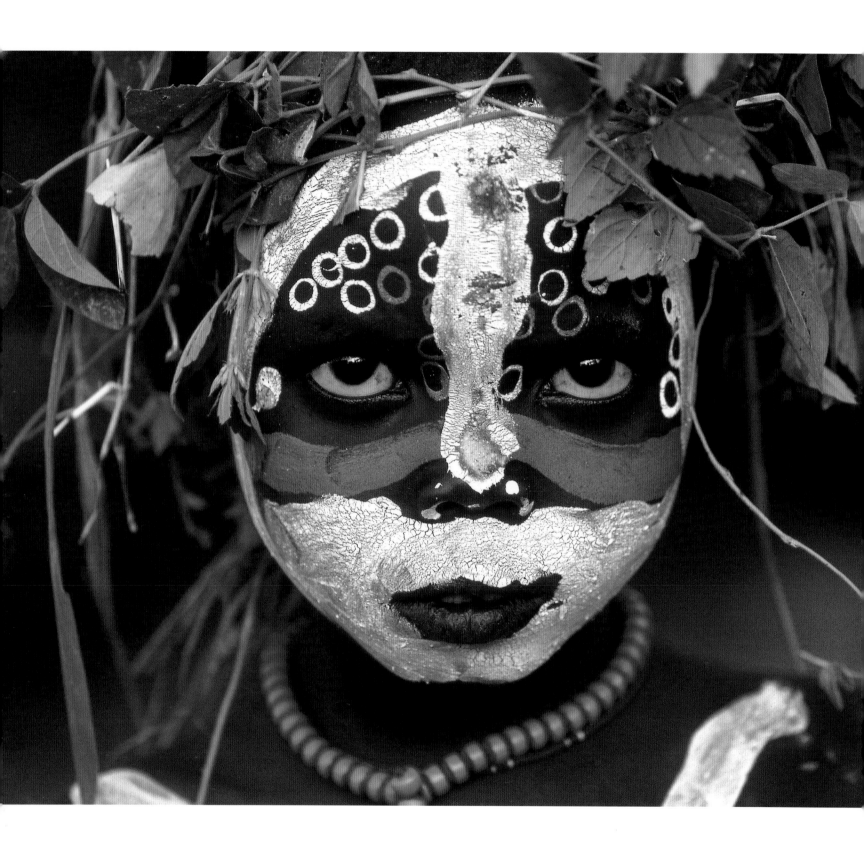

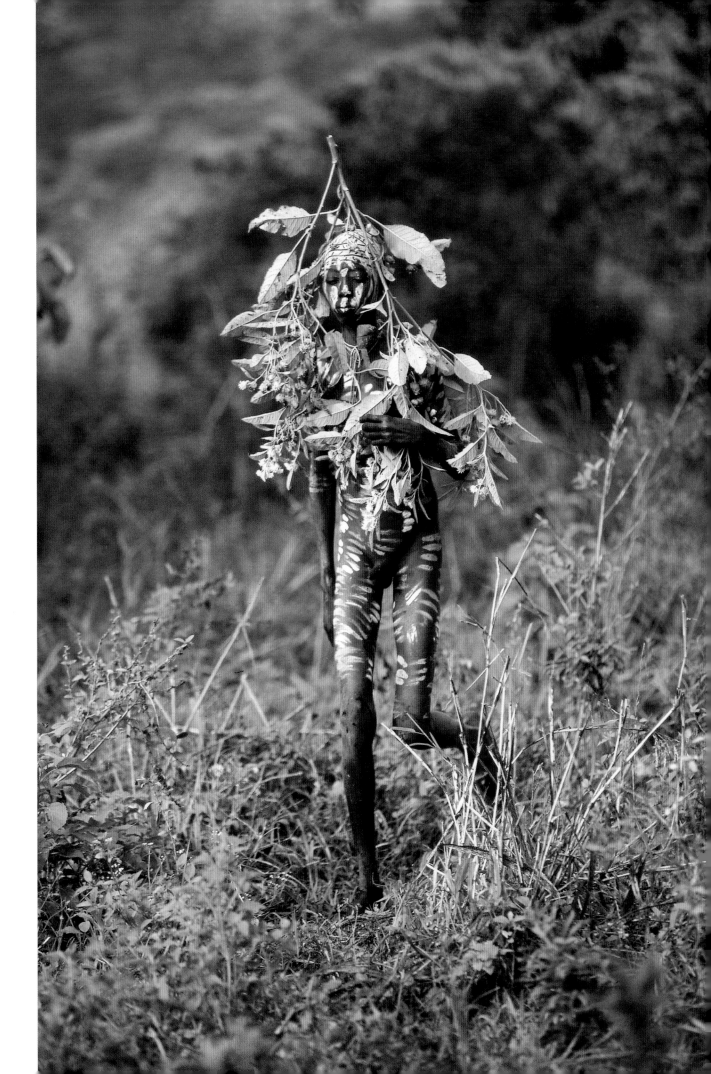

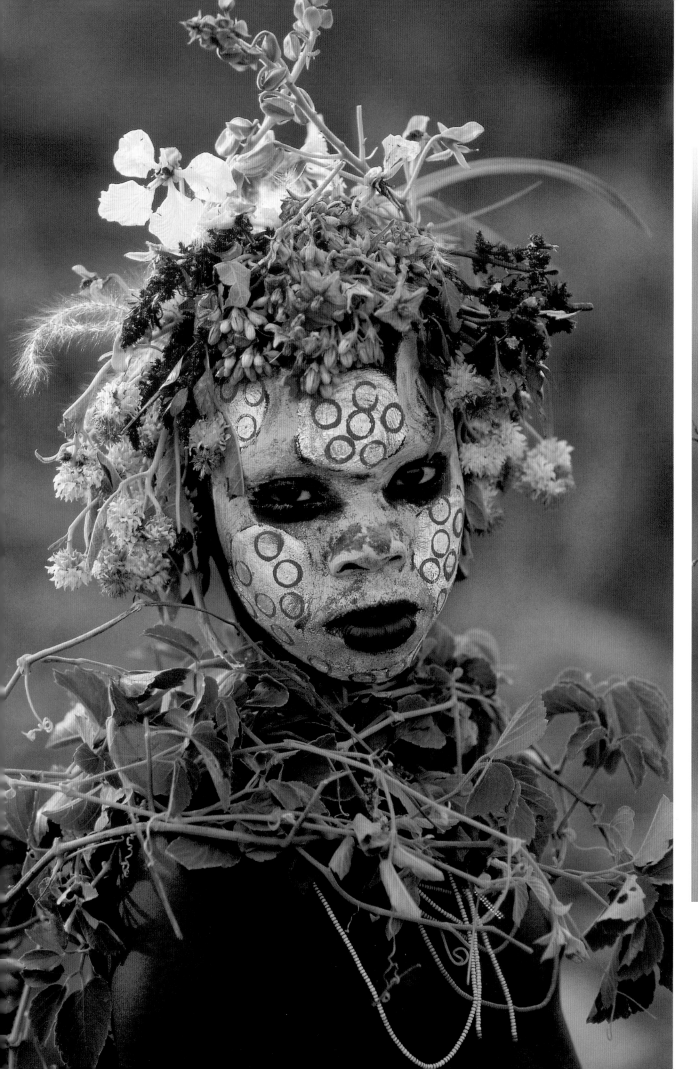

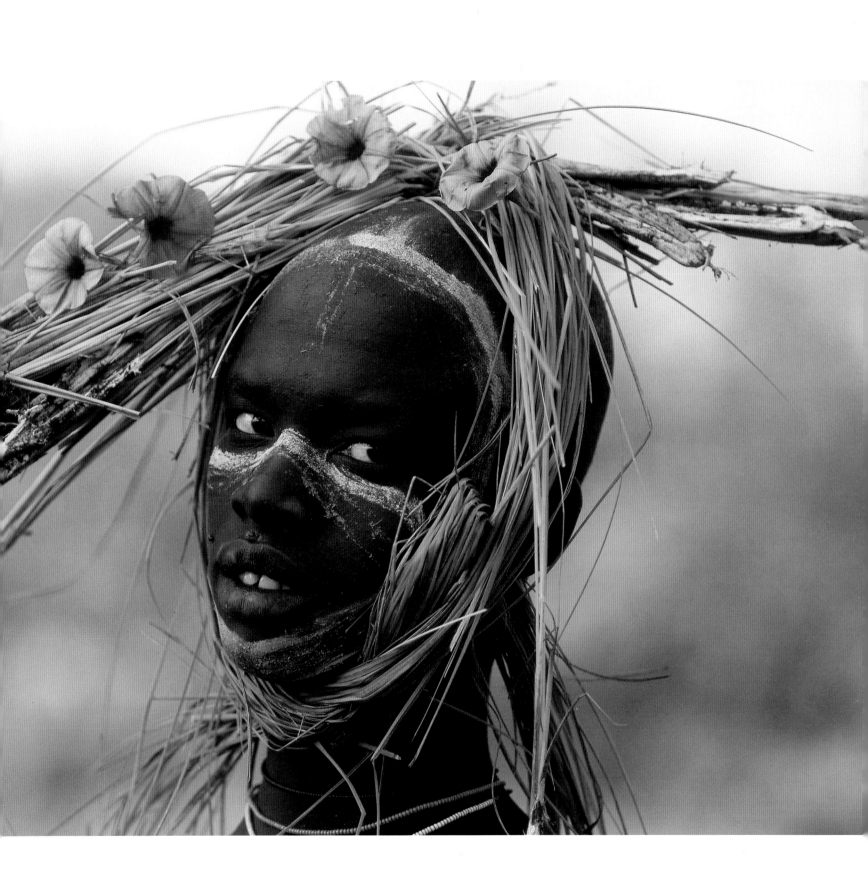

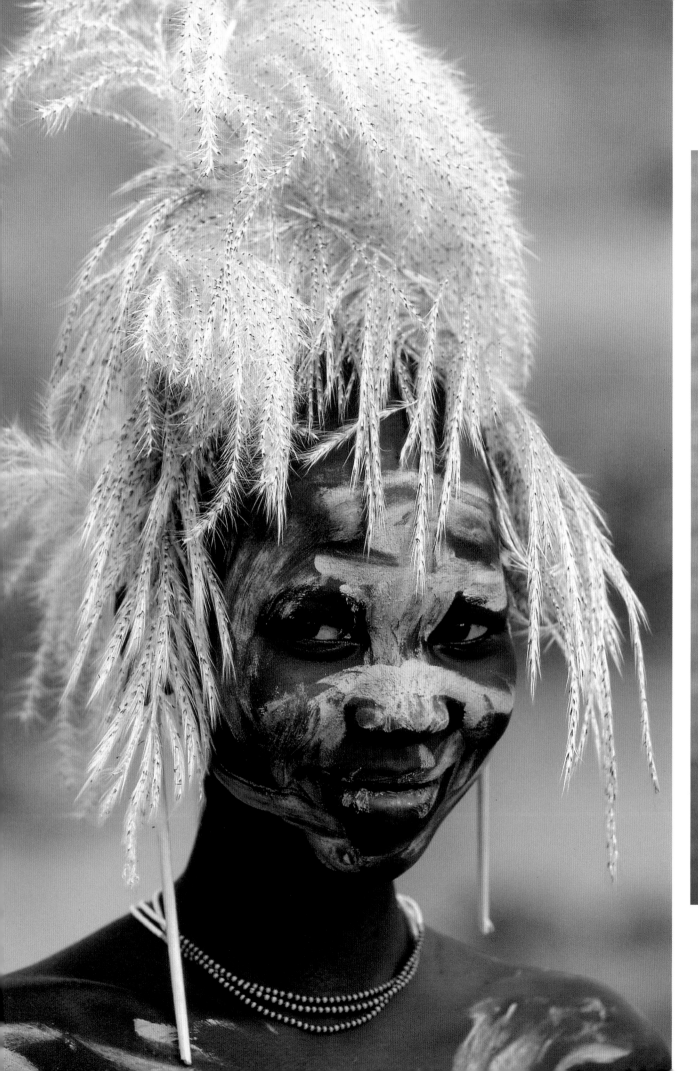

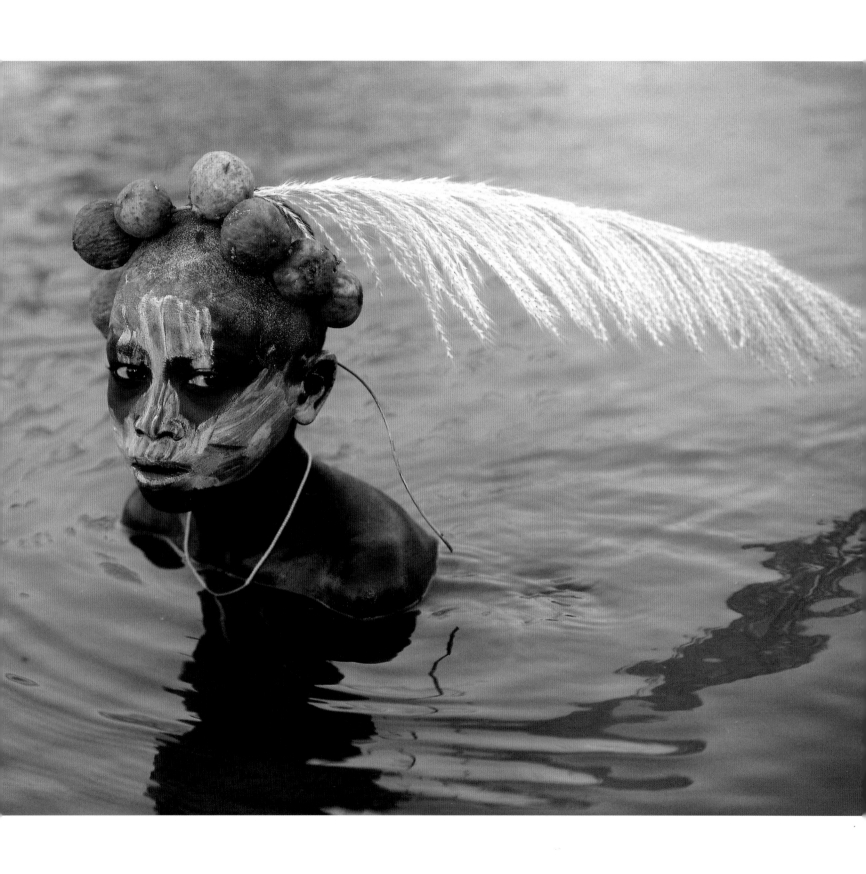

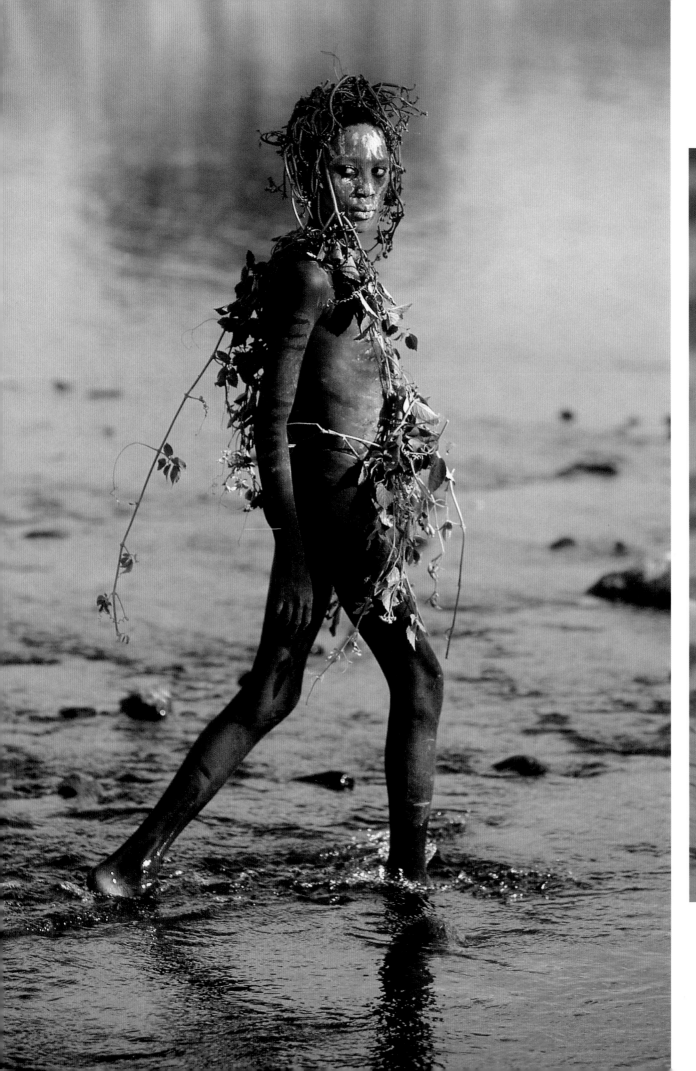

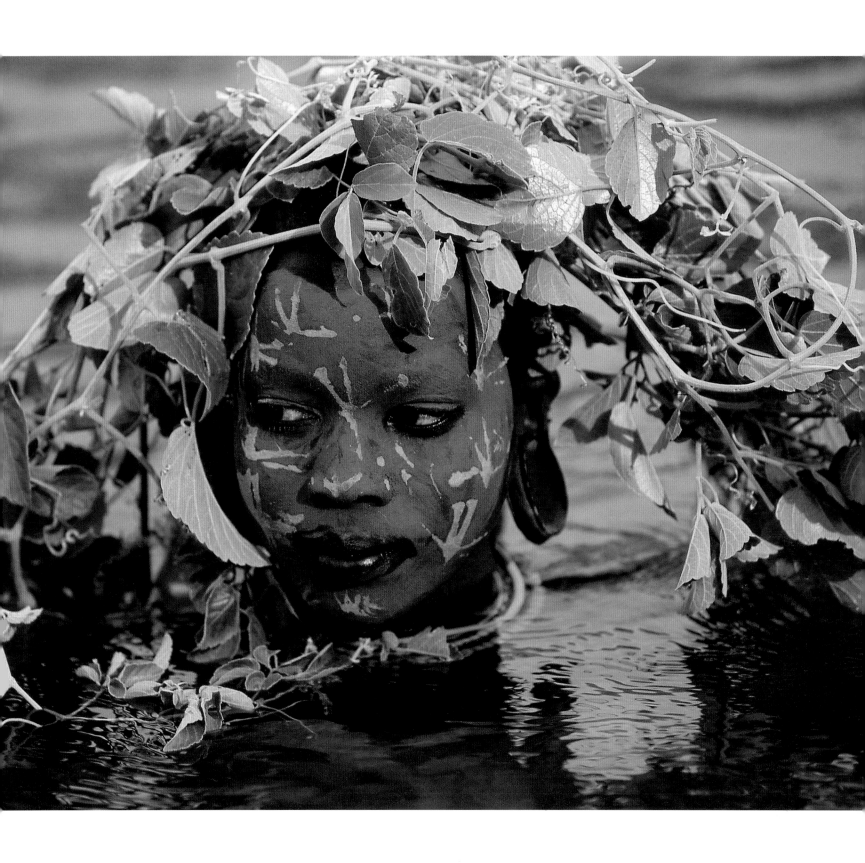

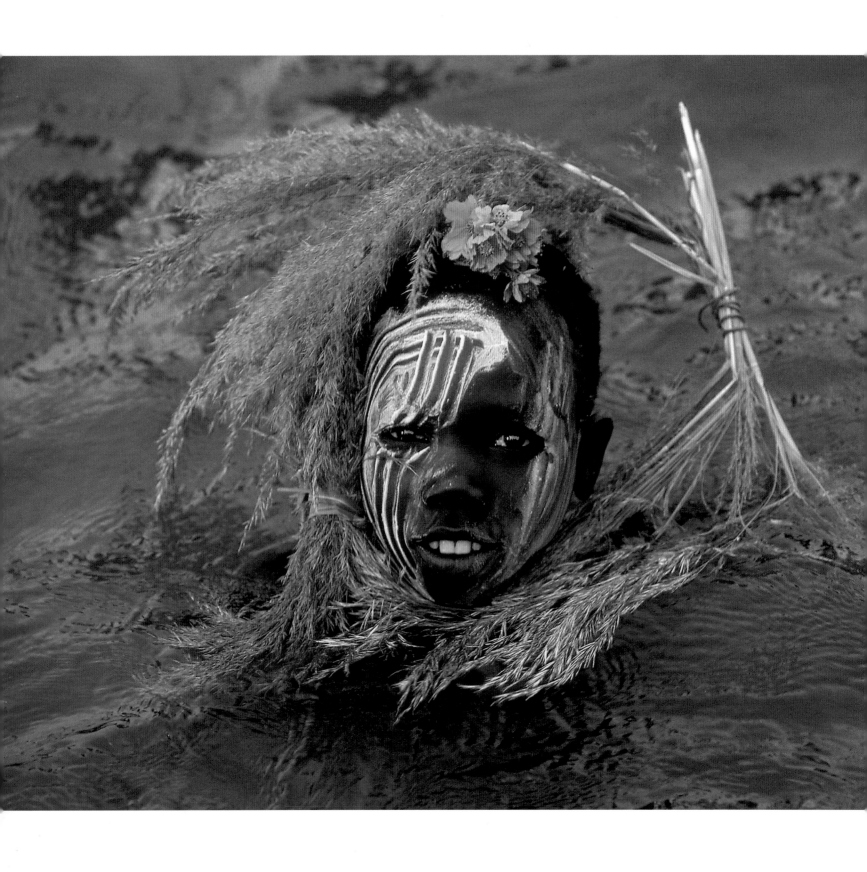

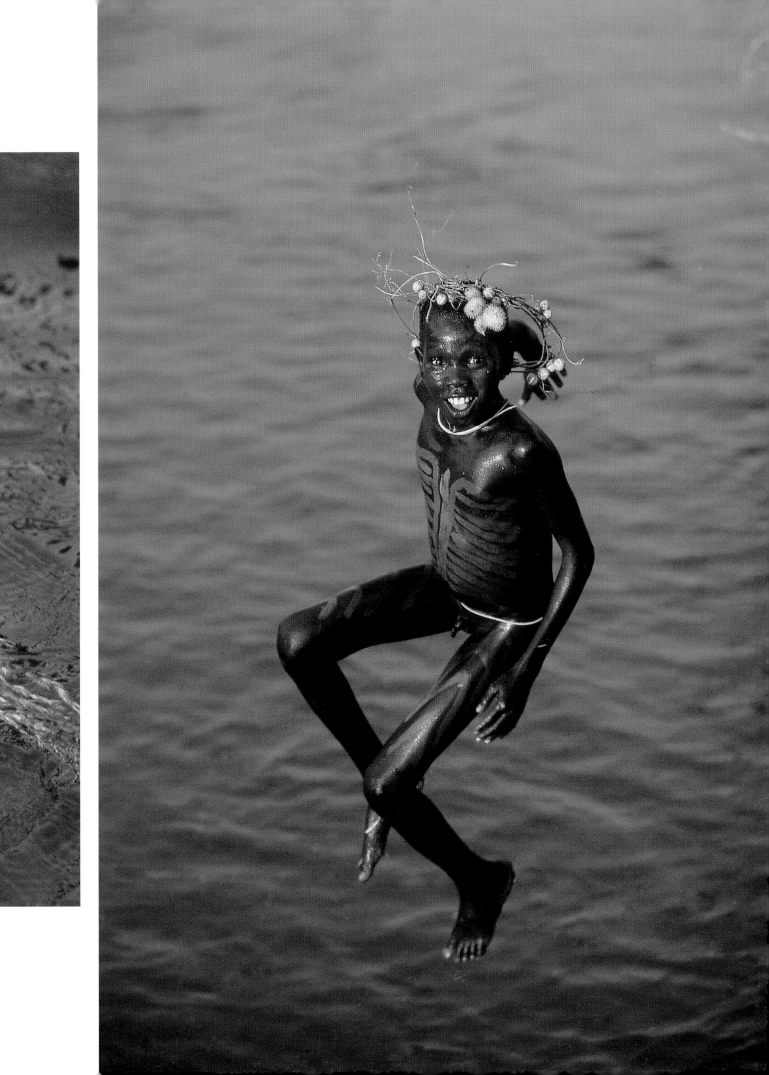

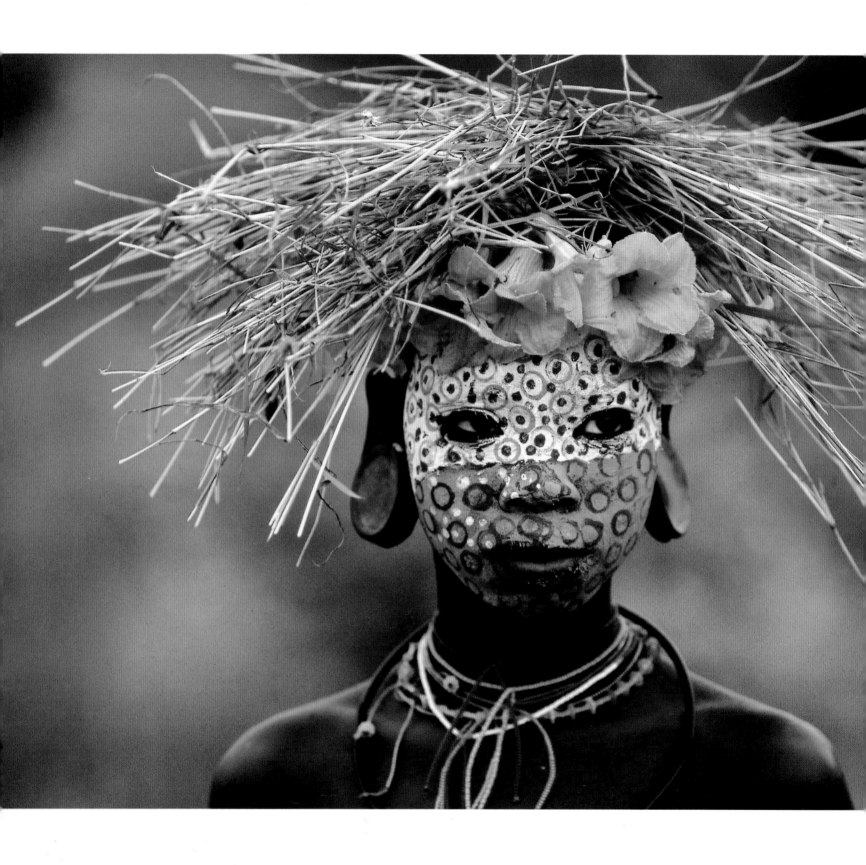

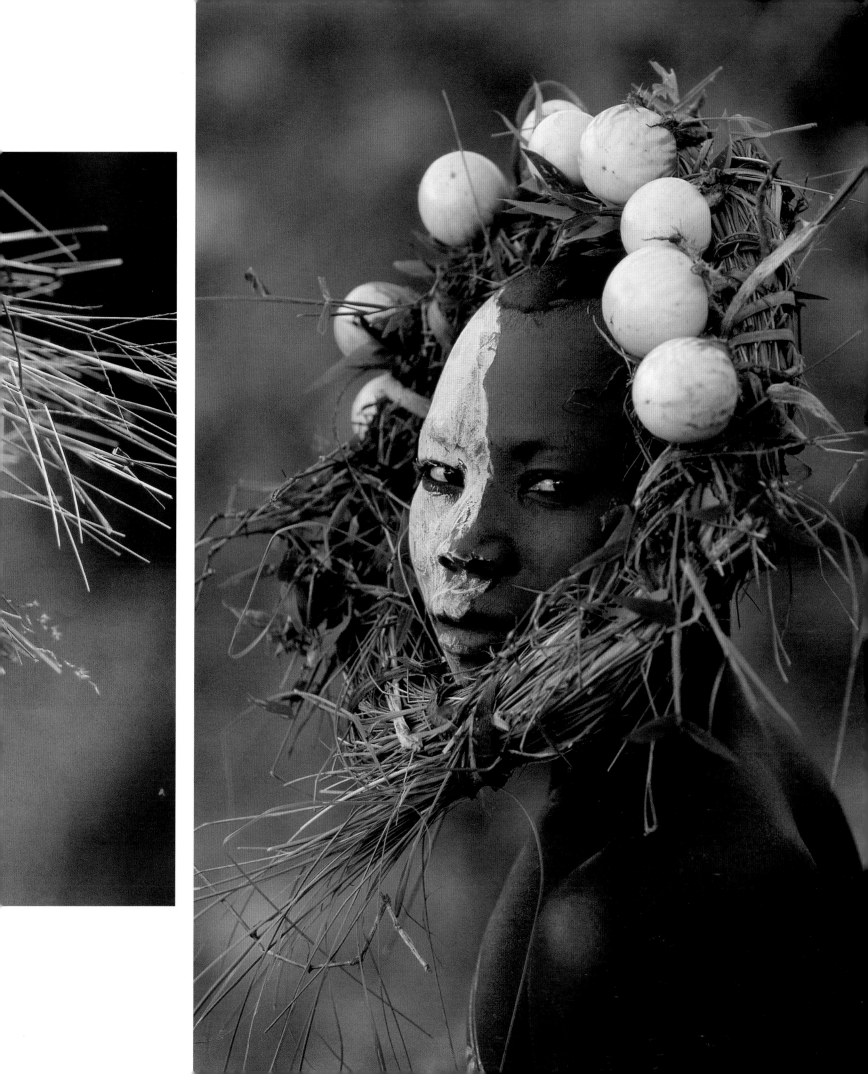

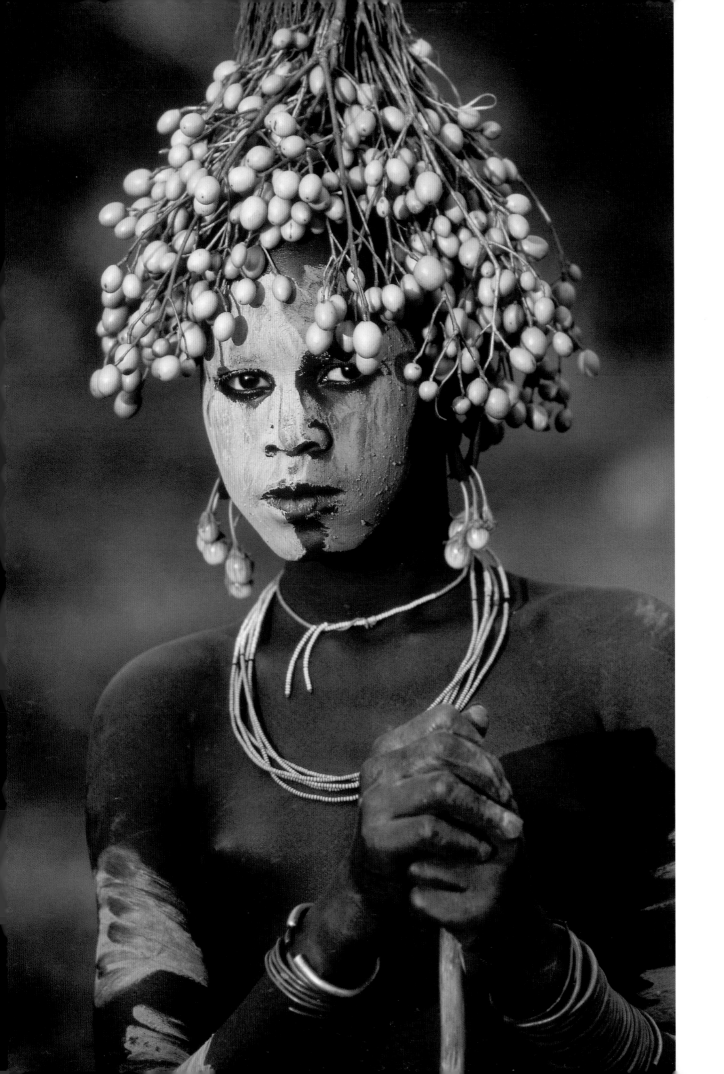

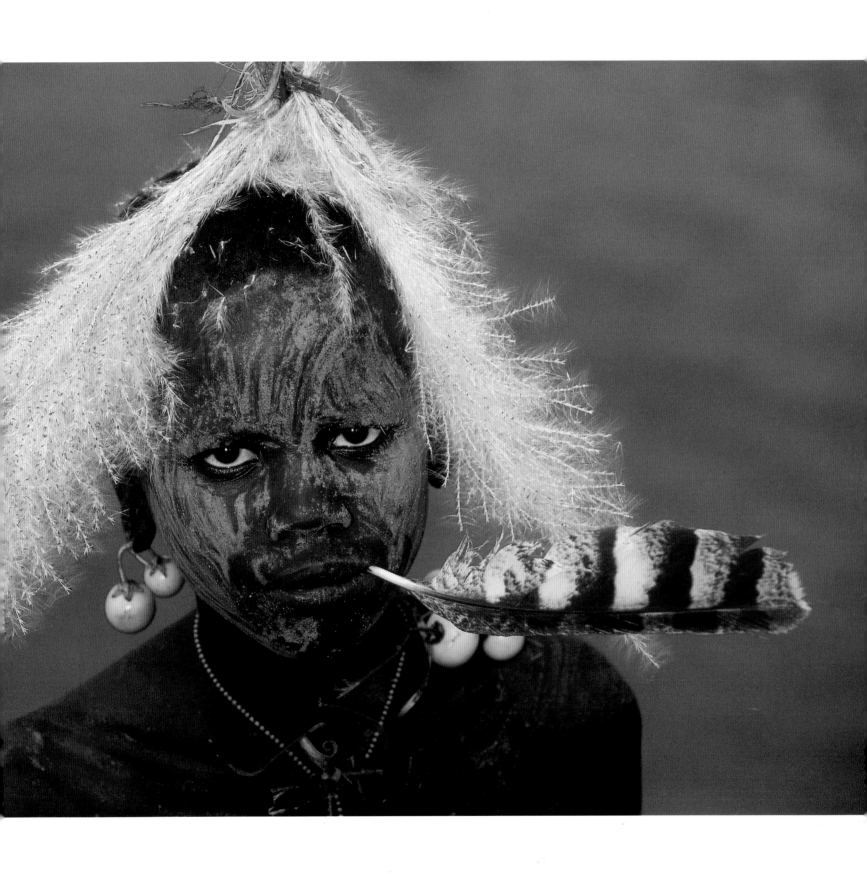

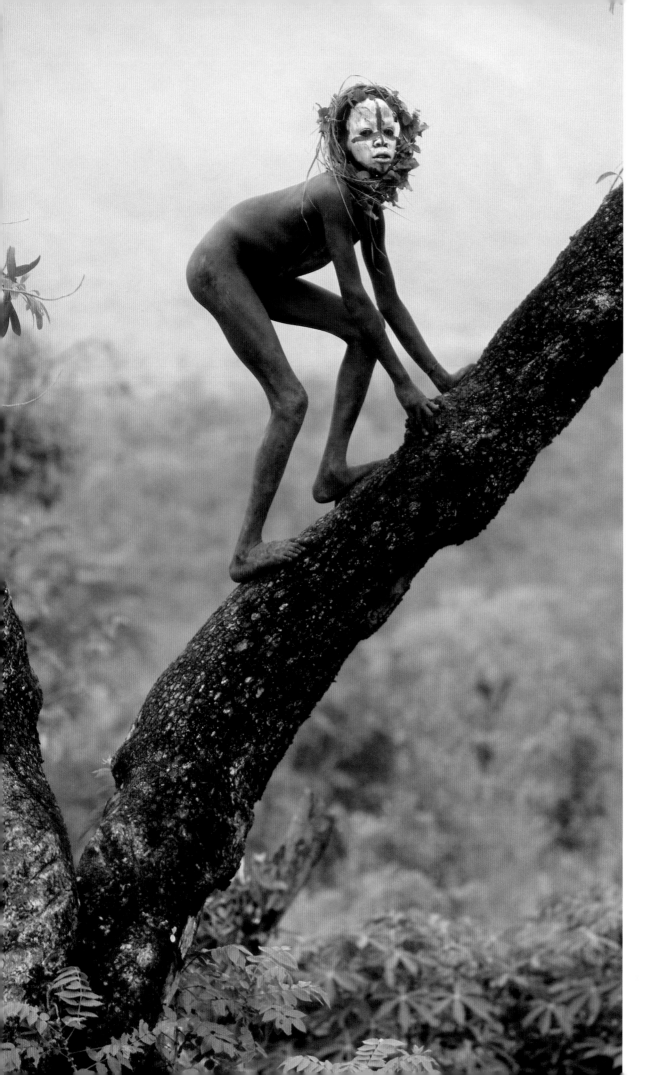

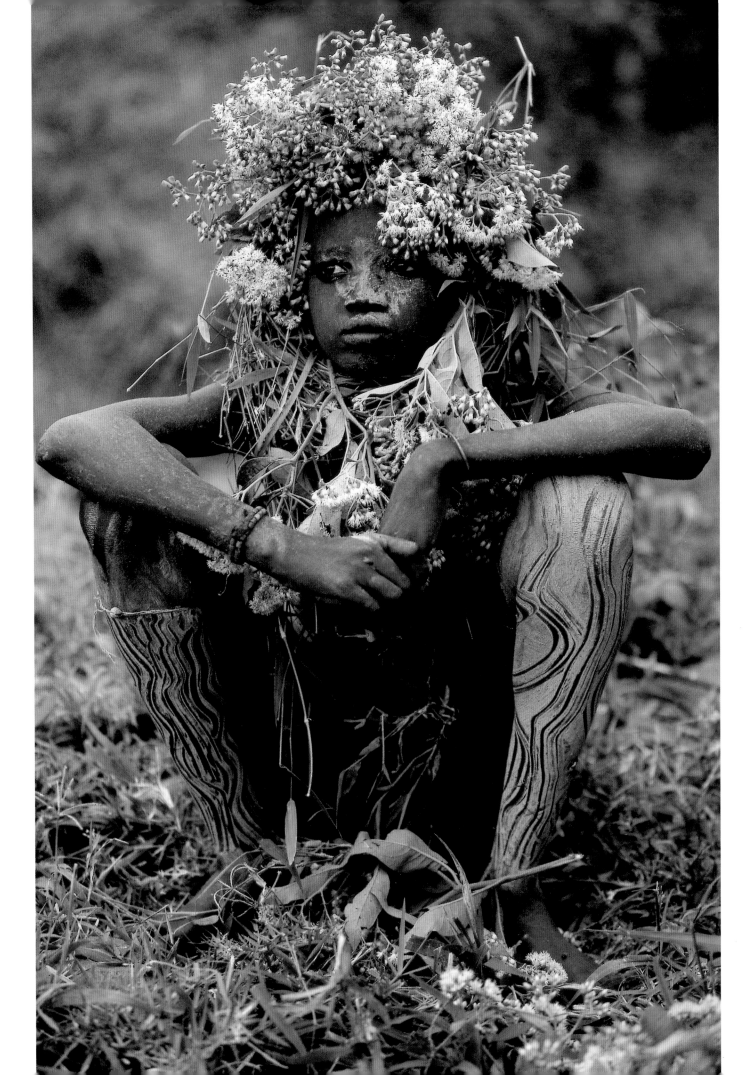

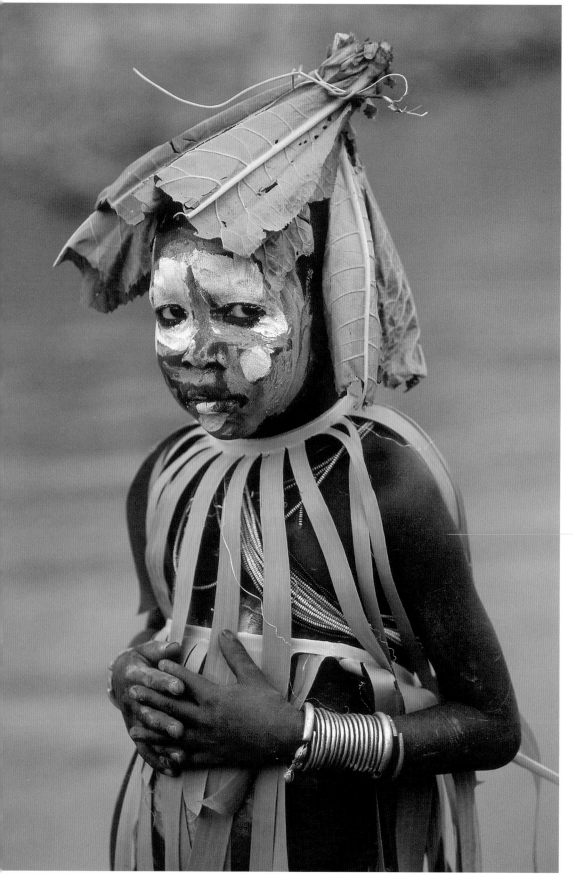

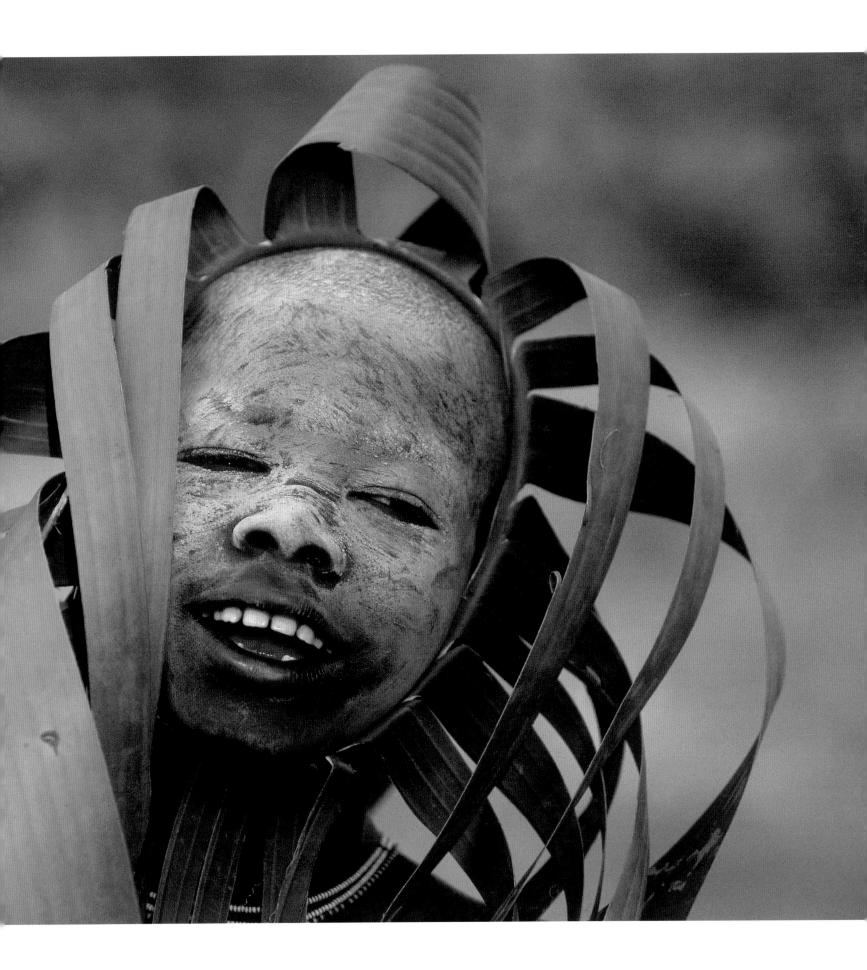

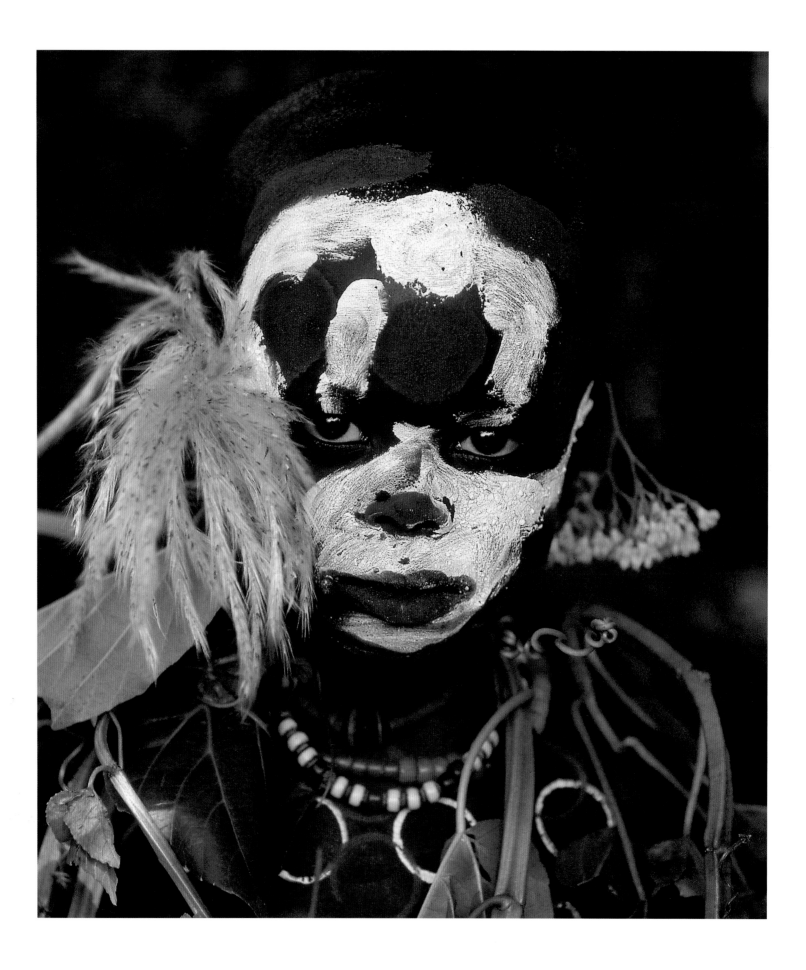

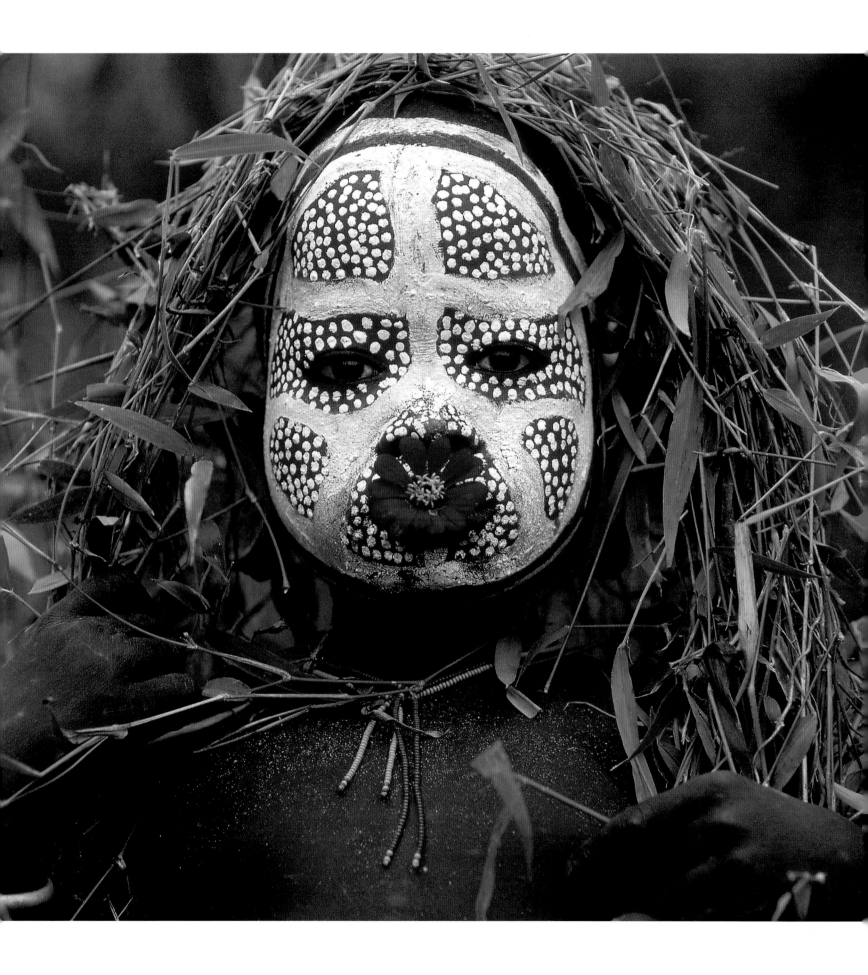

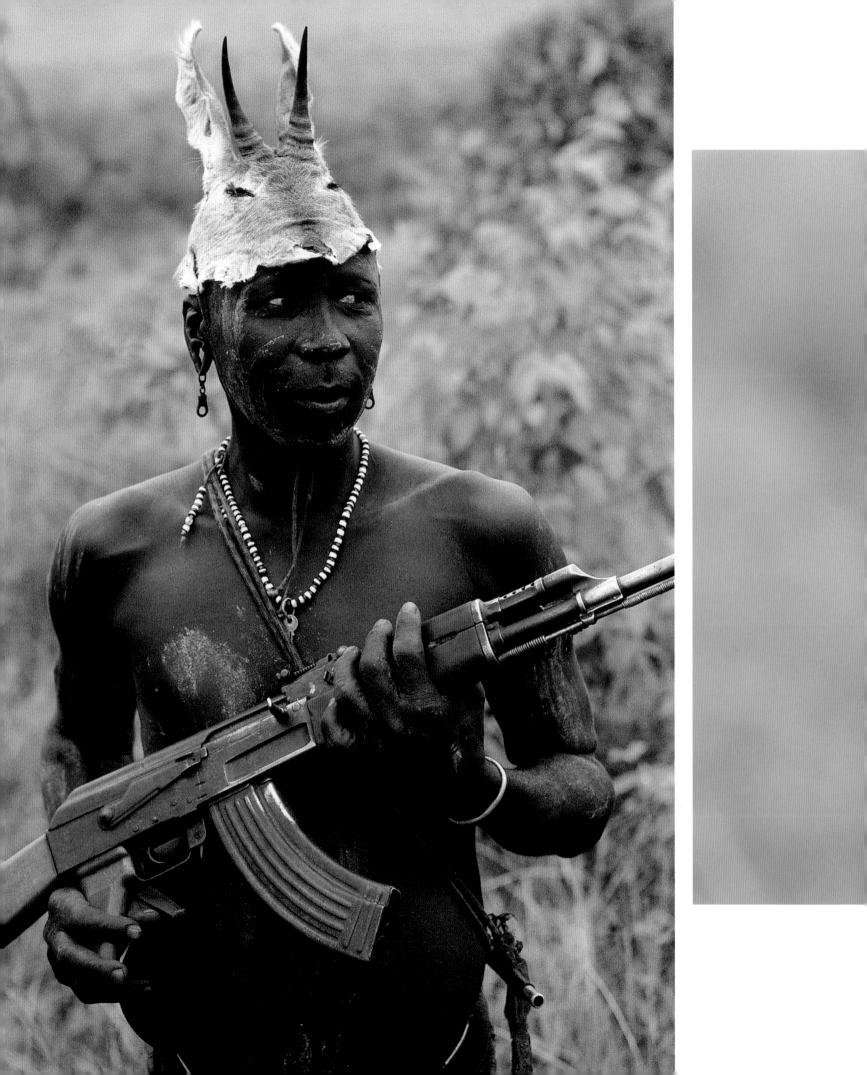

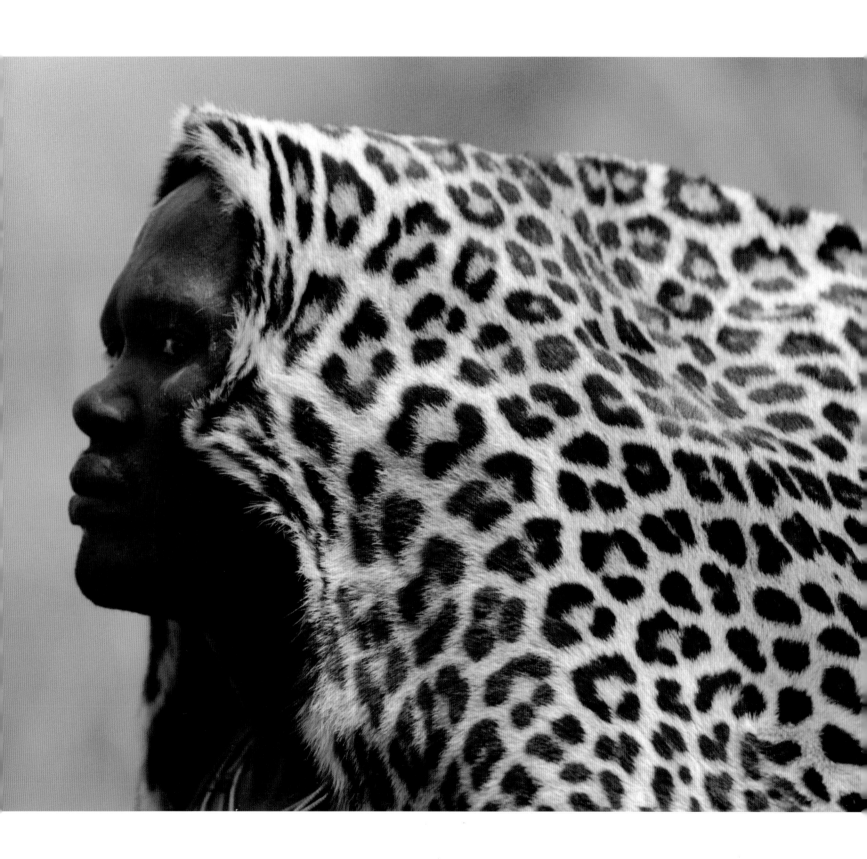

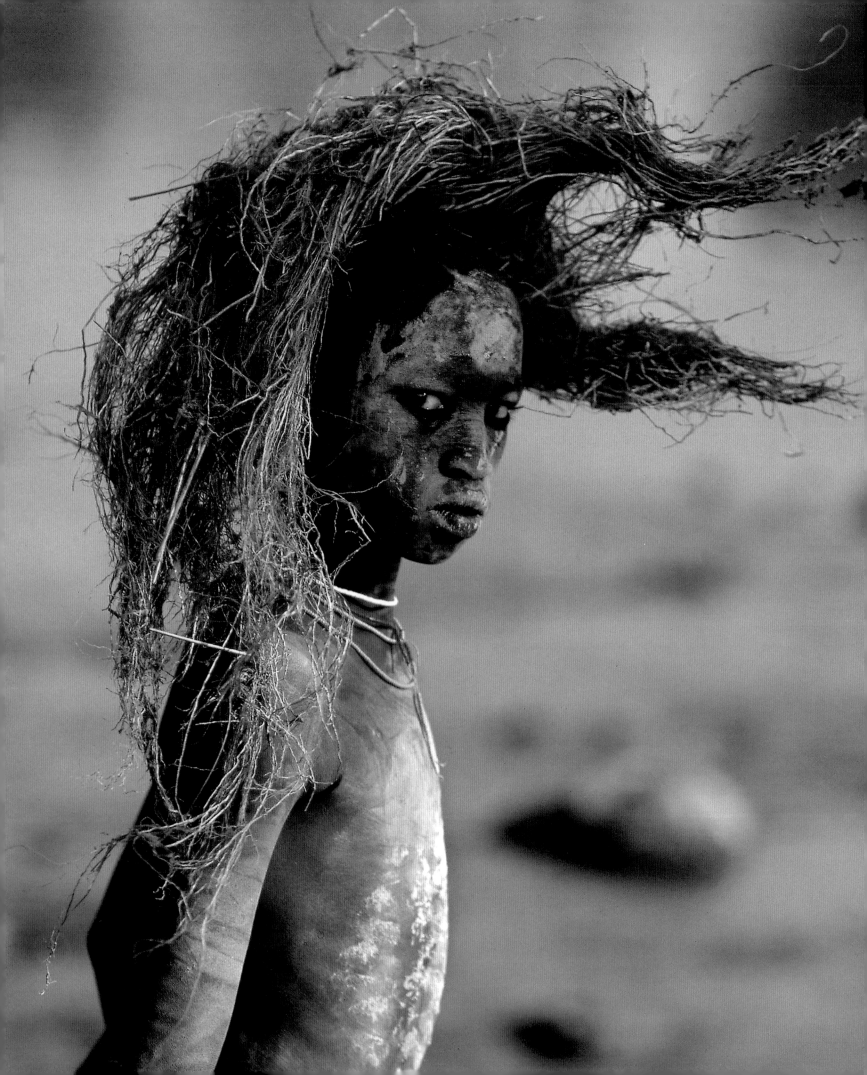

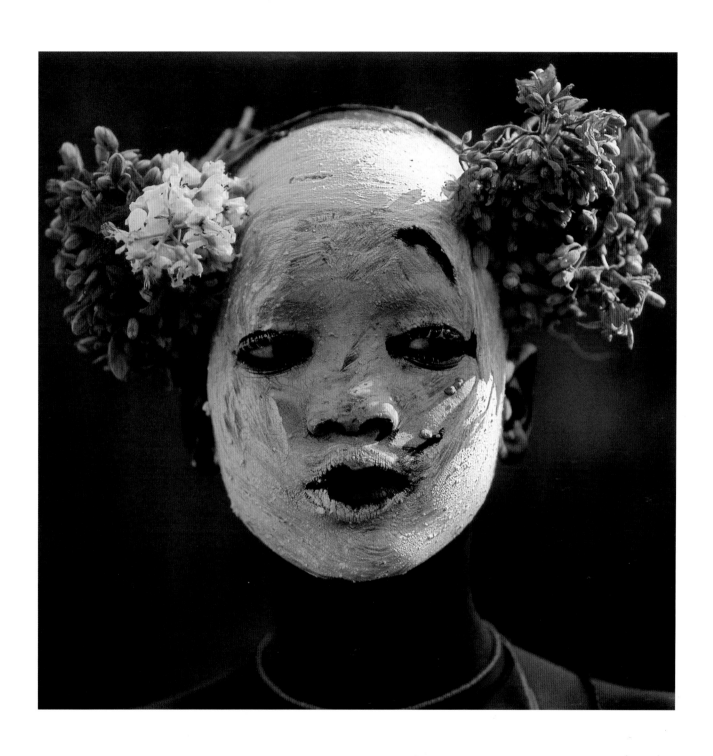

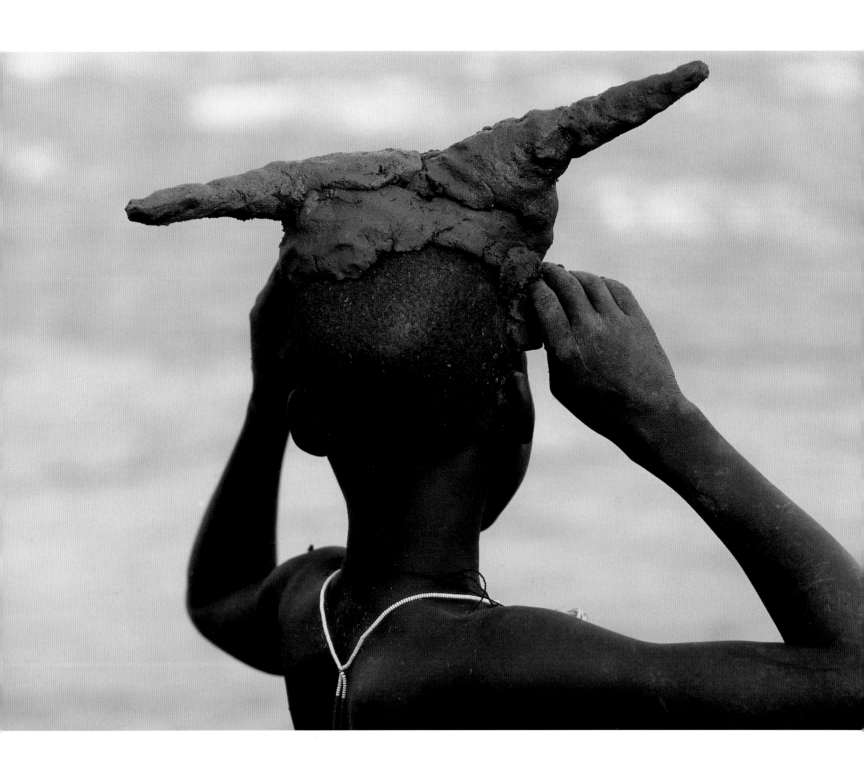

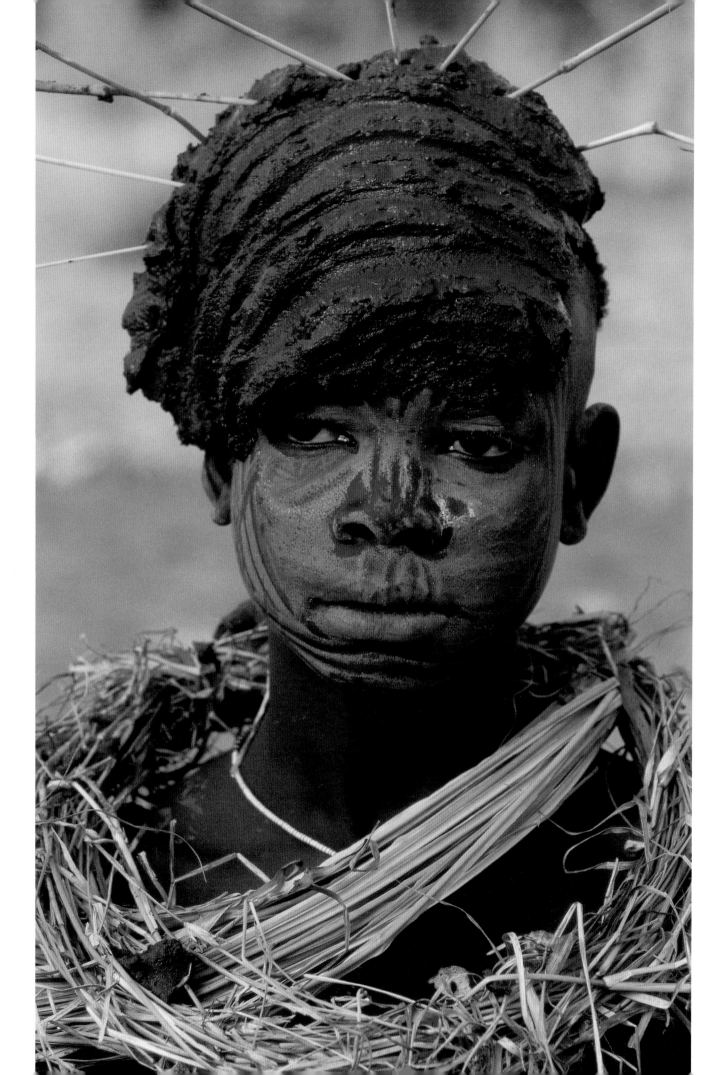

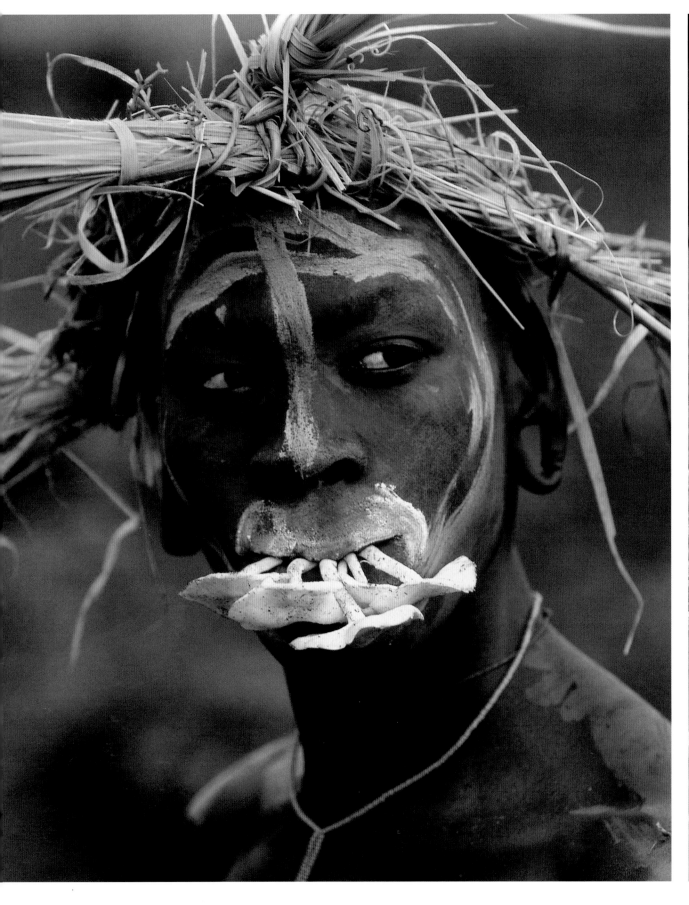

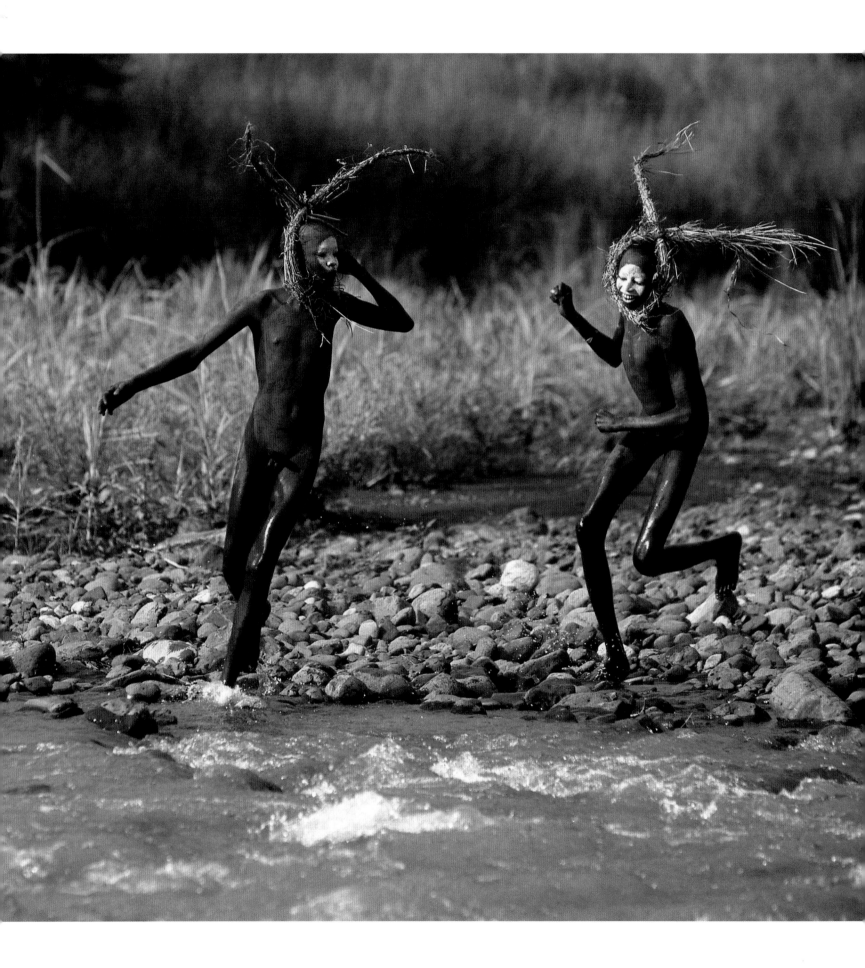

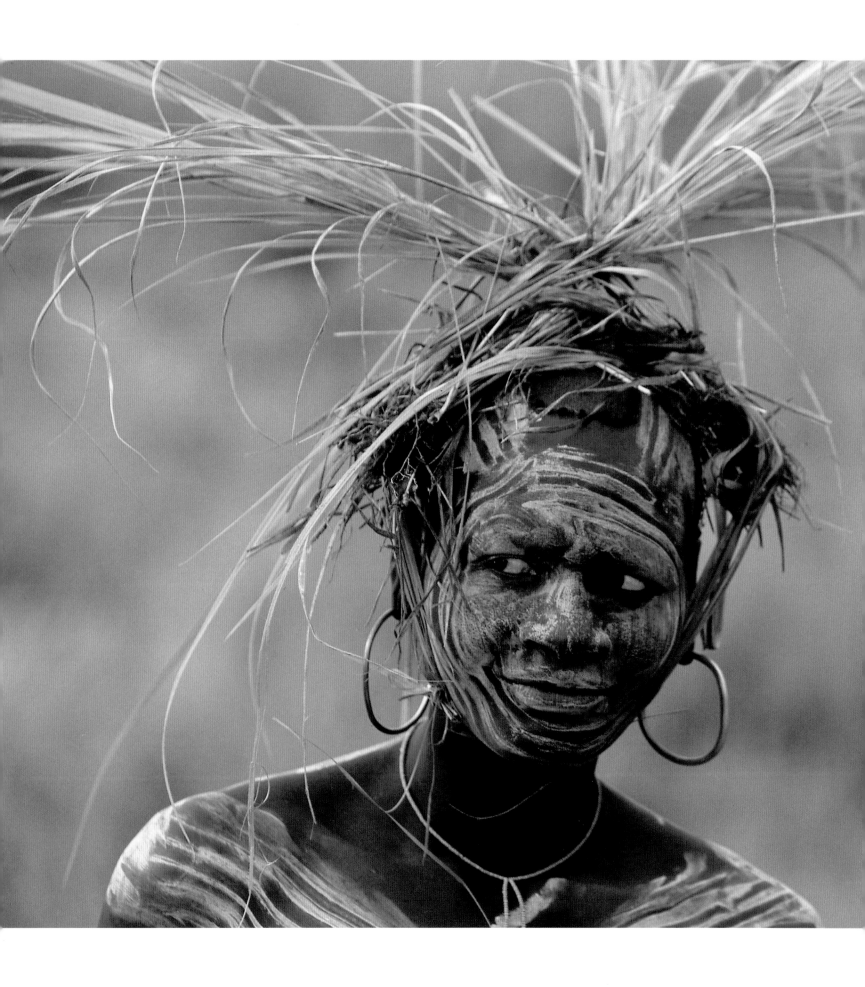

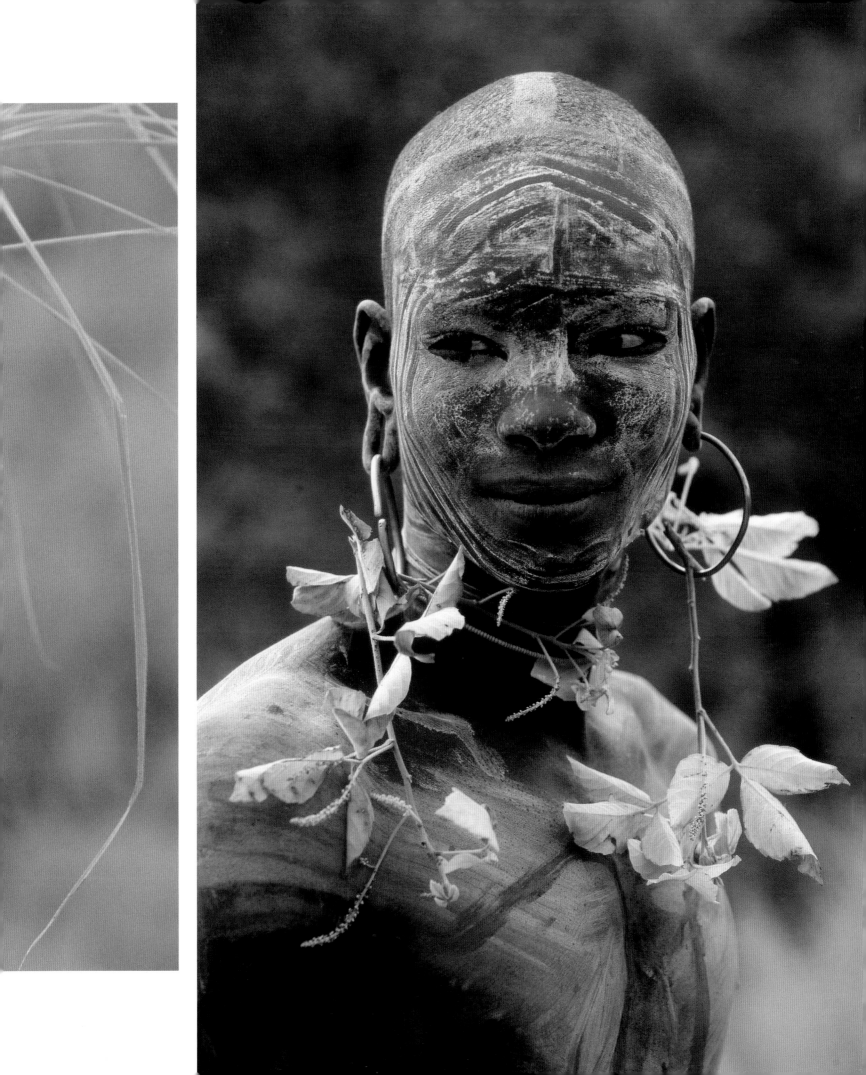

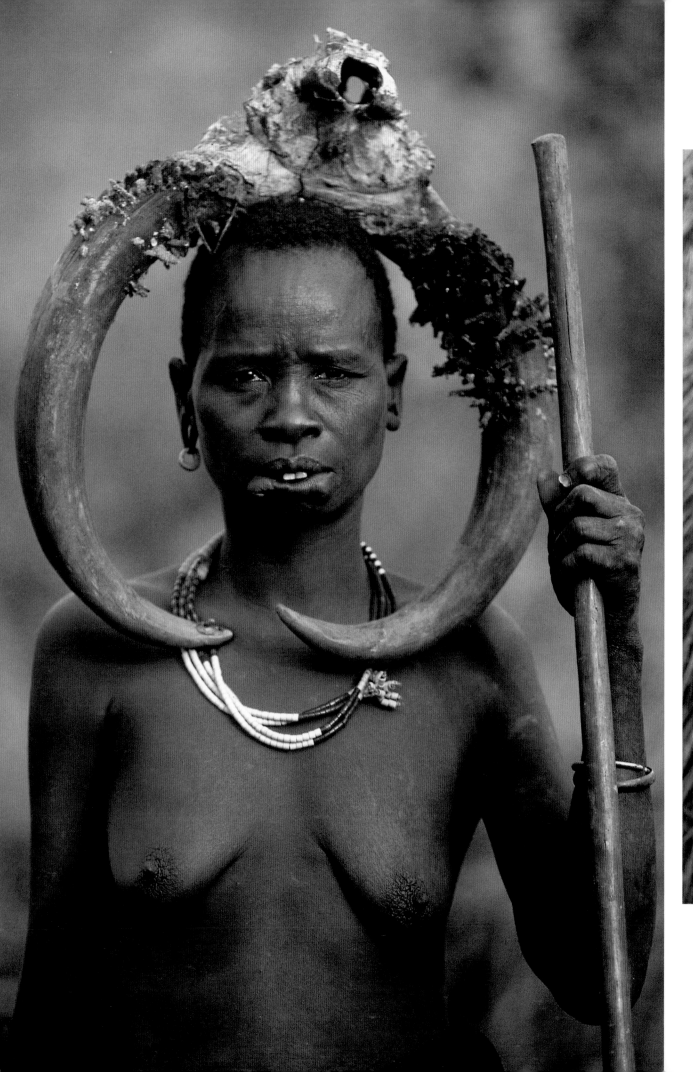

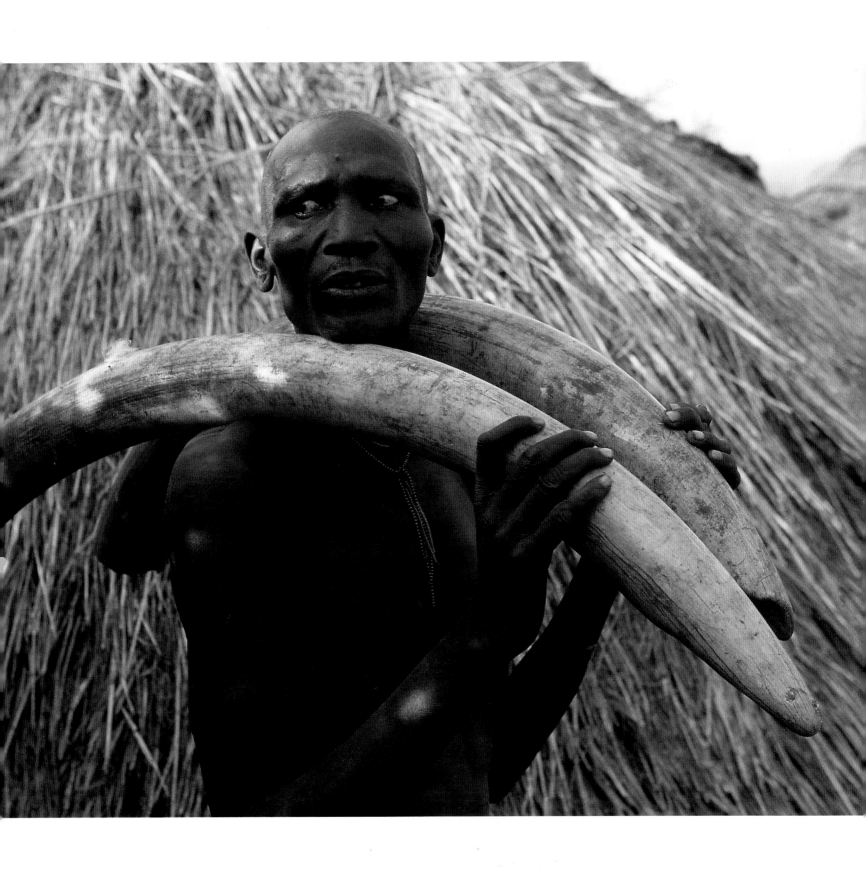

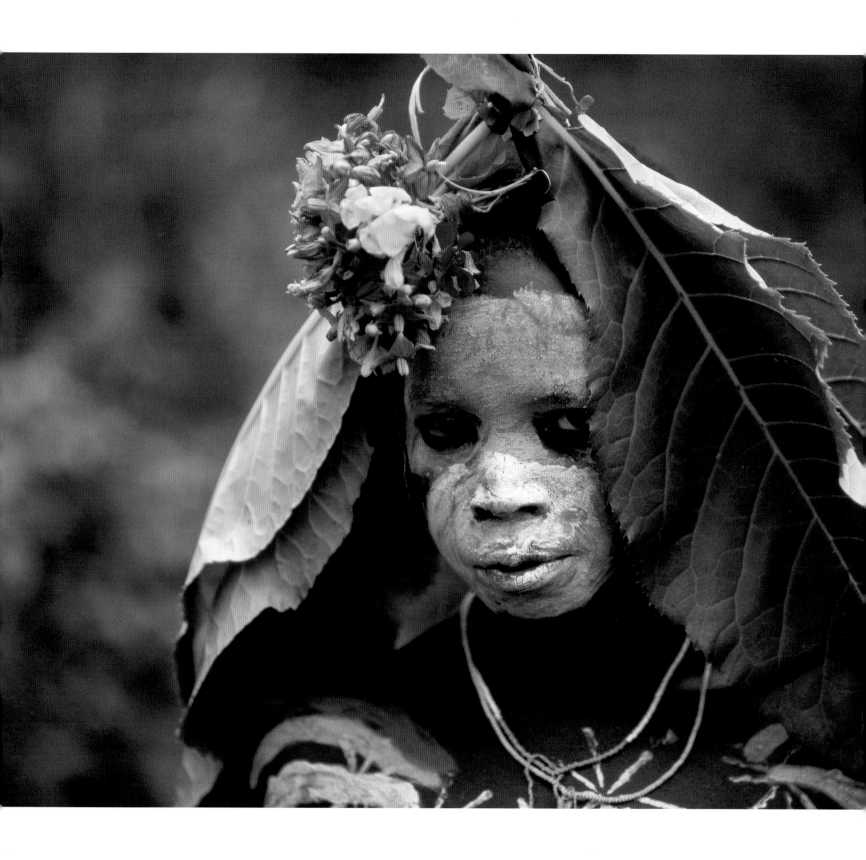

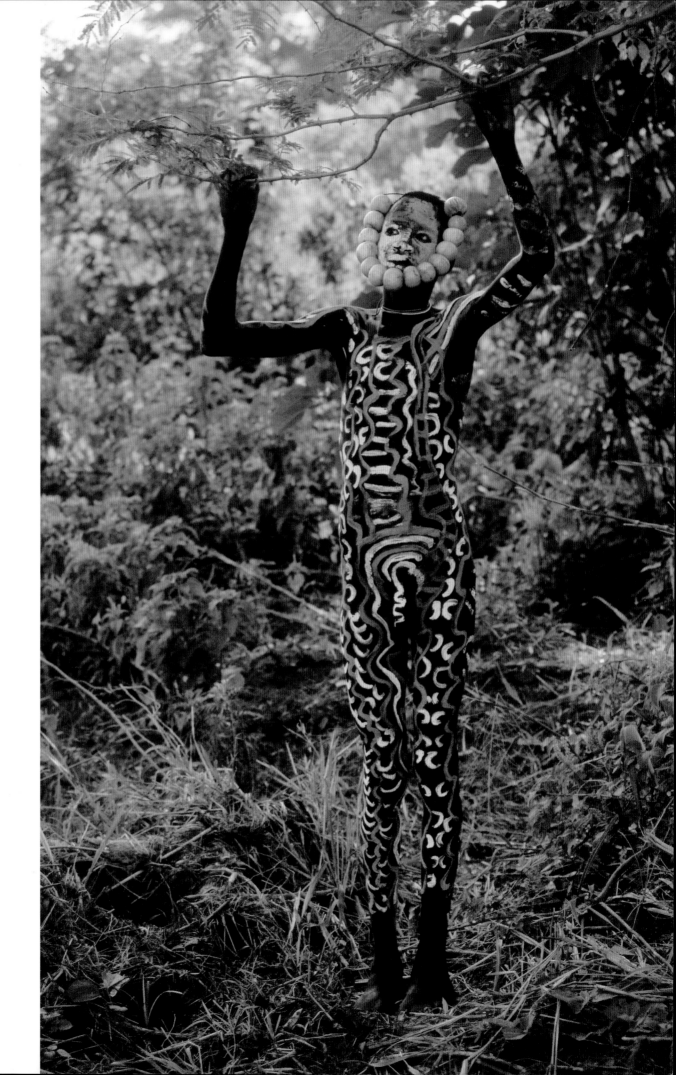

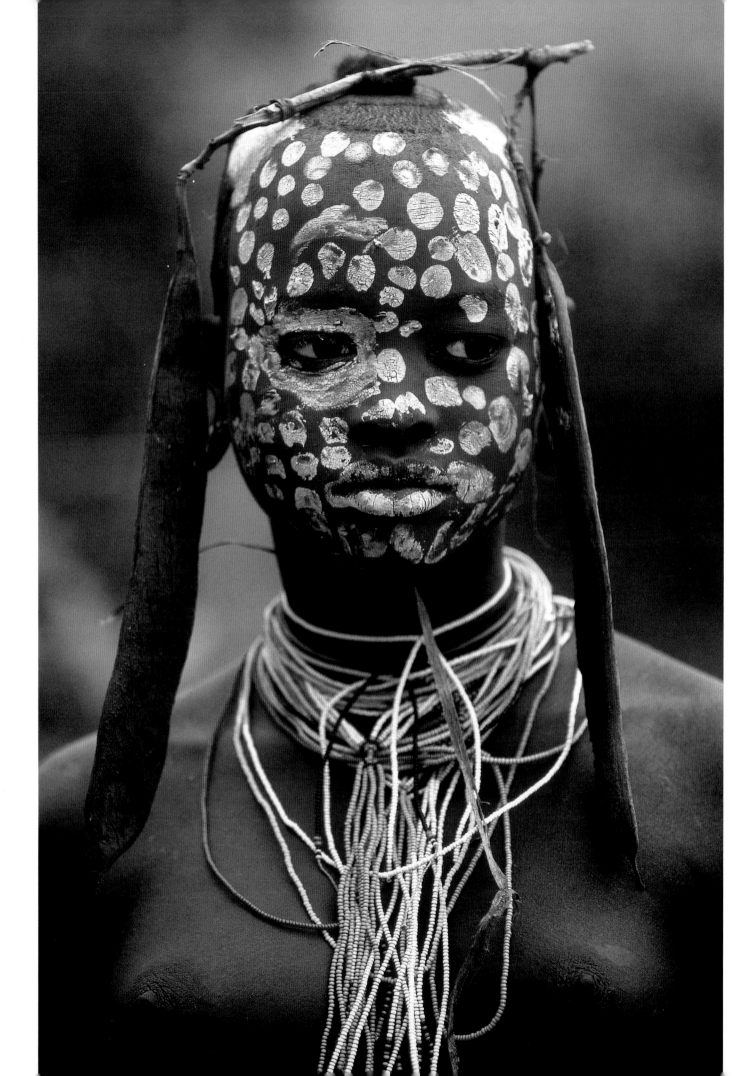

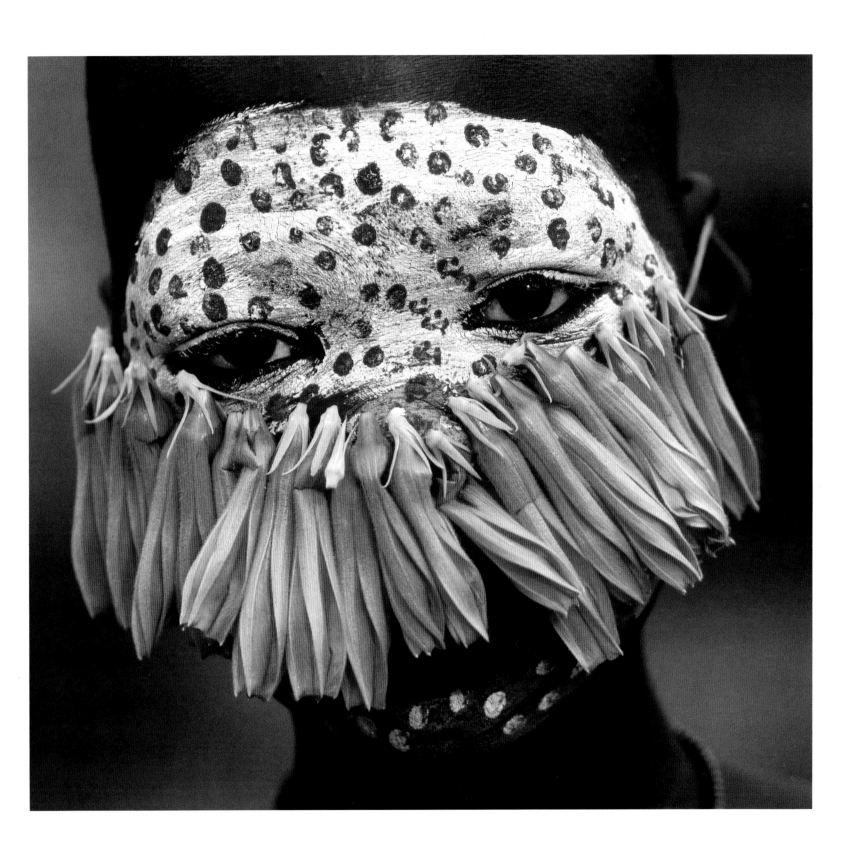

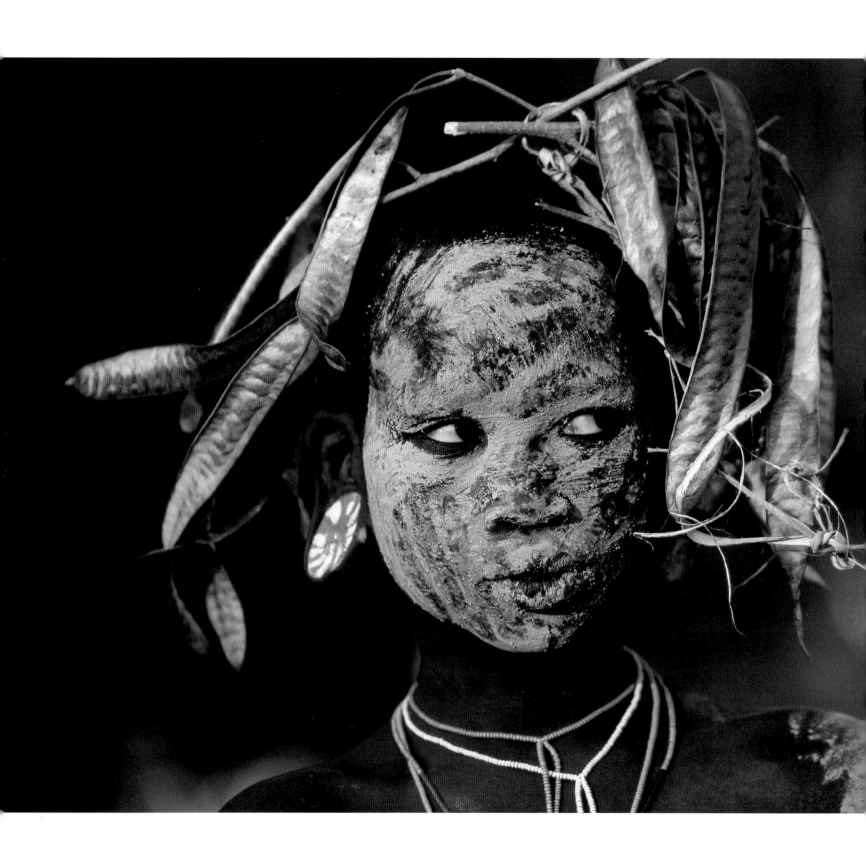

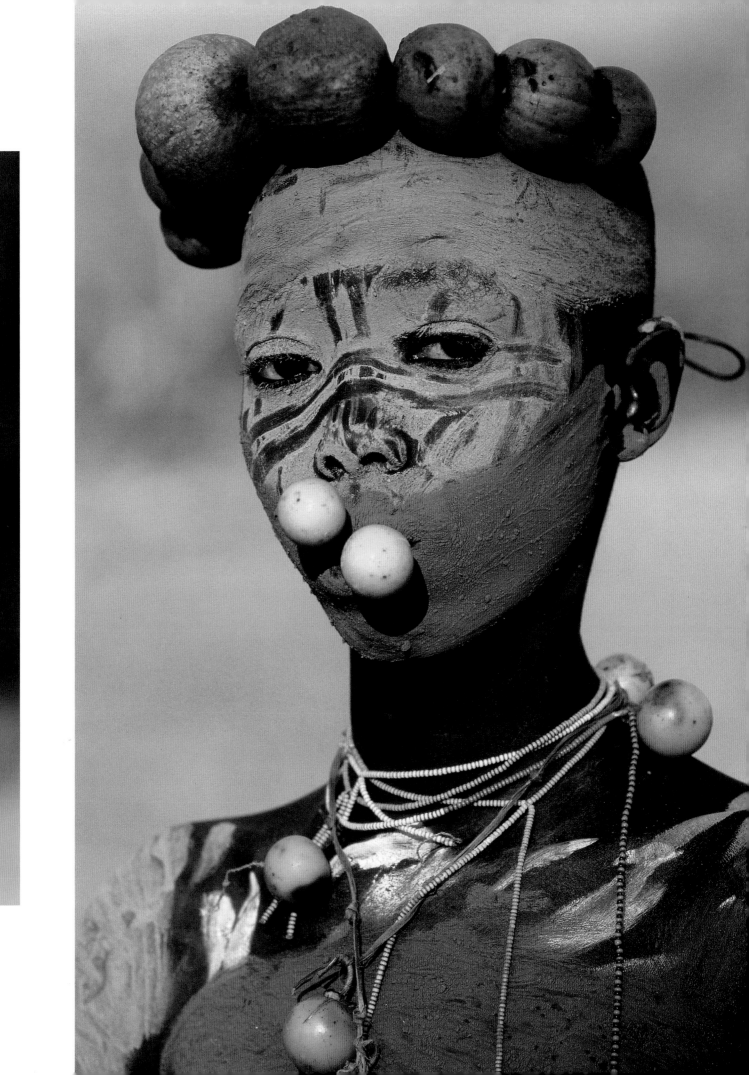

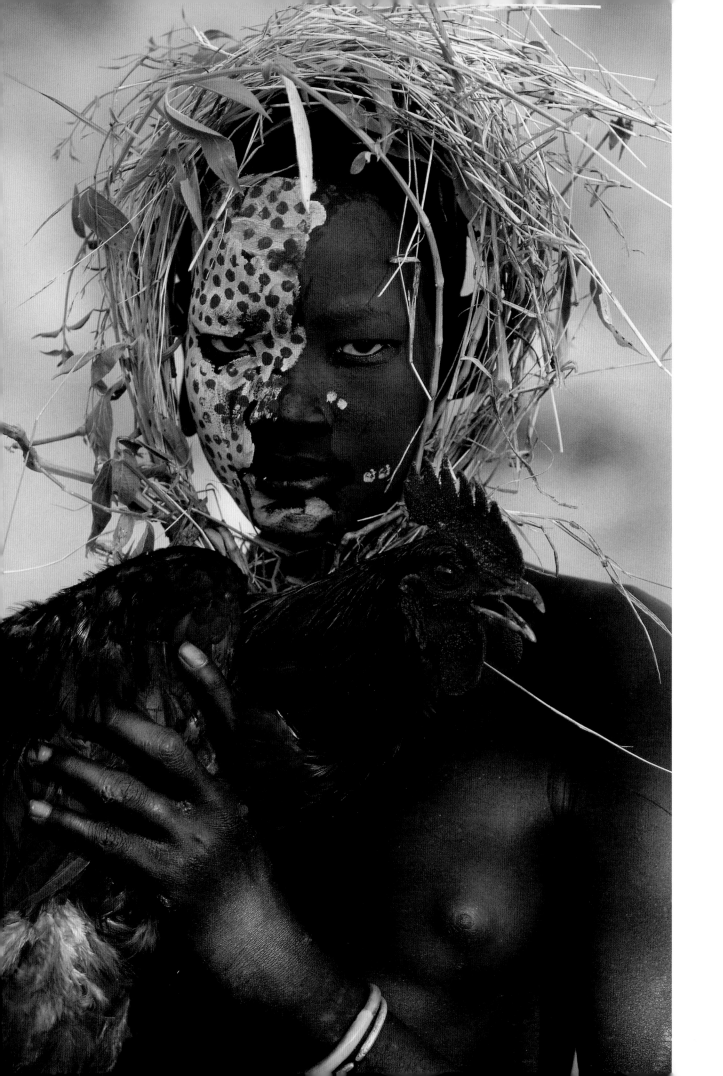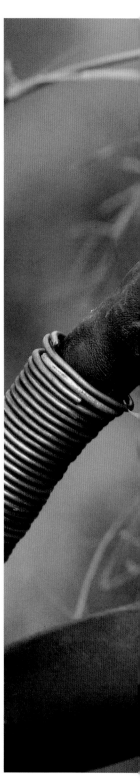

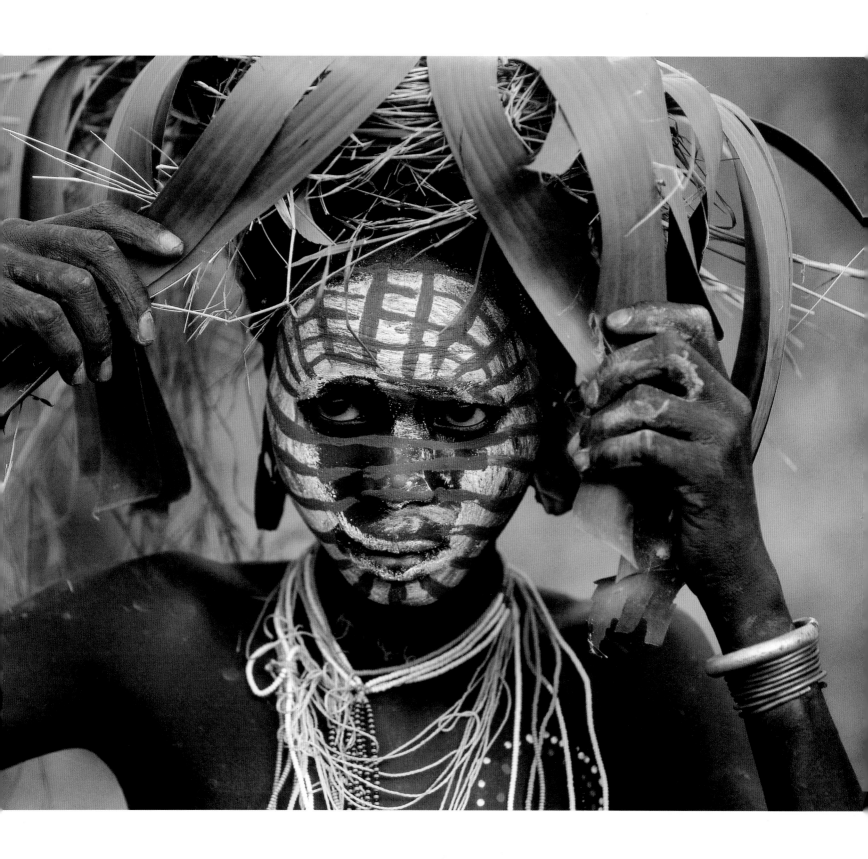

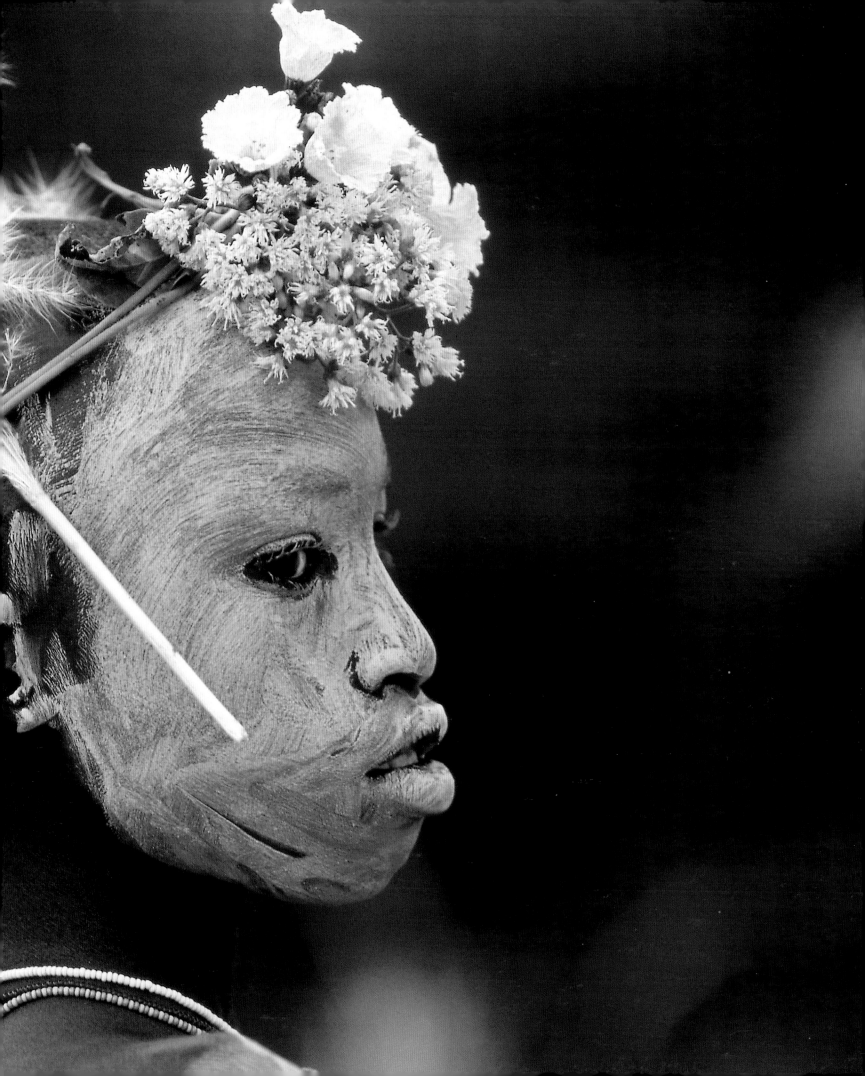

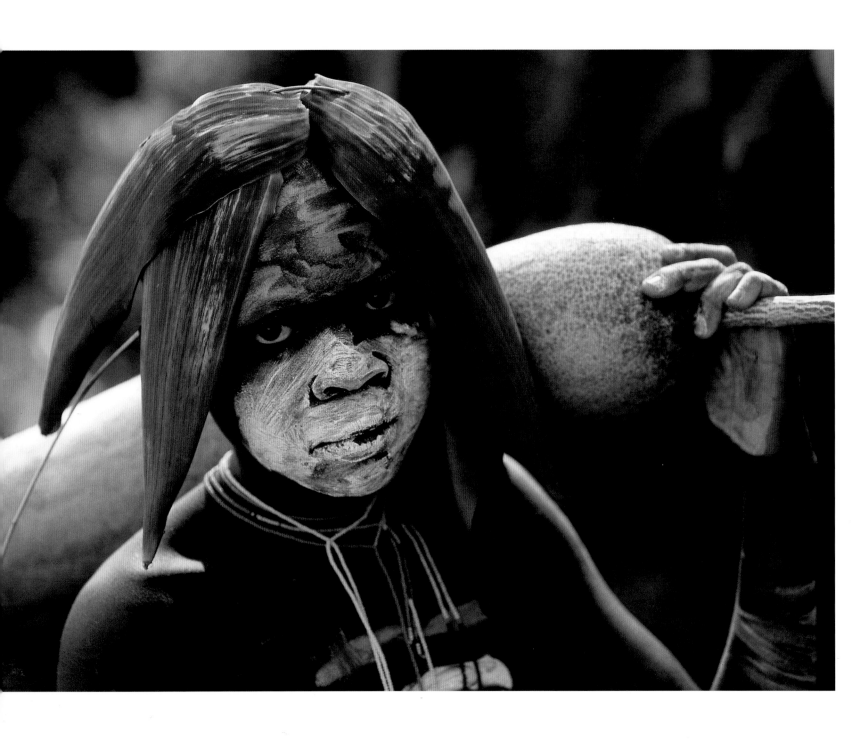

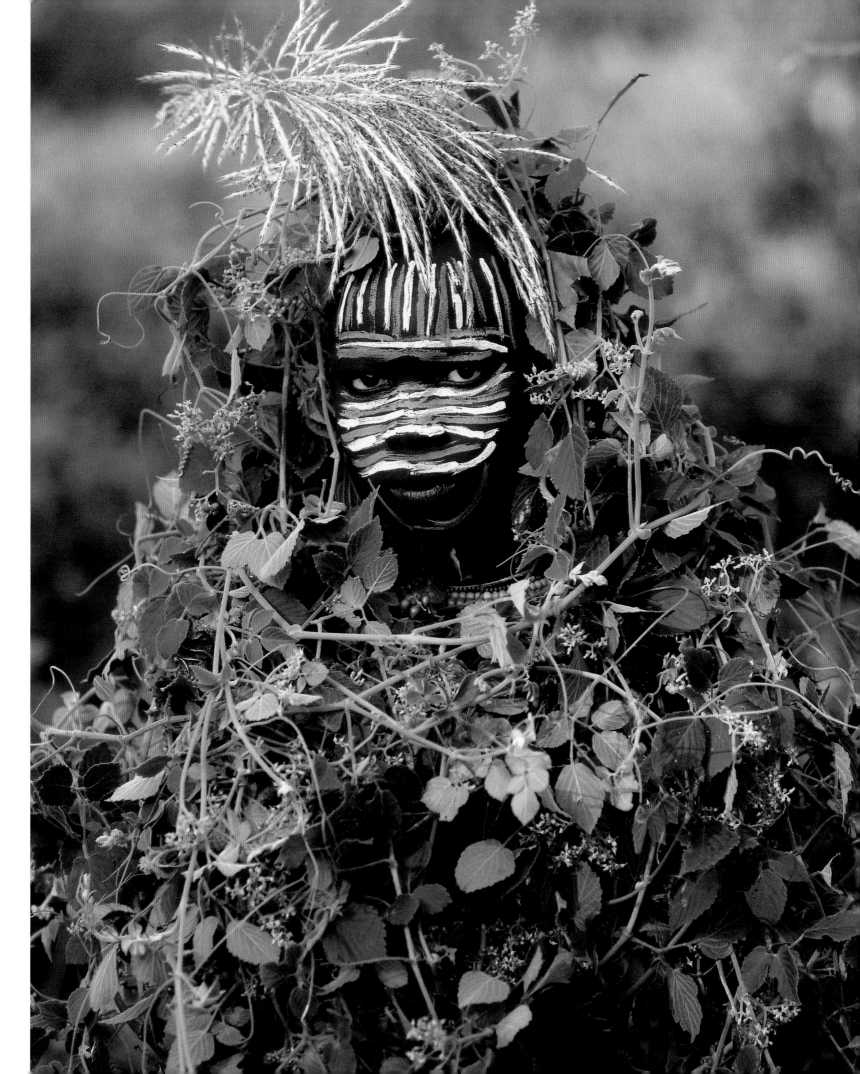

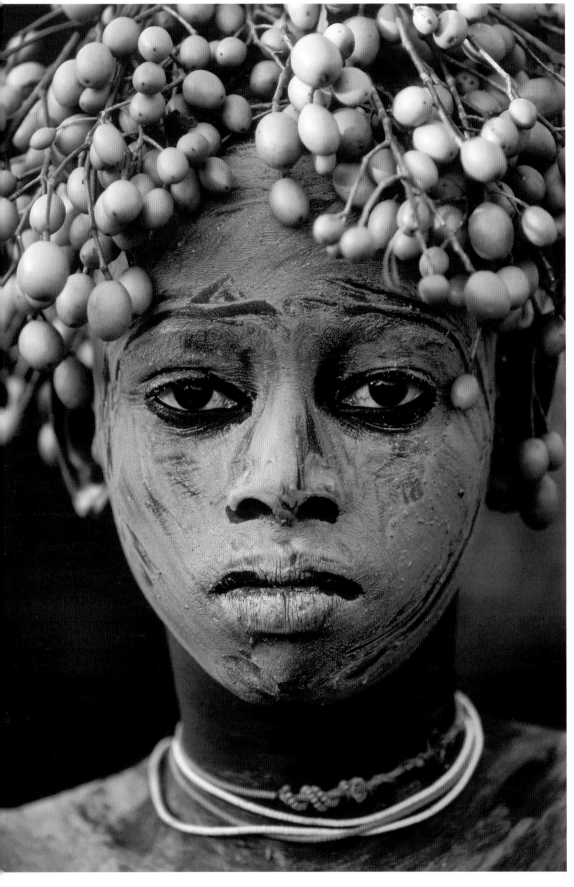

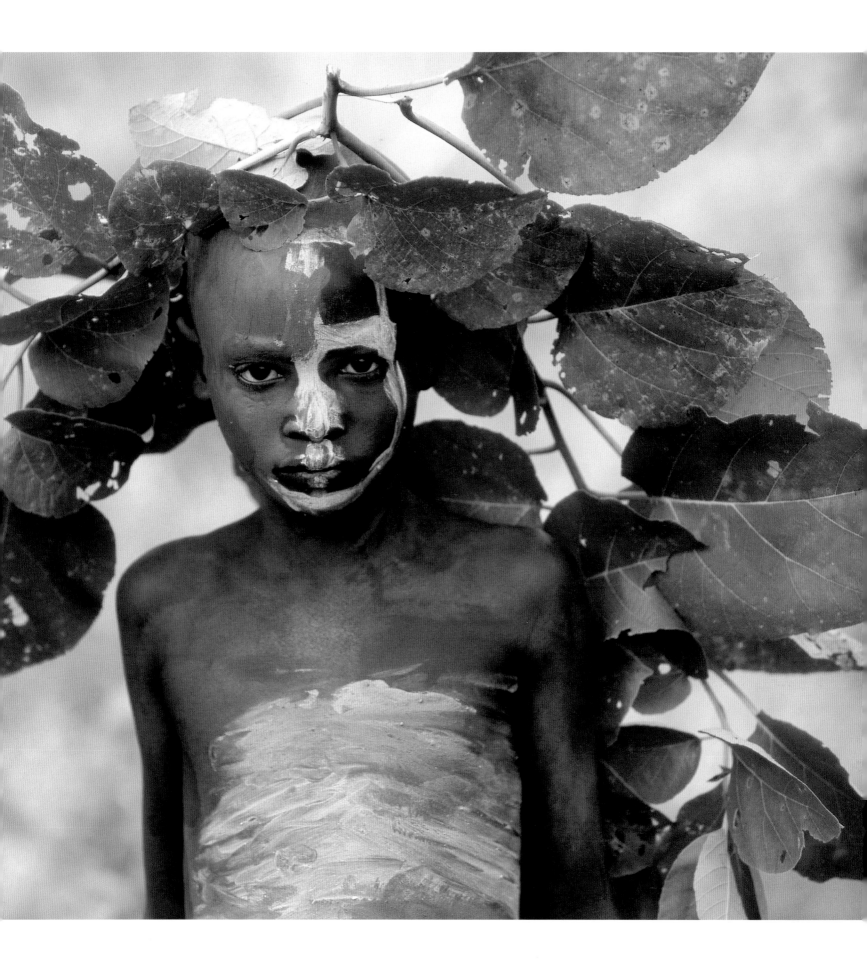

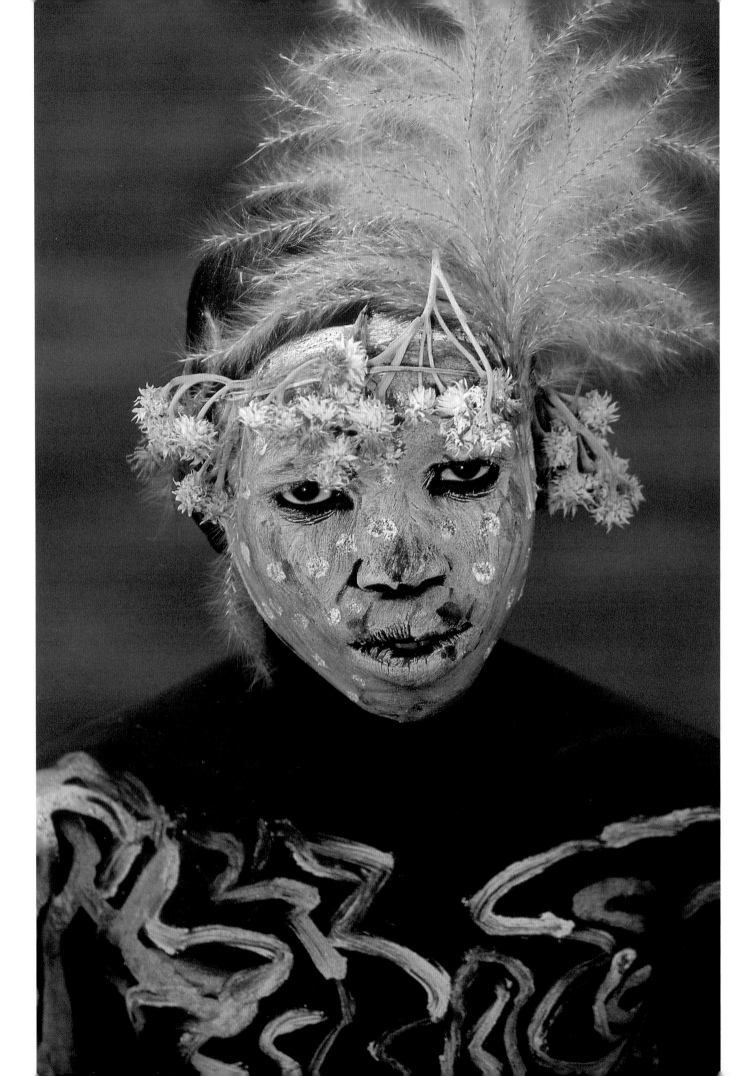

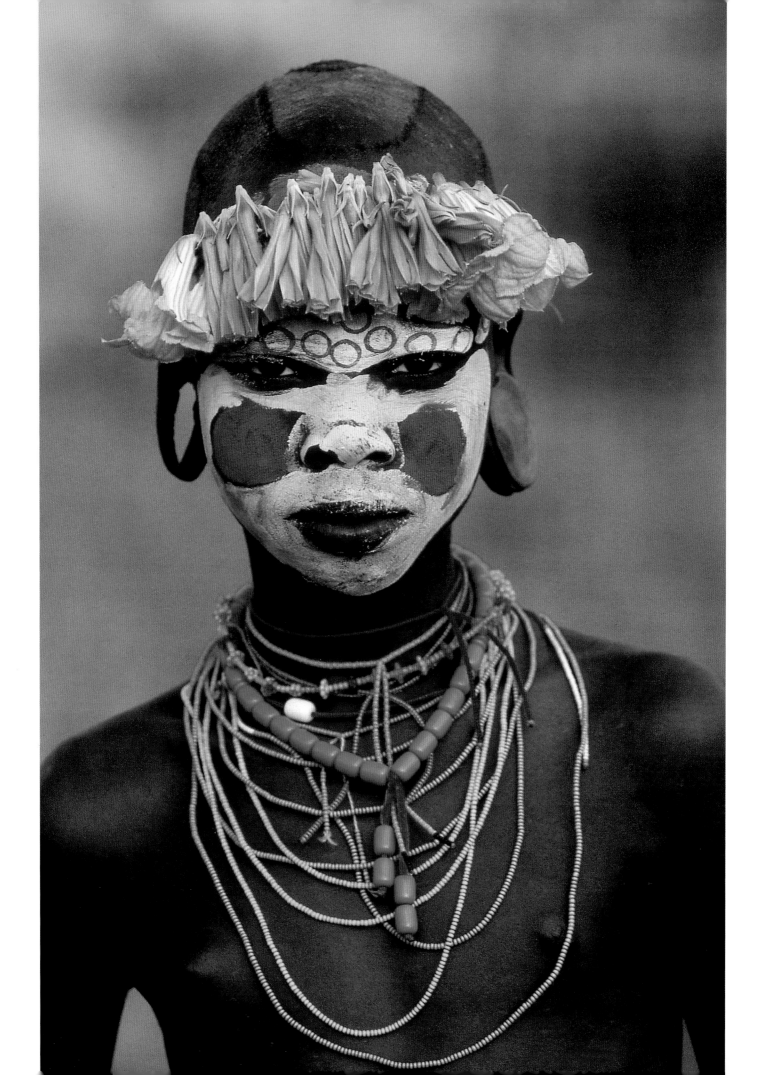

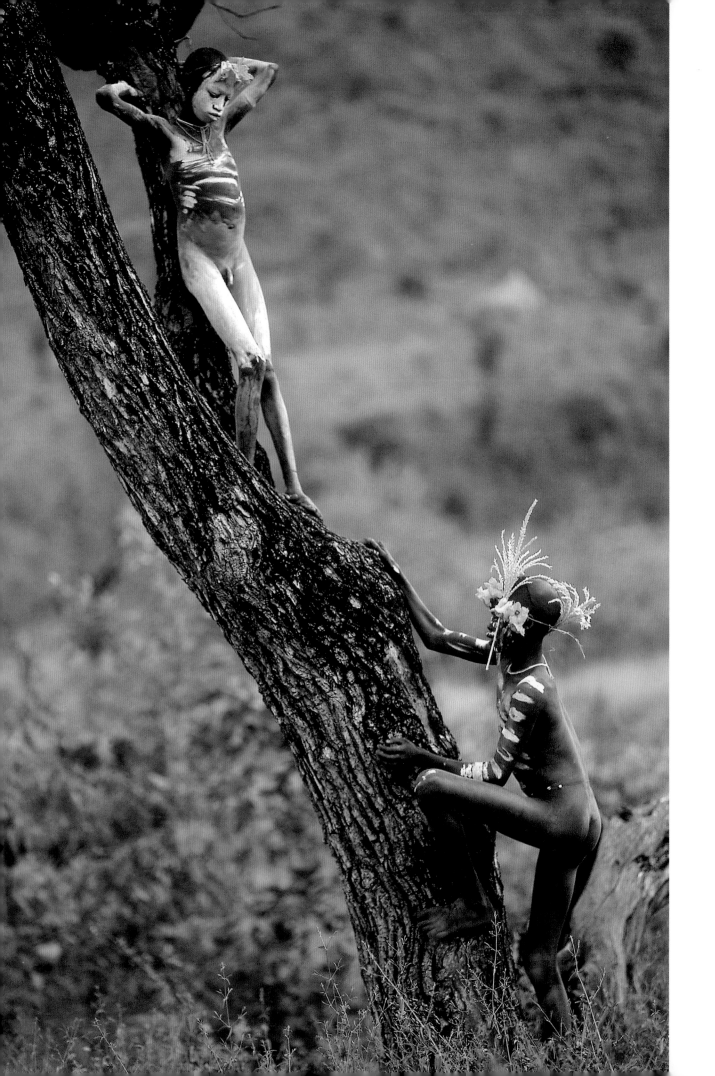

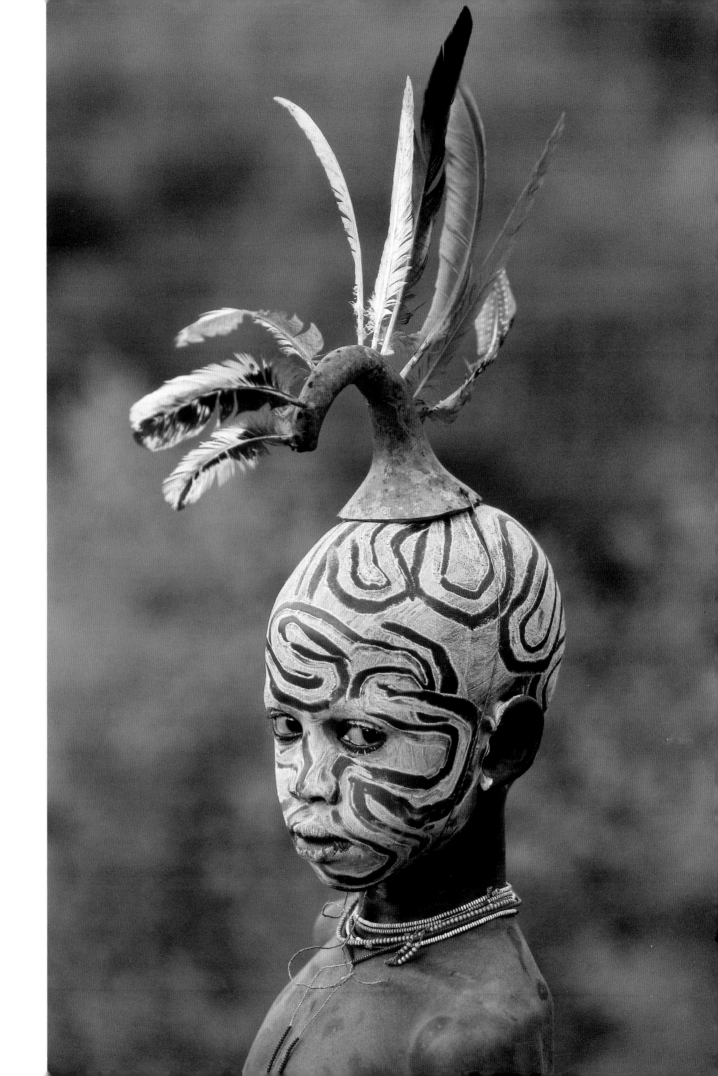

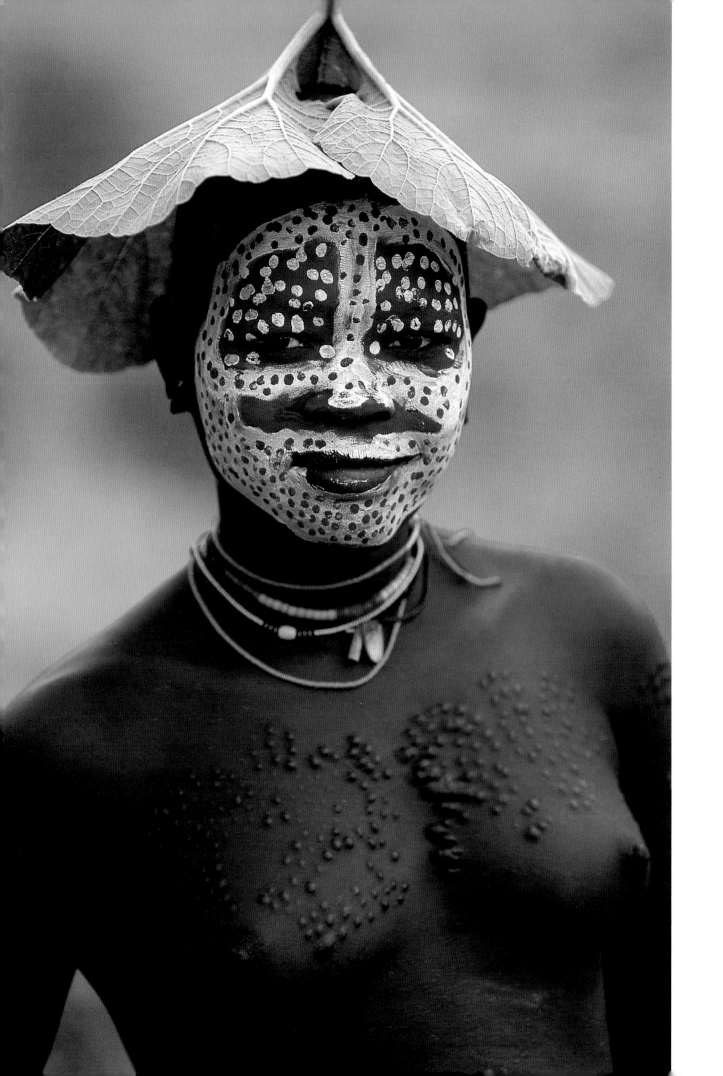

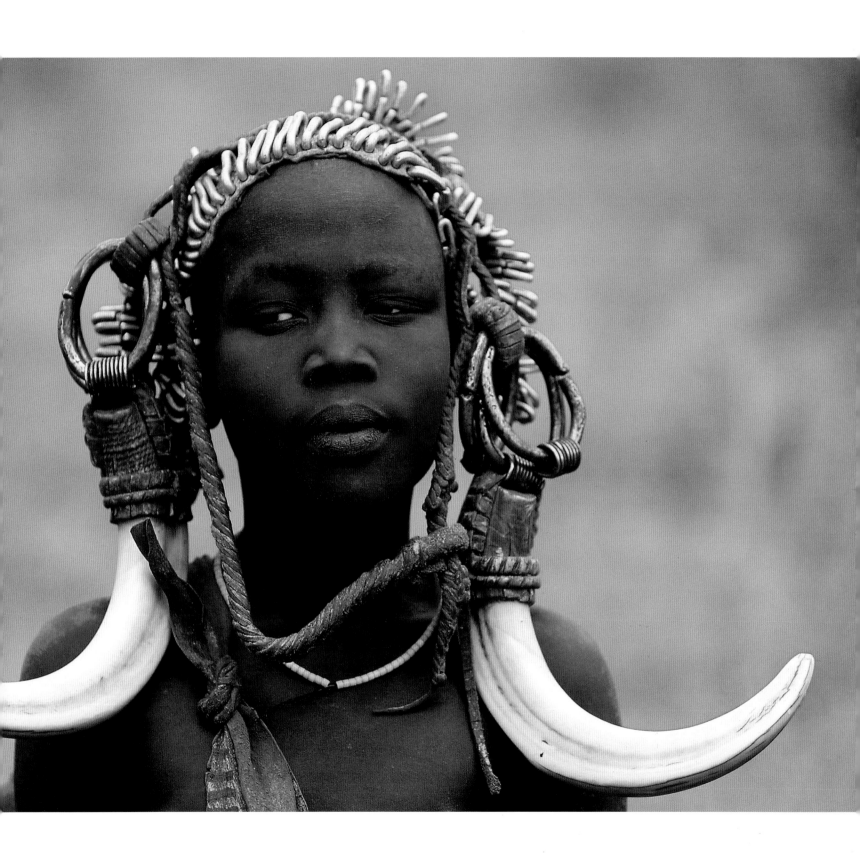

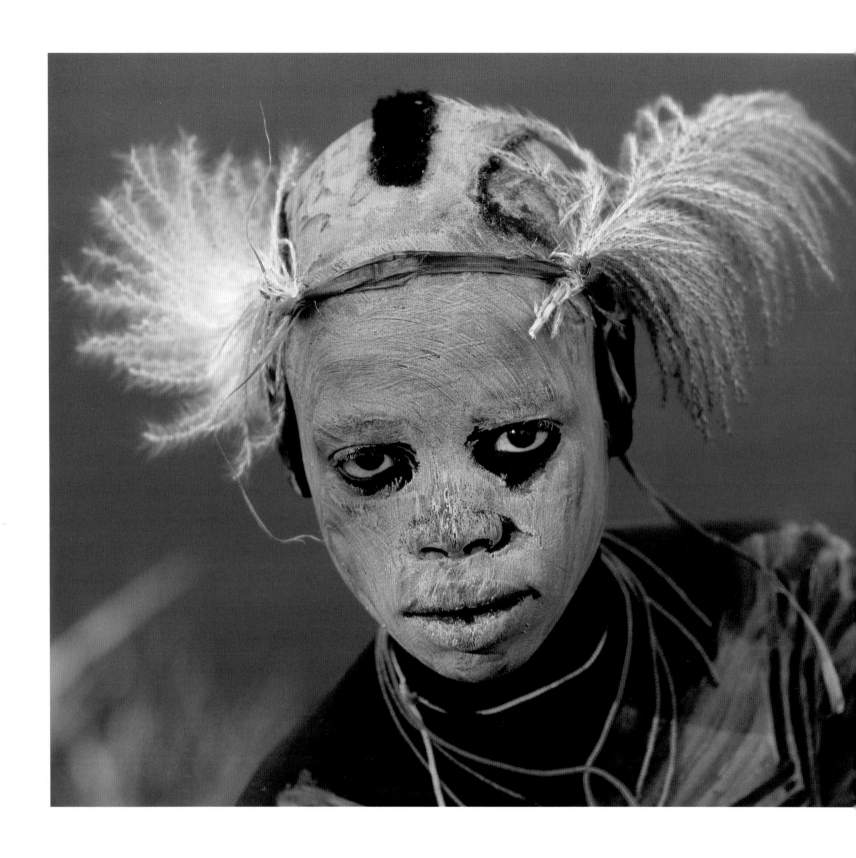

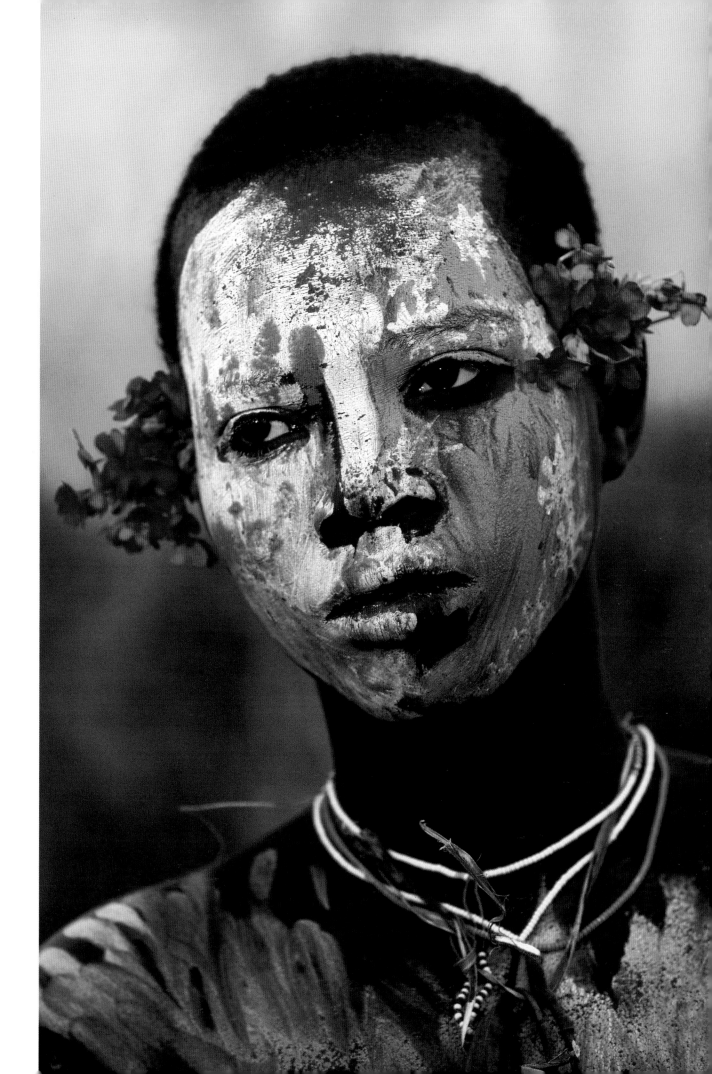

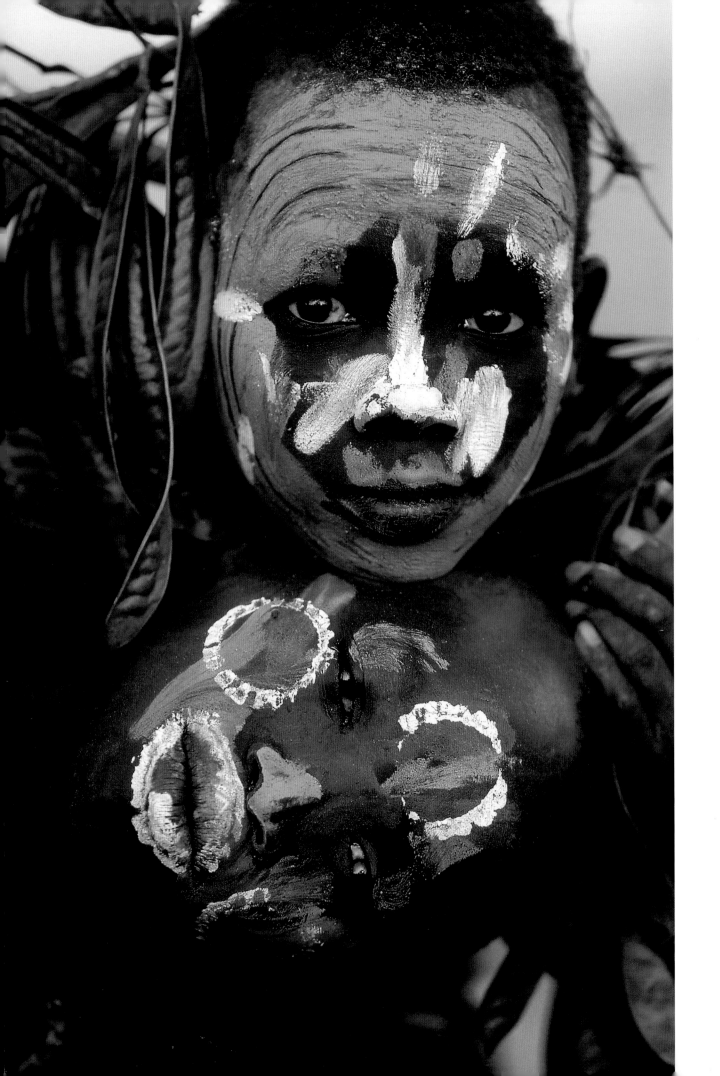

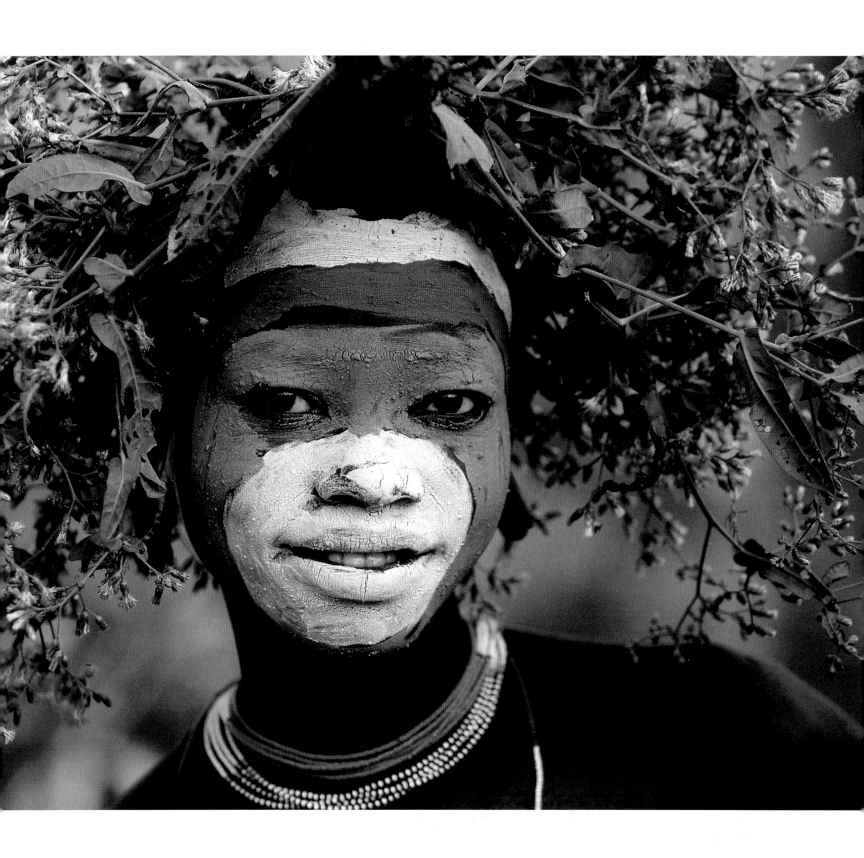

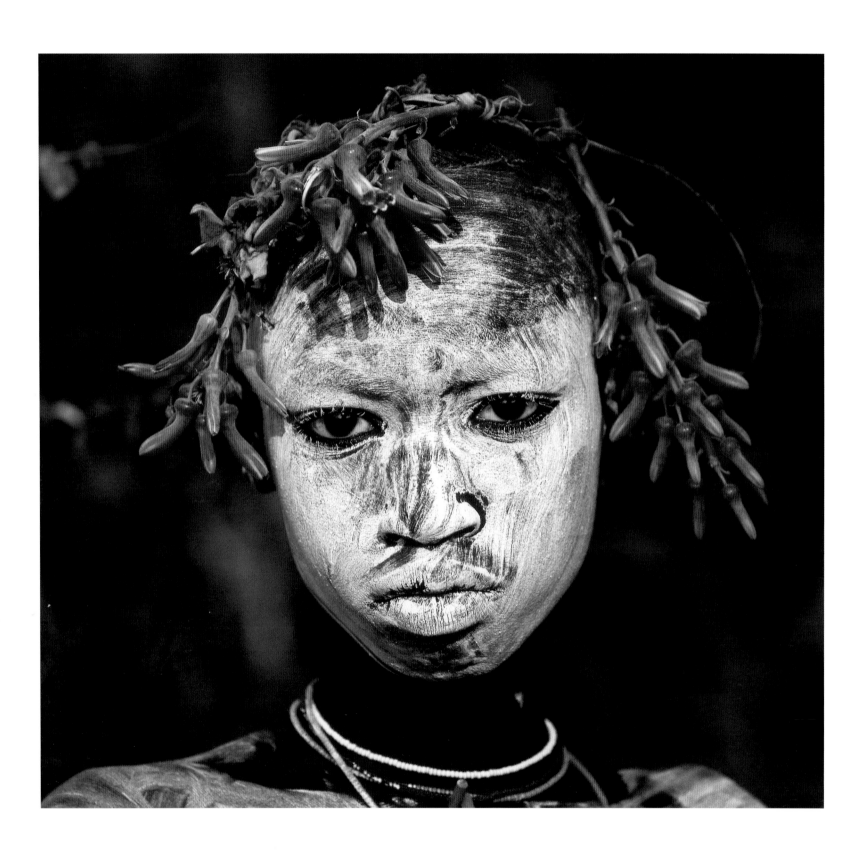

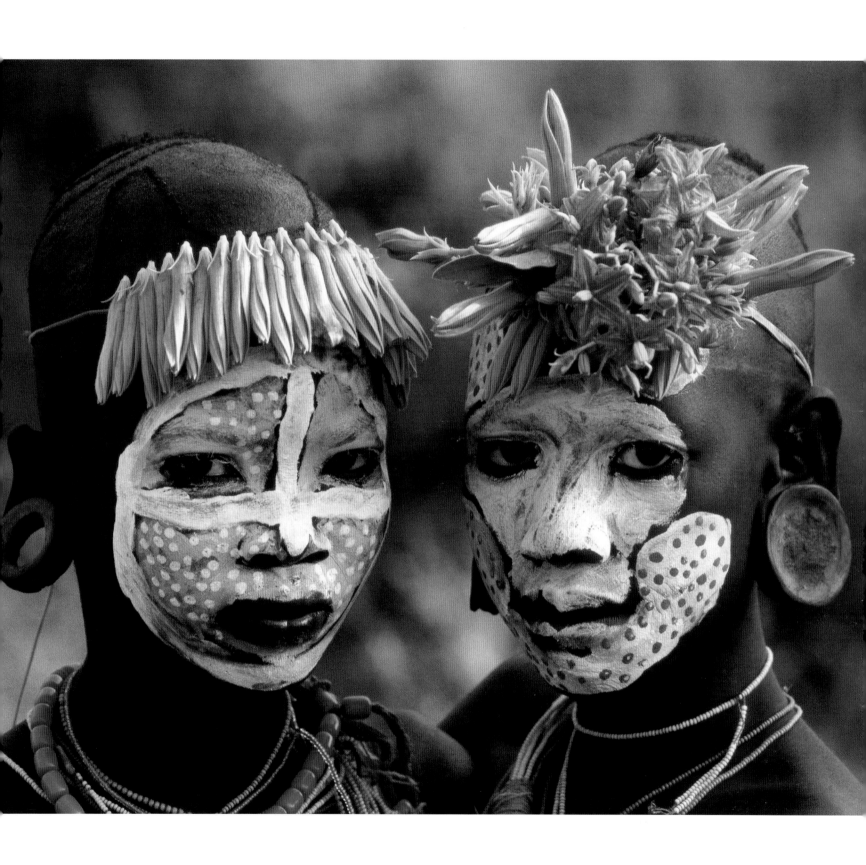

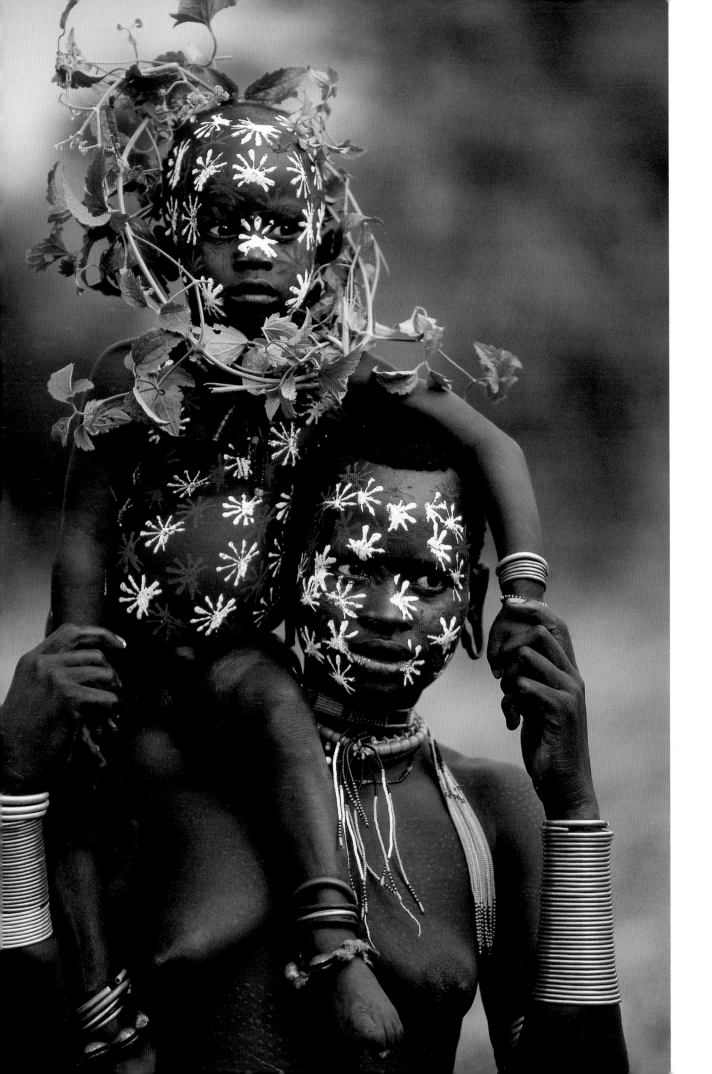

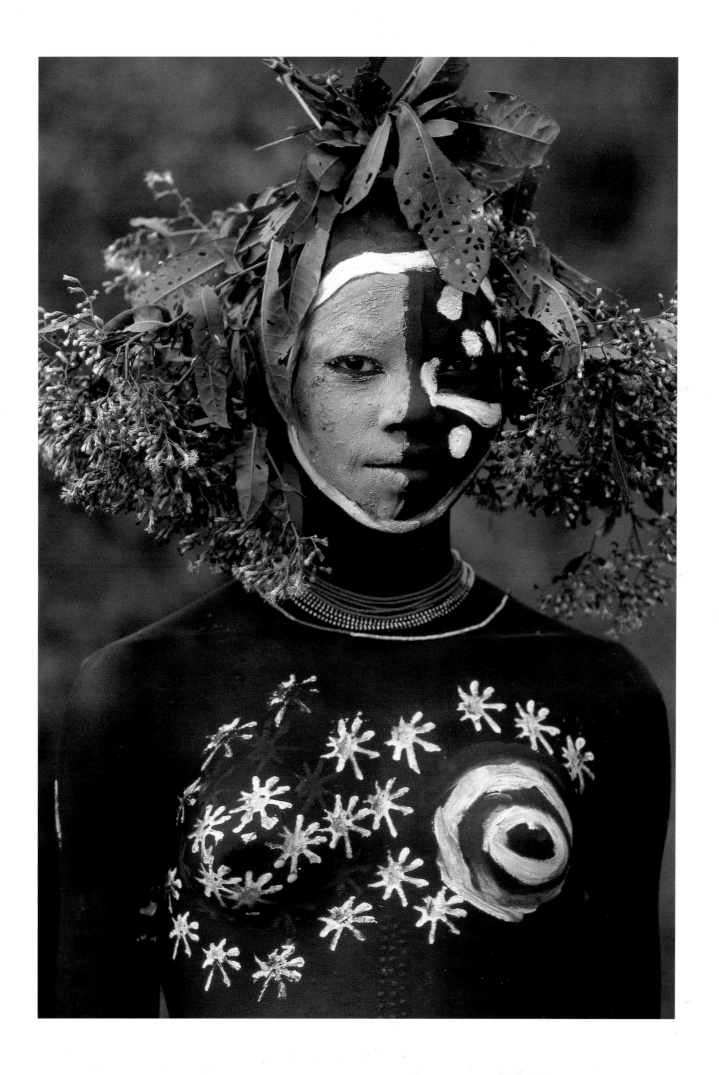

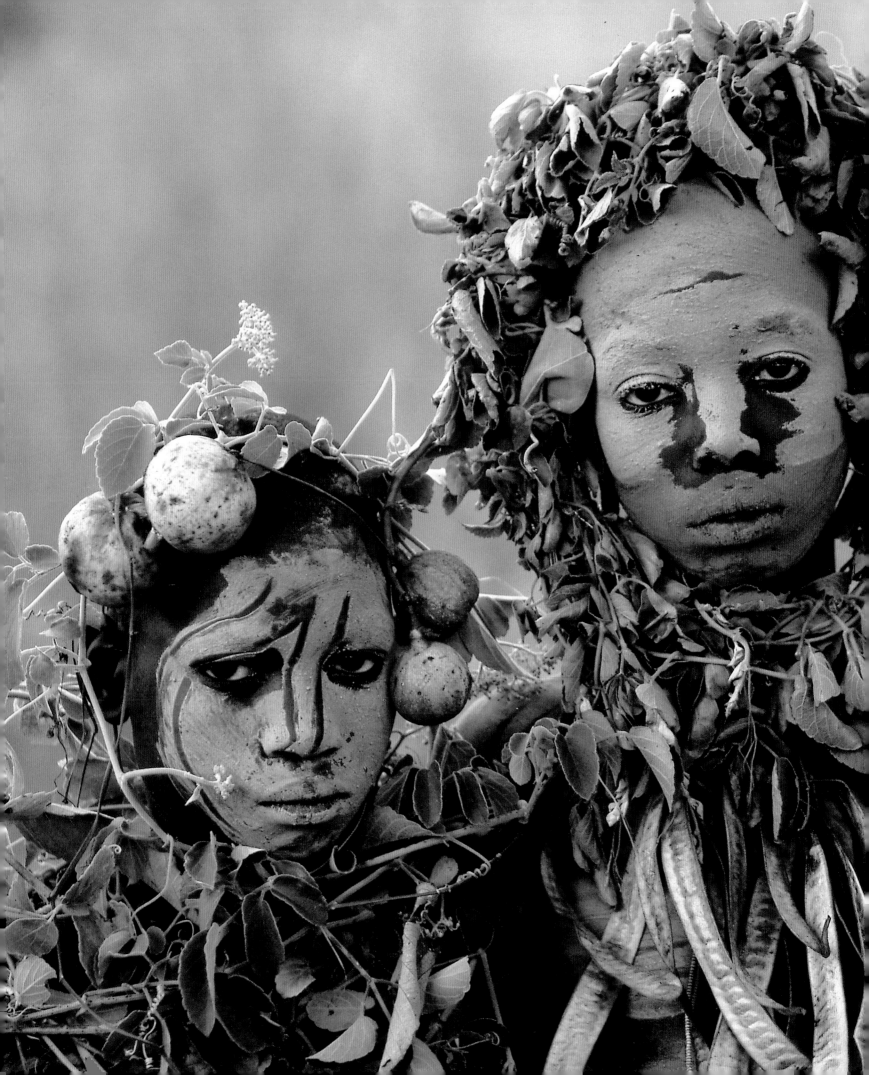

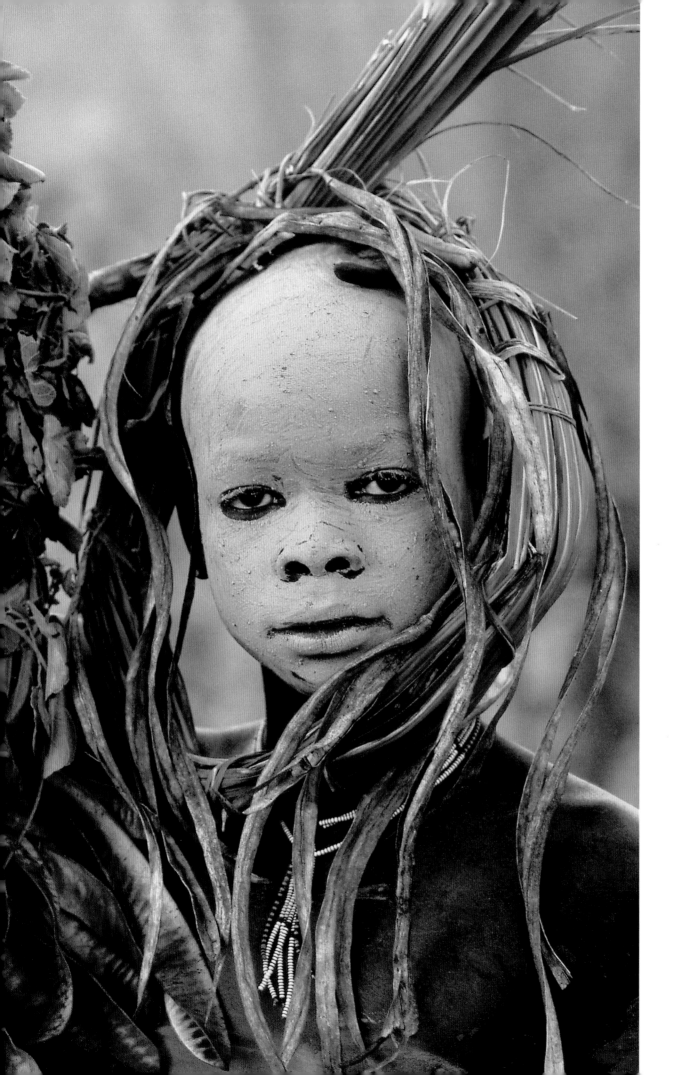

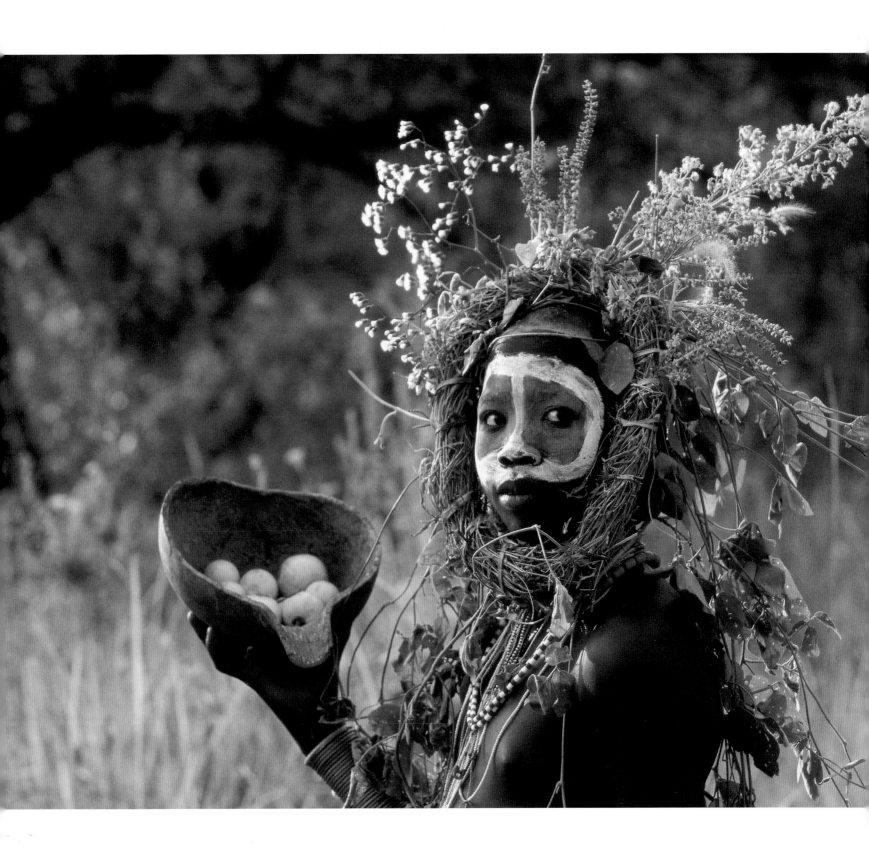

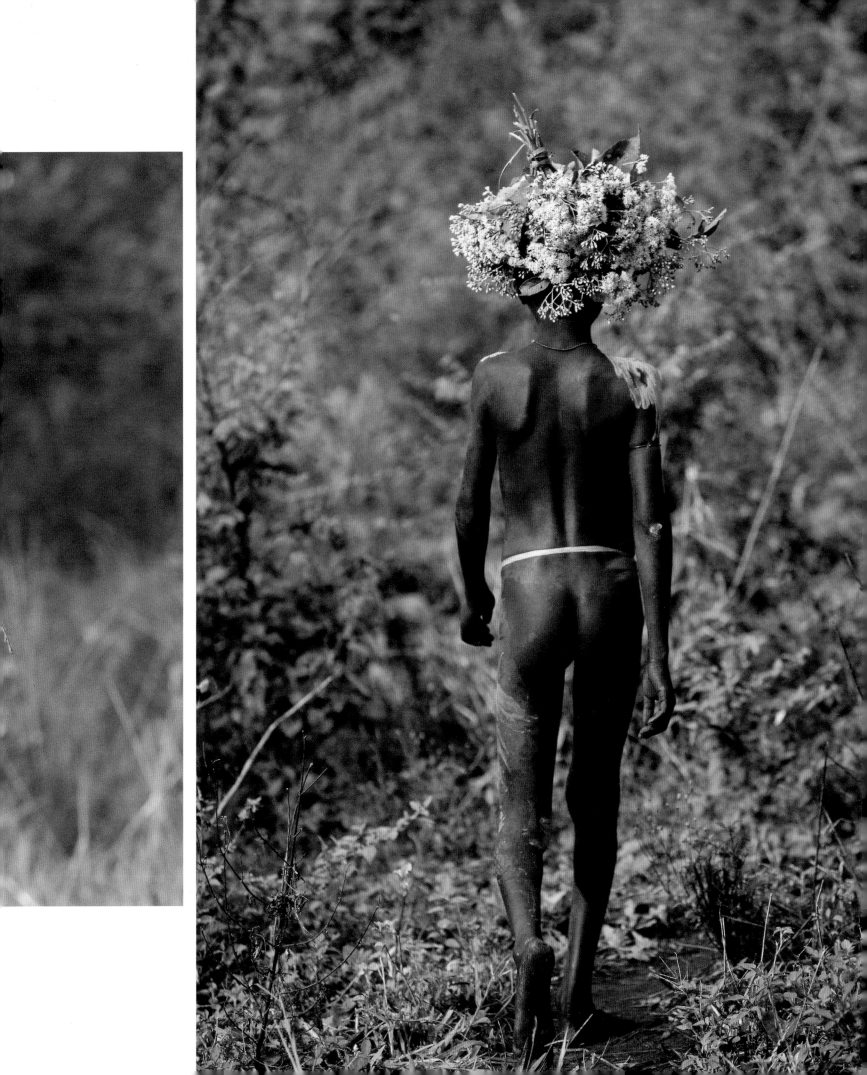

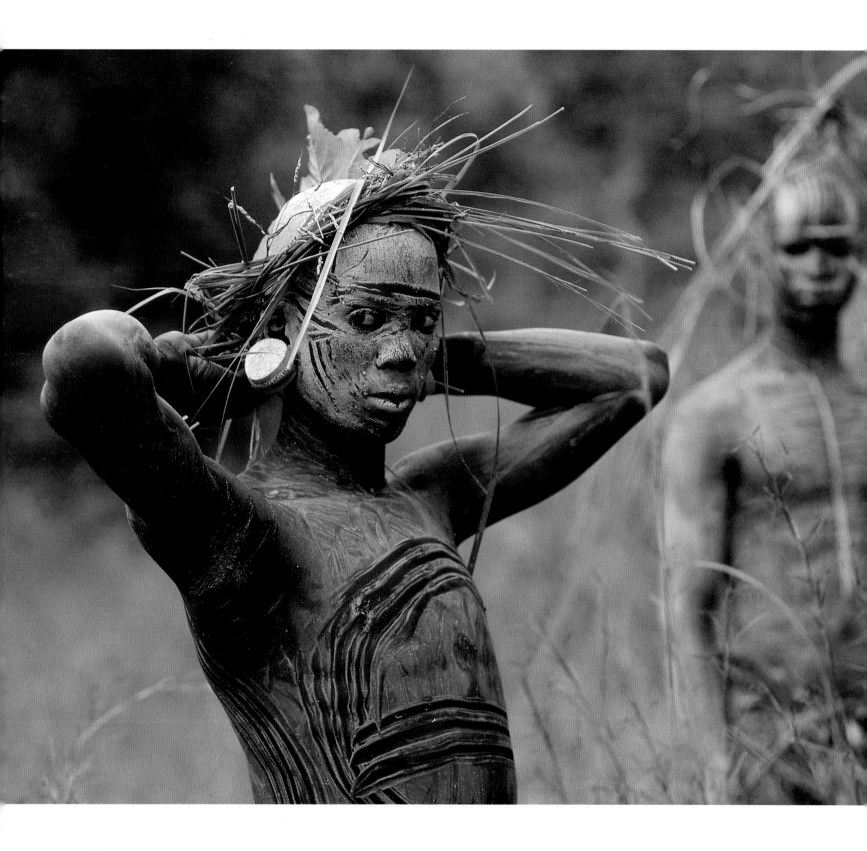

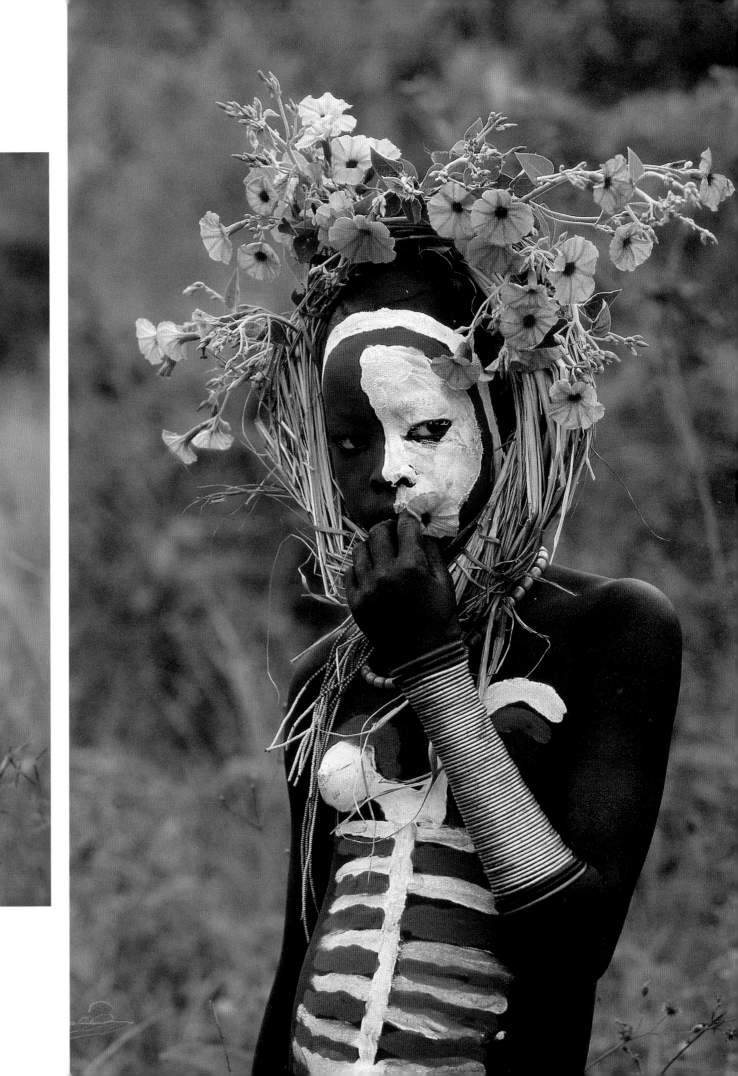

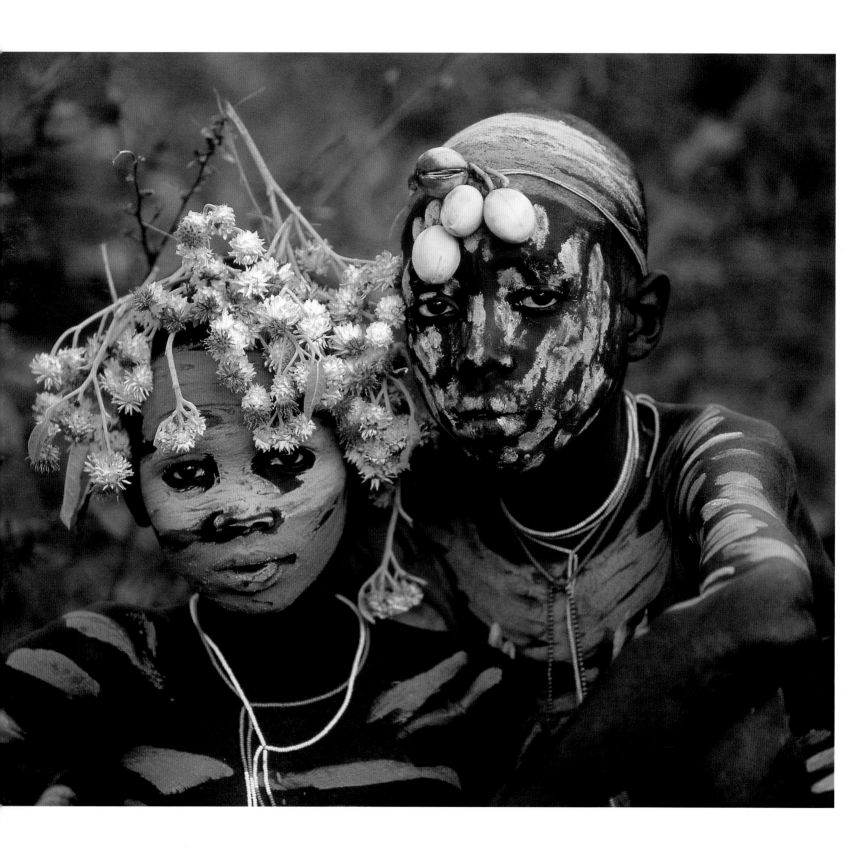

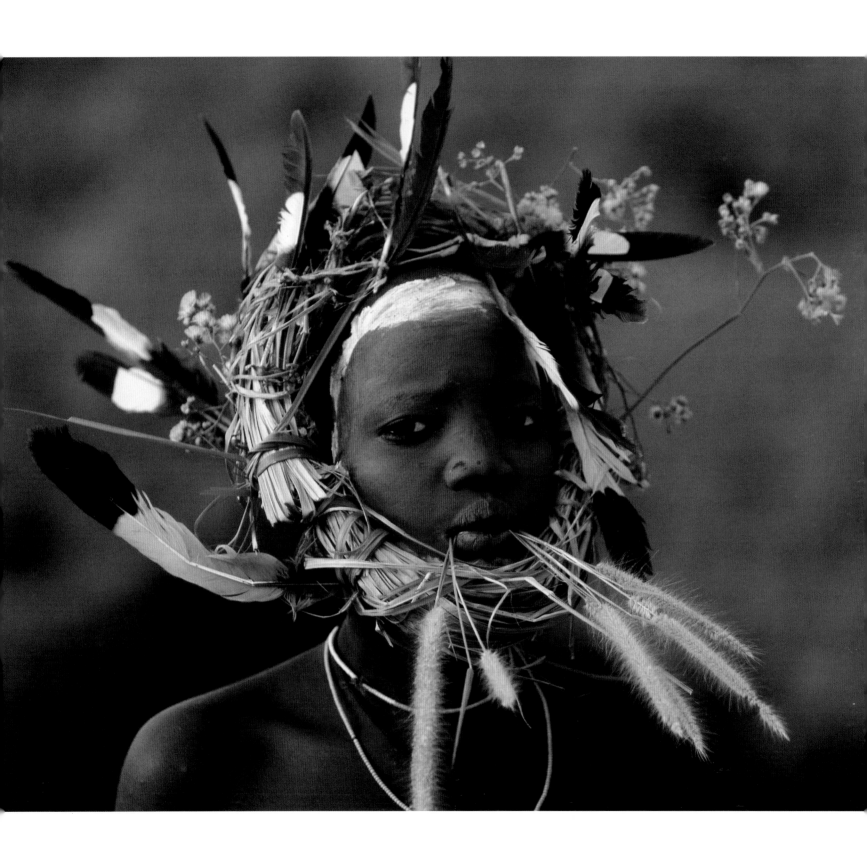

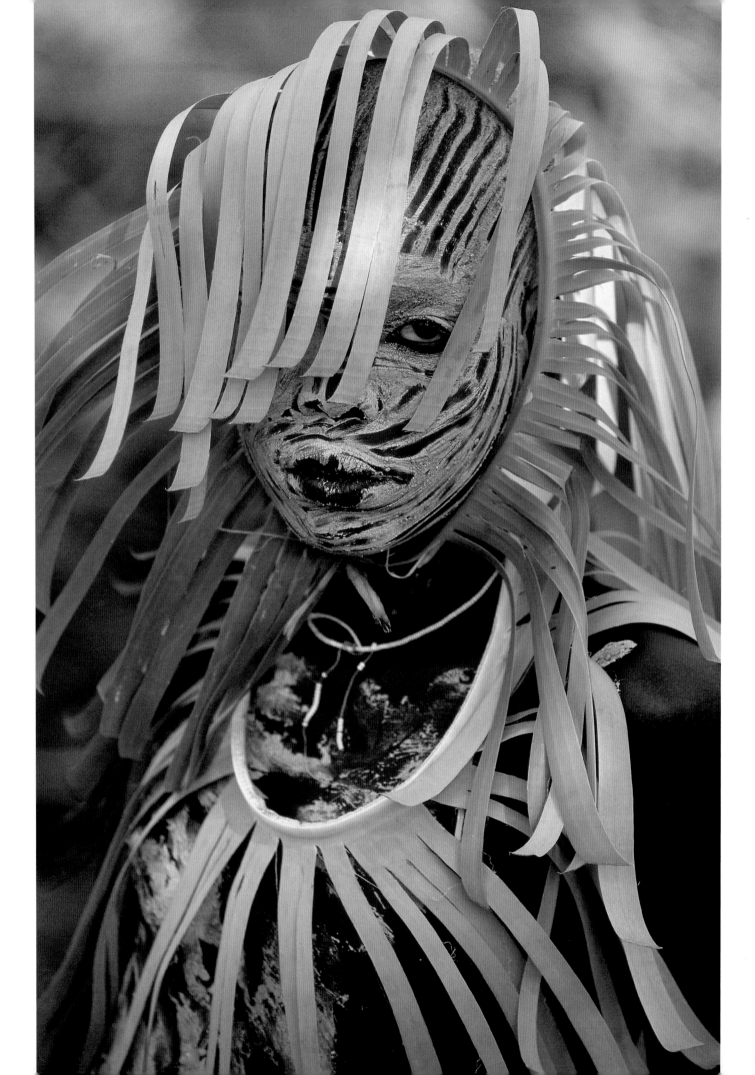

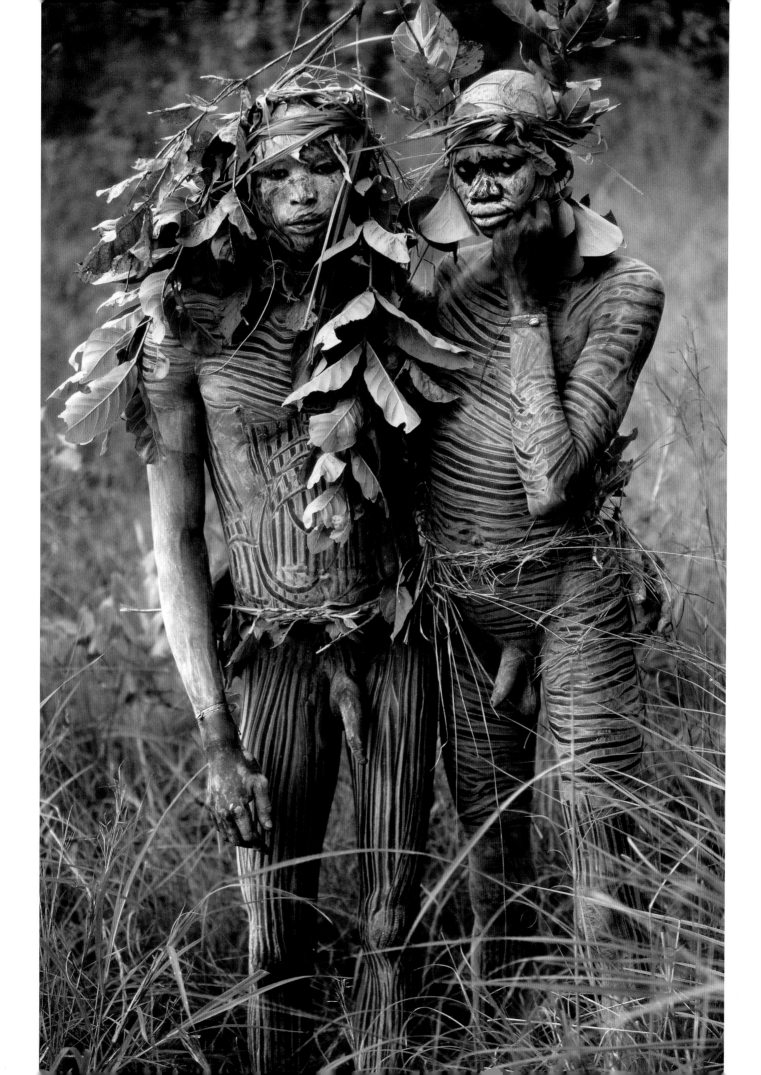

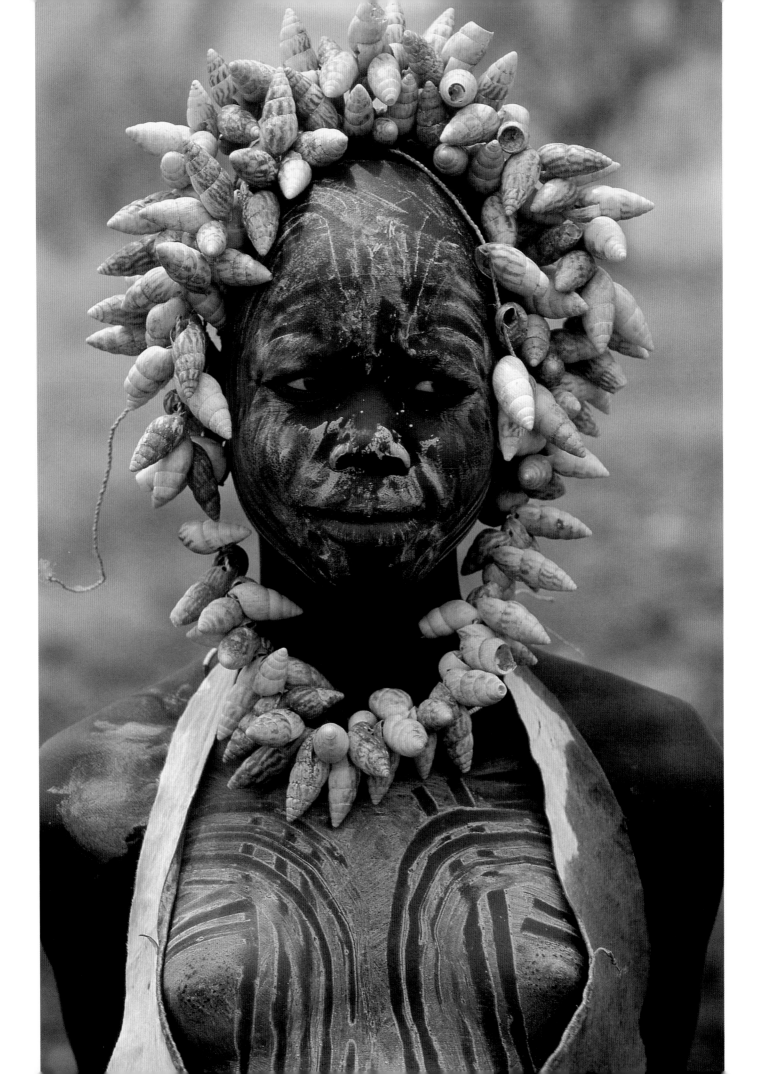

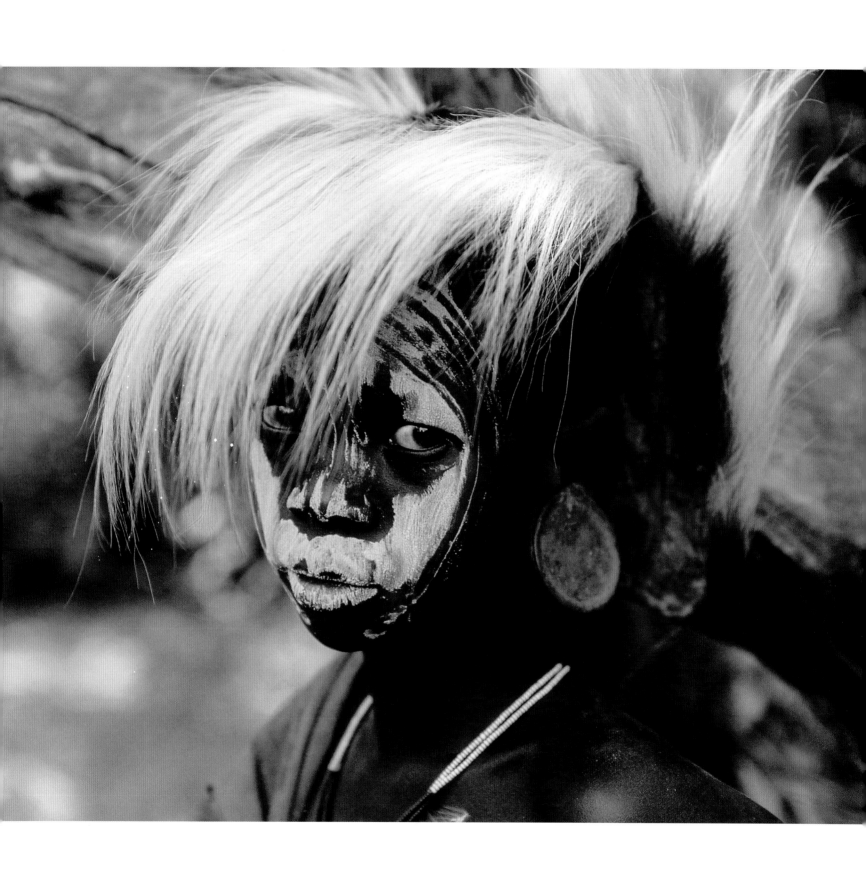

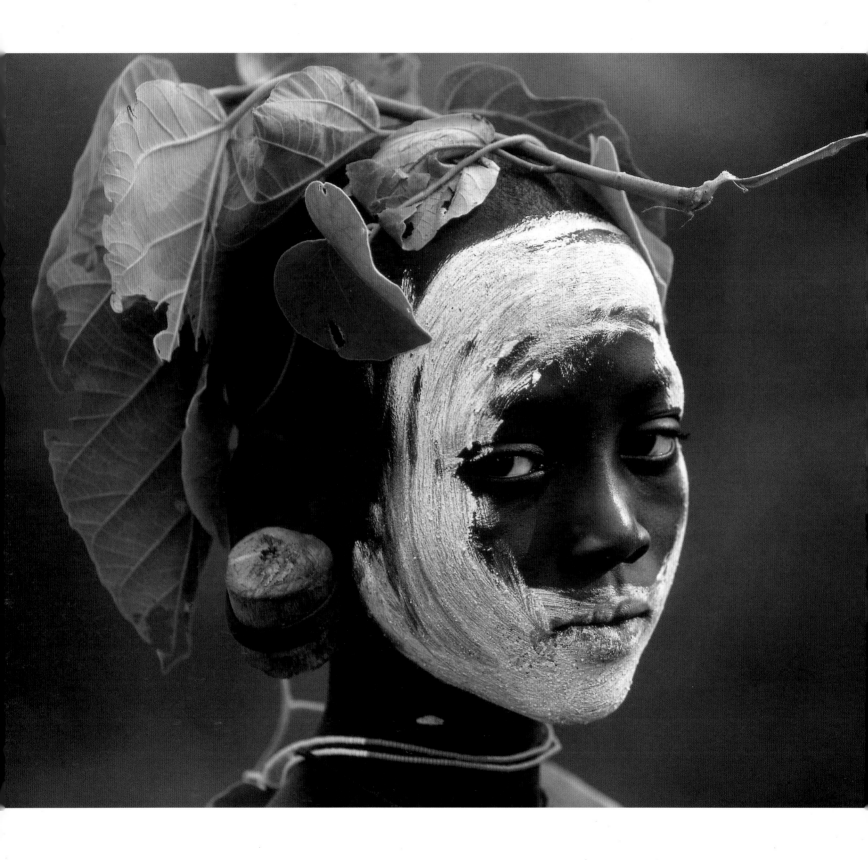

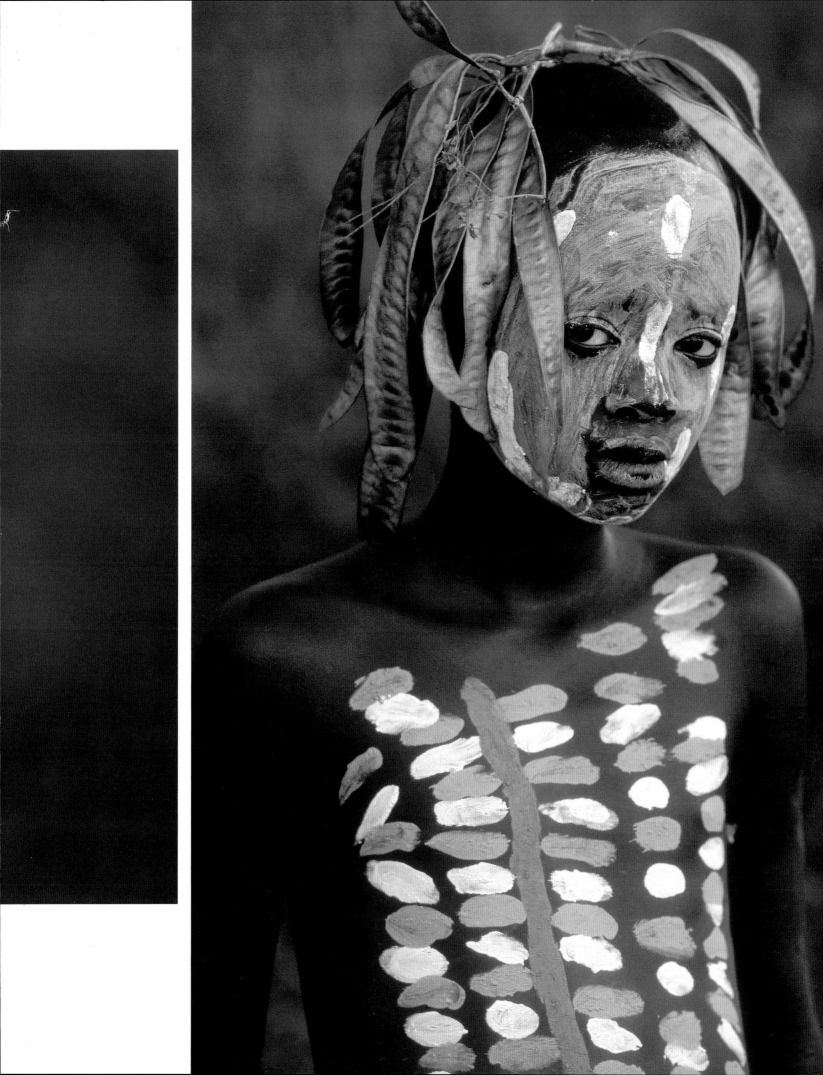

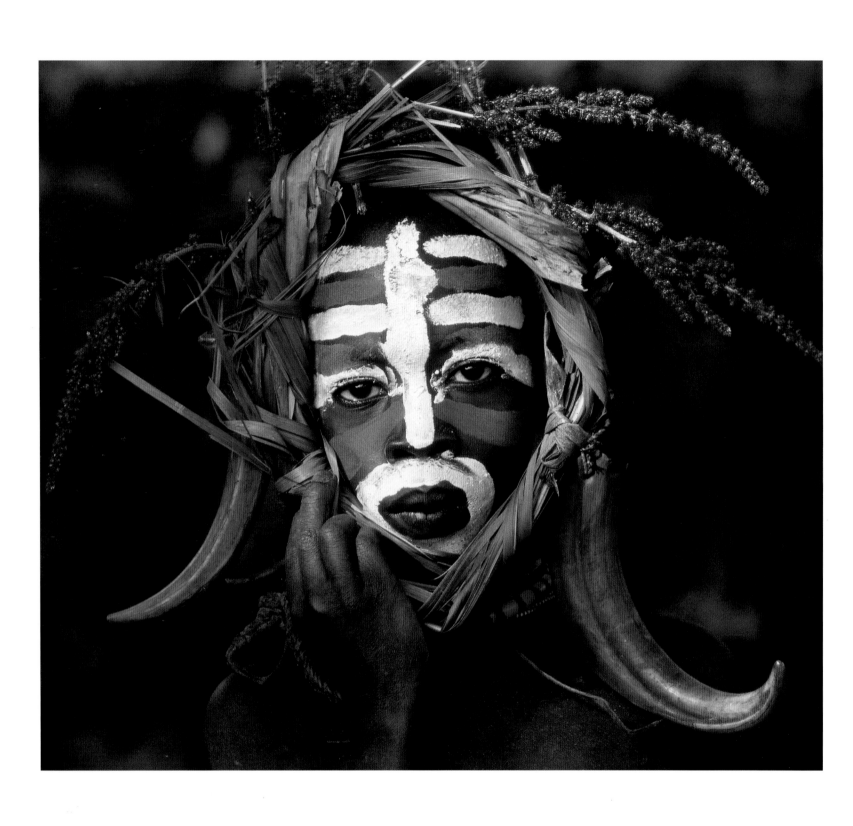

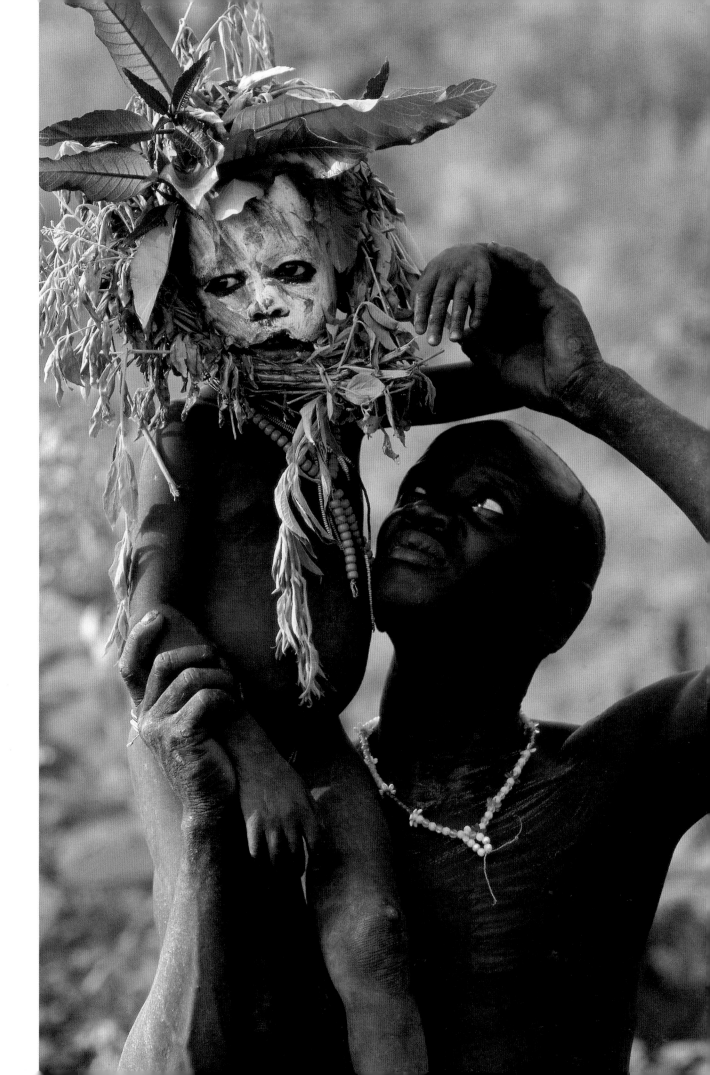

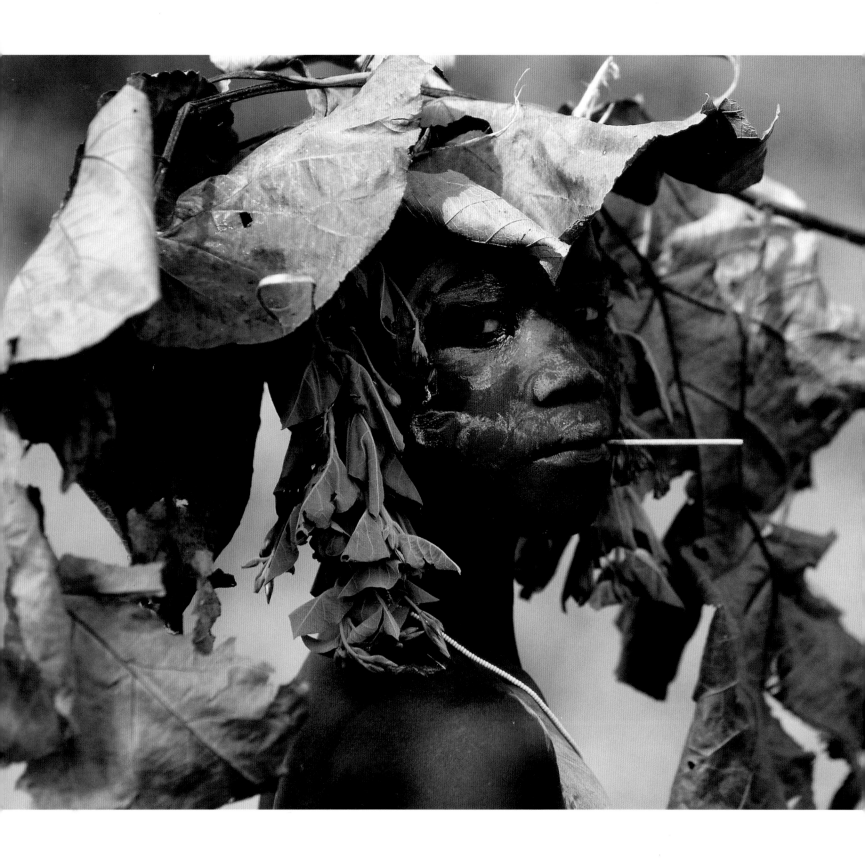

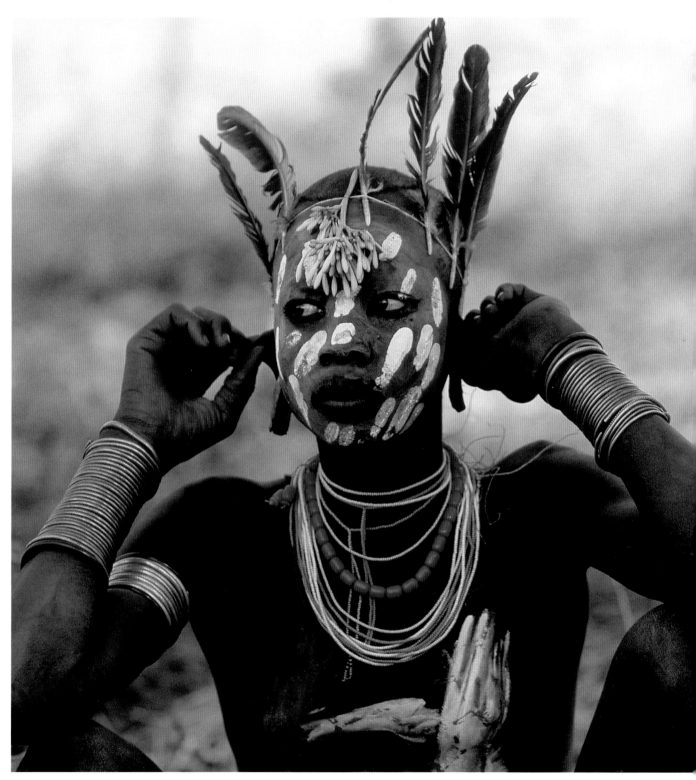

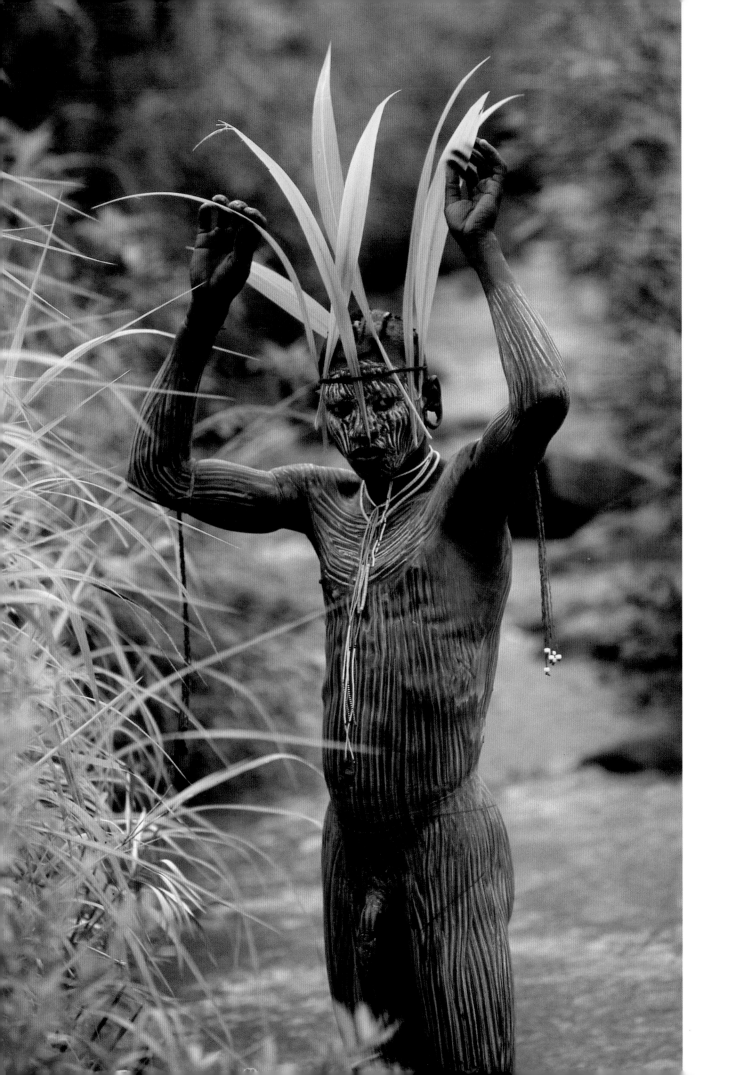

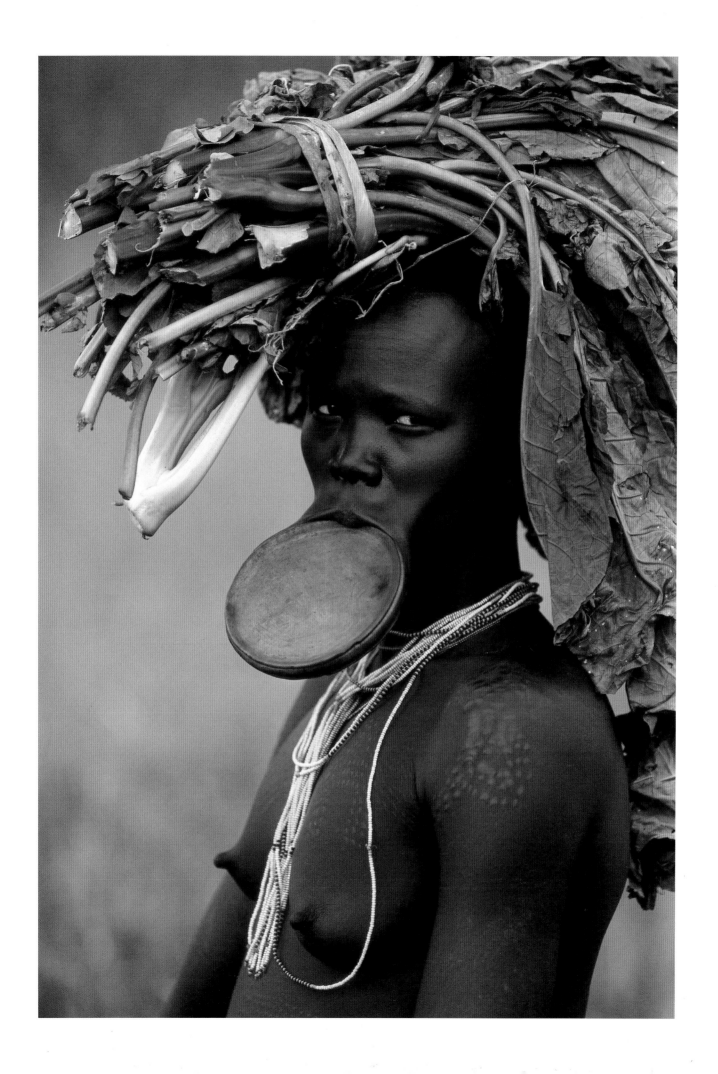

153

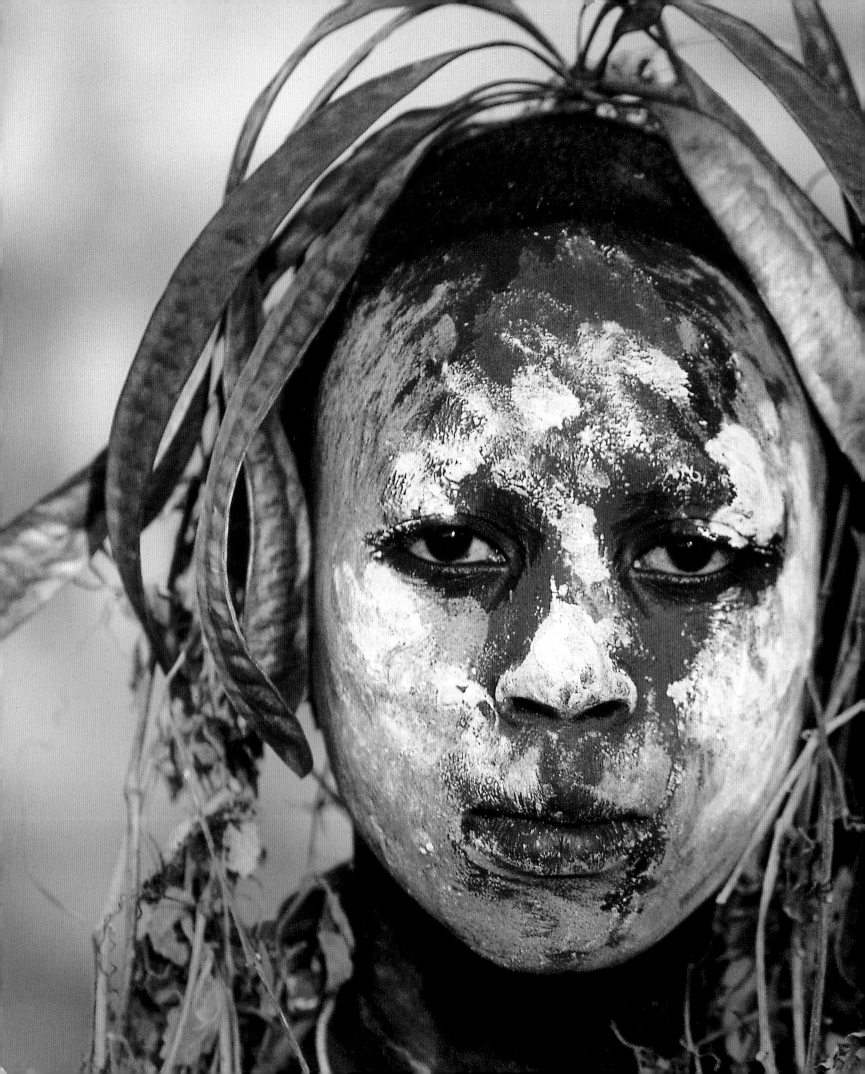

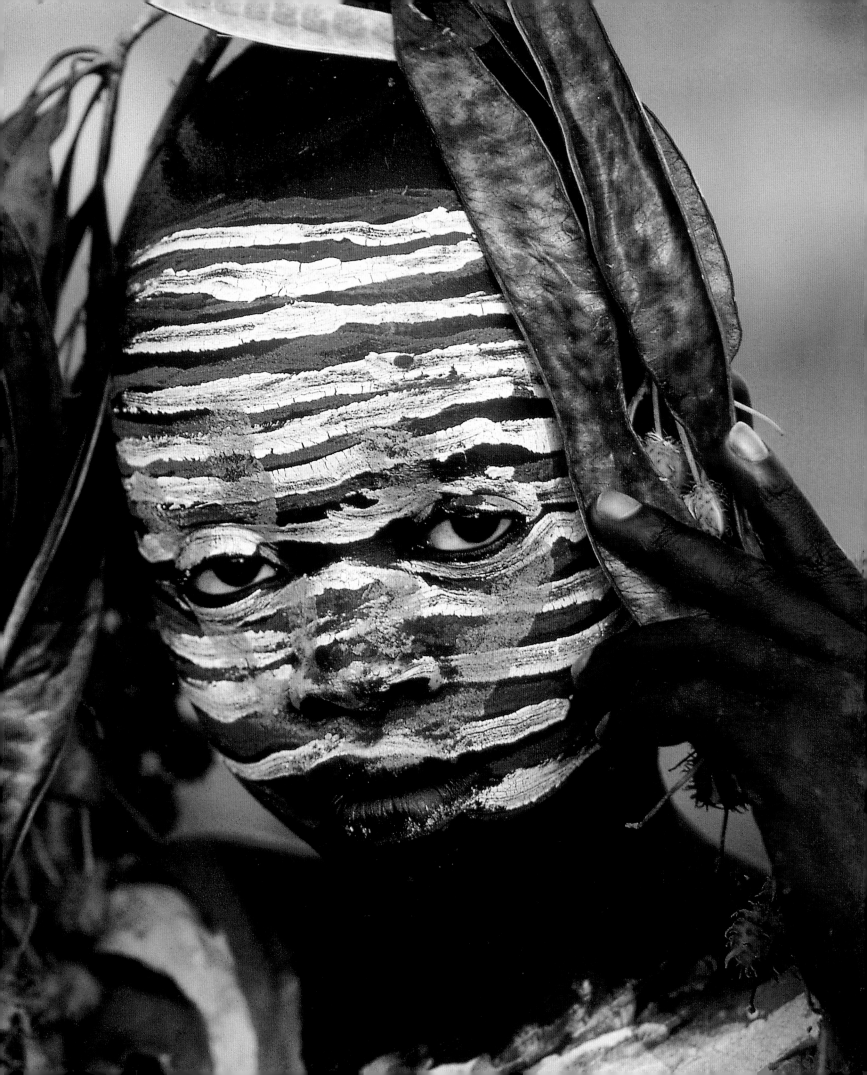

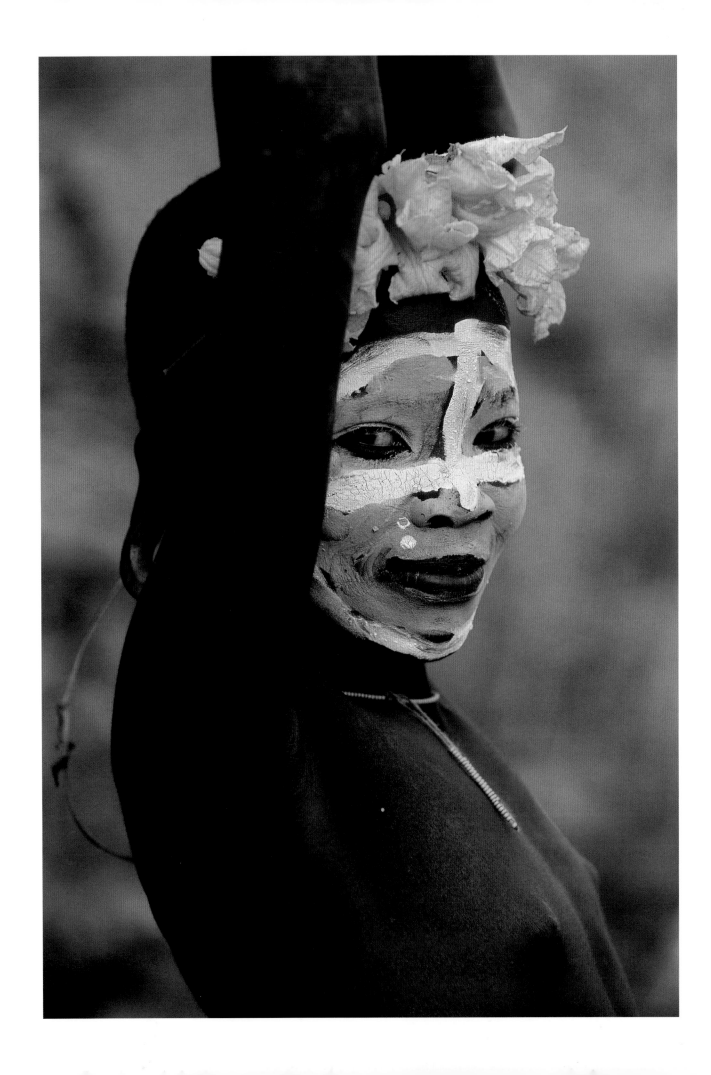

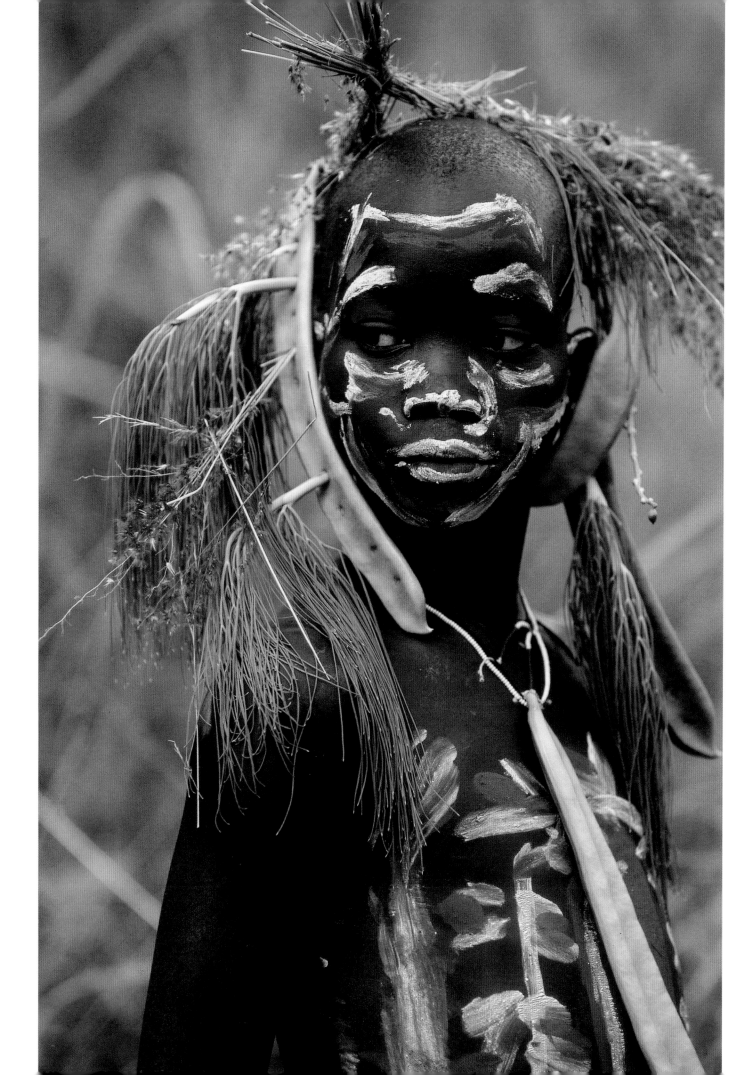

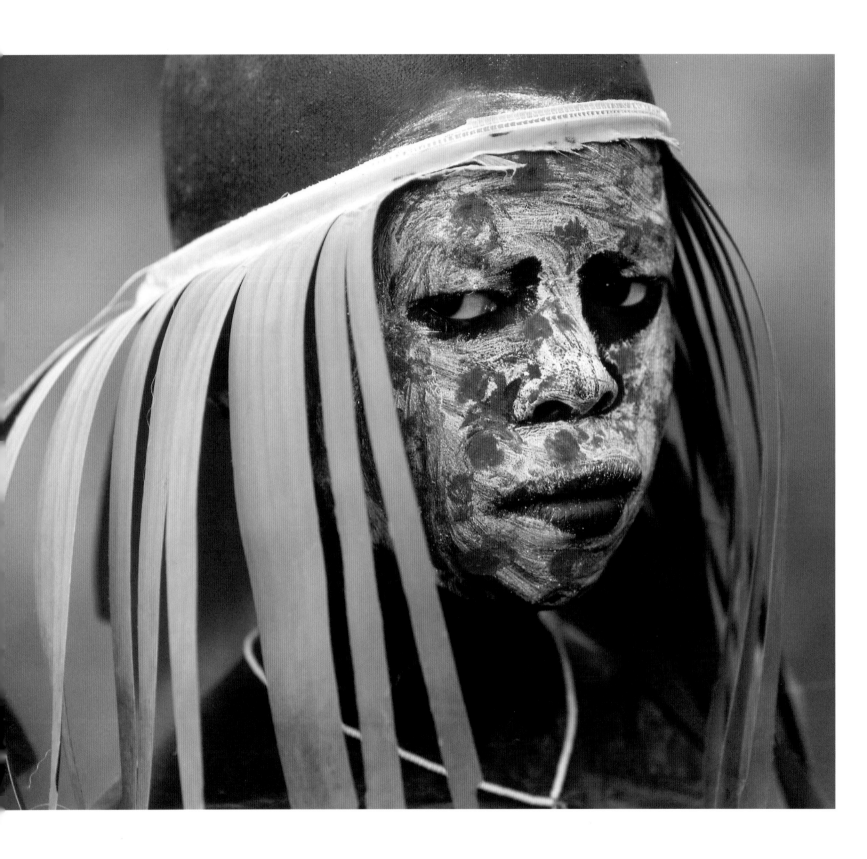

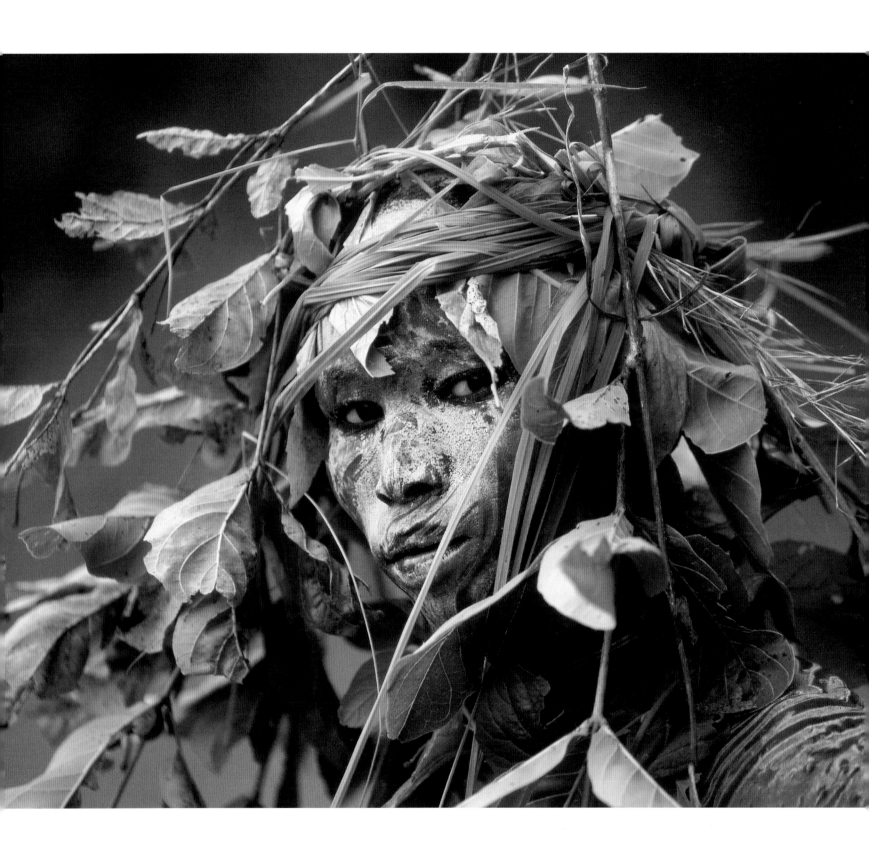

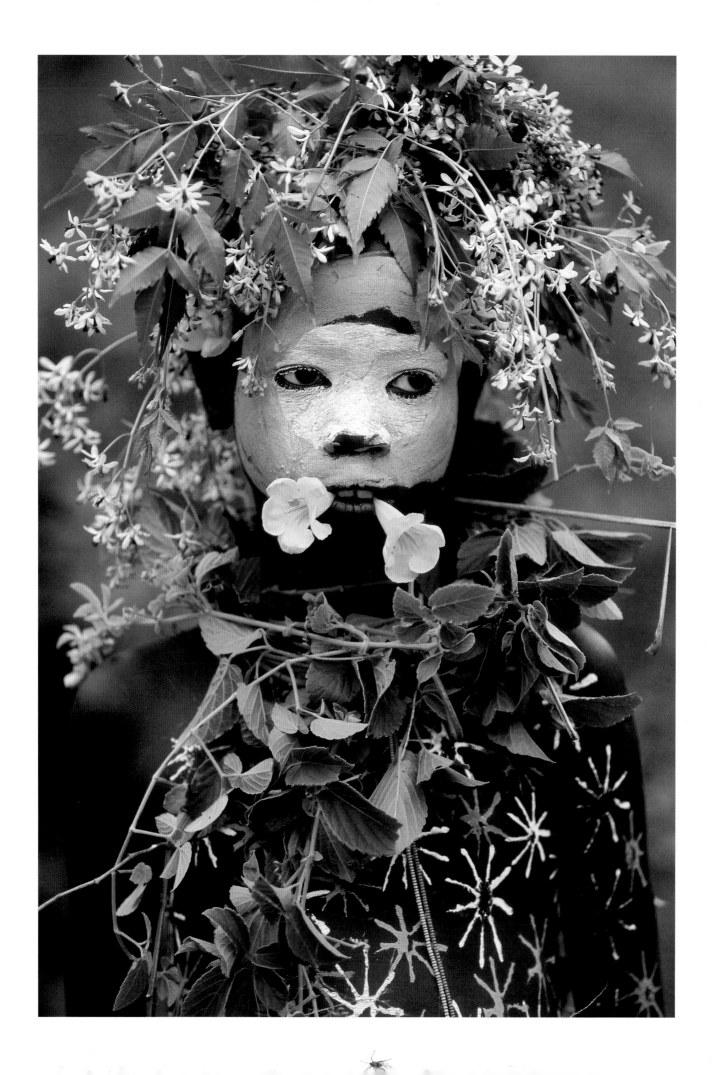

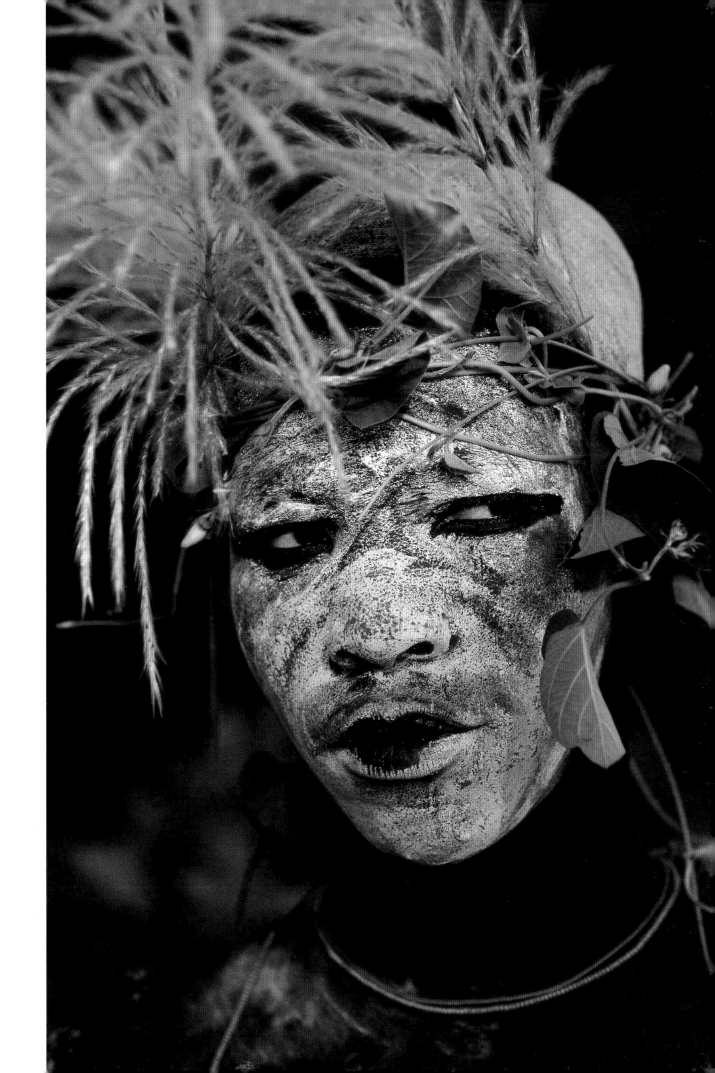

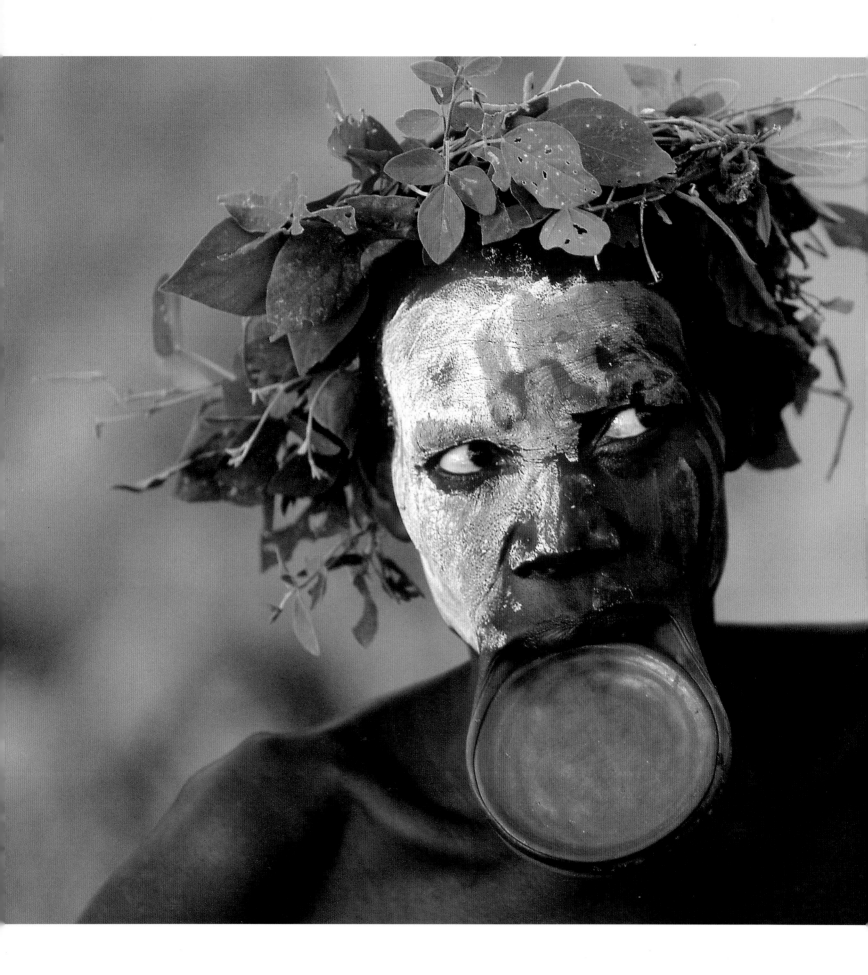

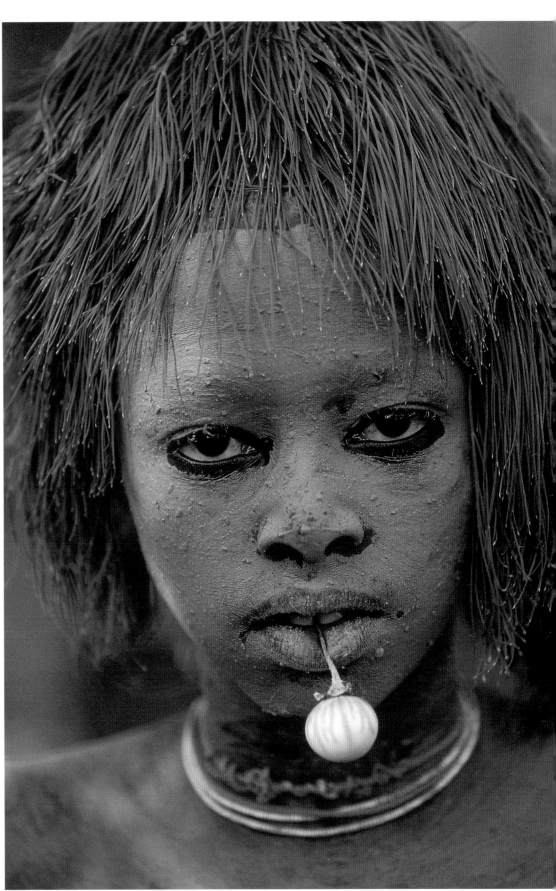

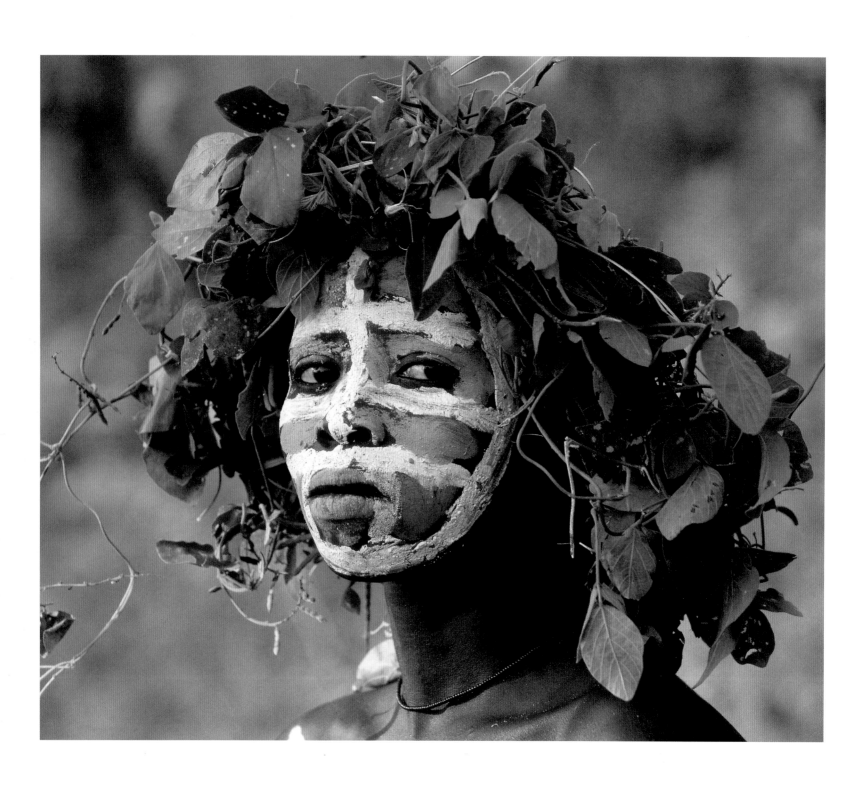

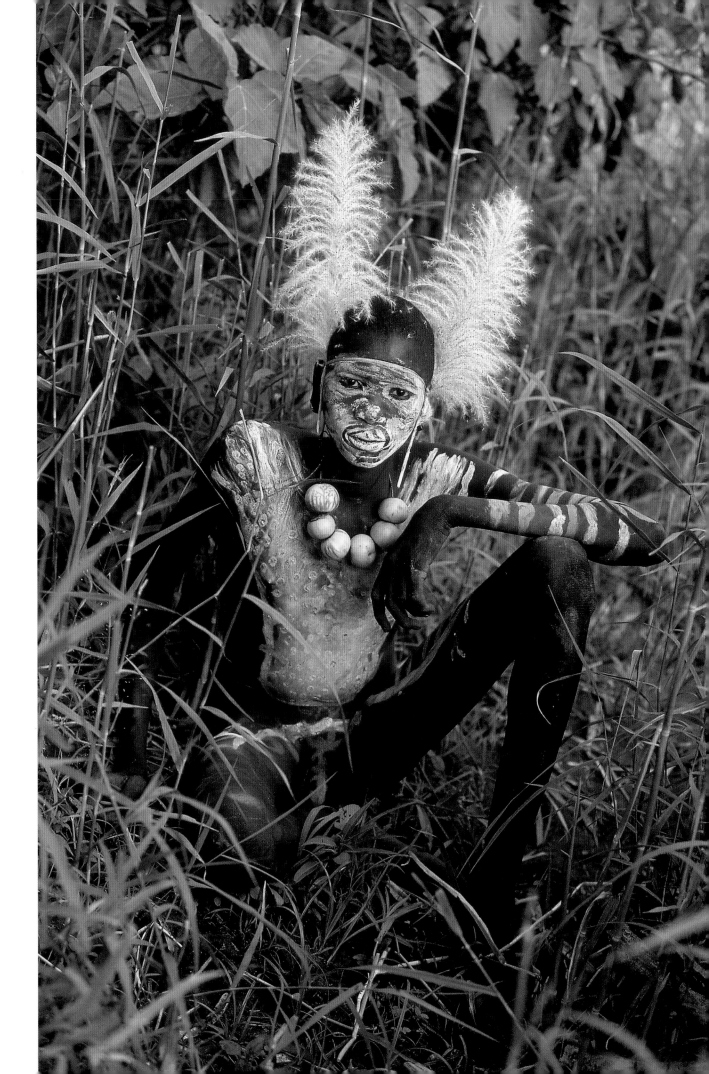

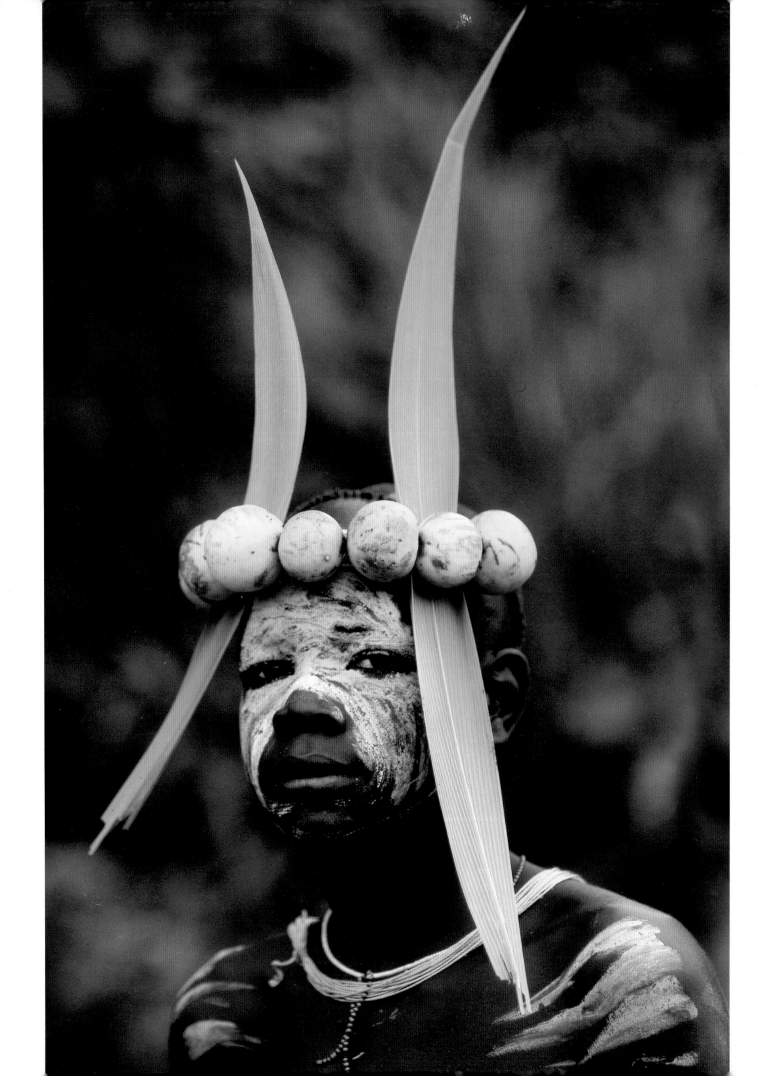

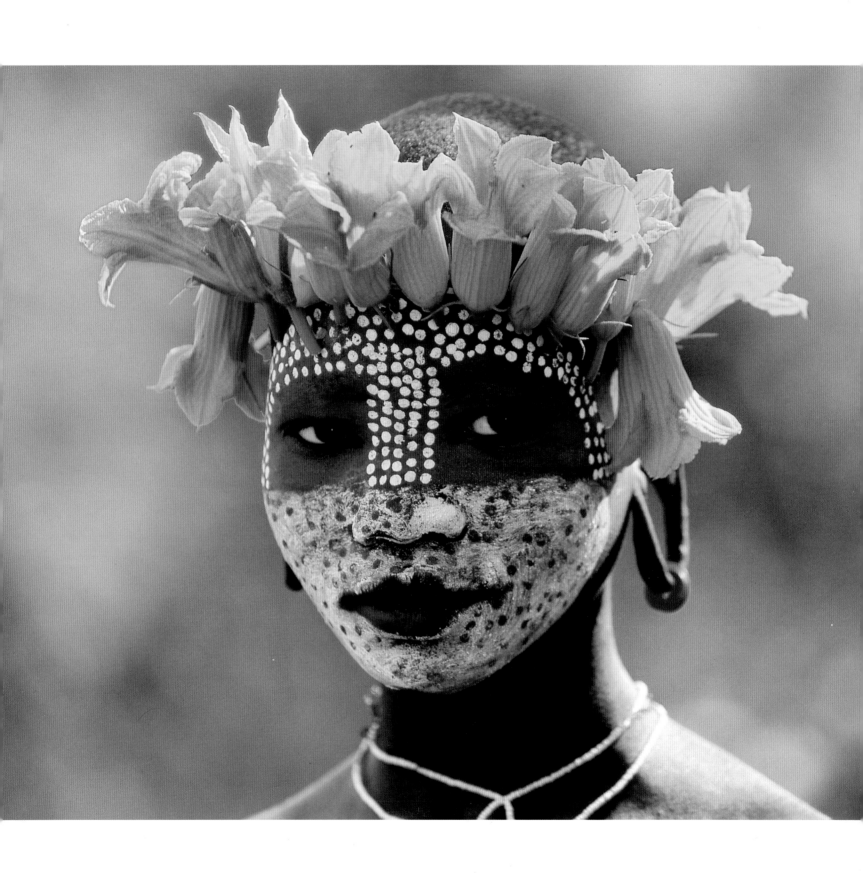

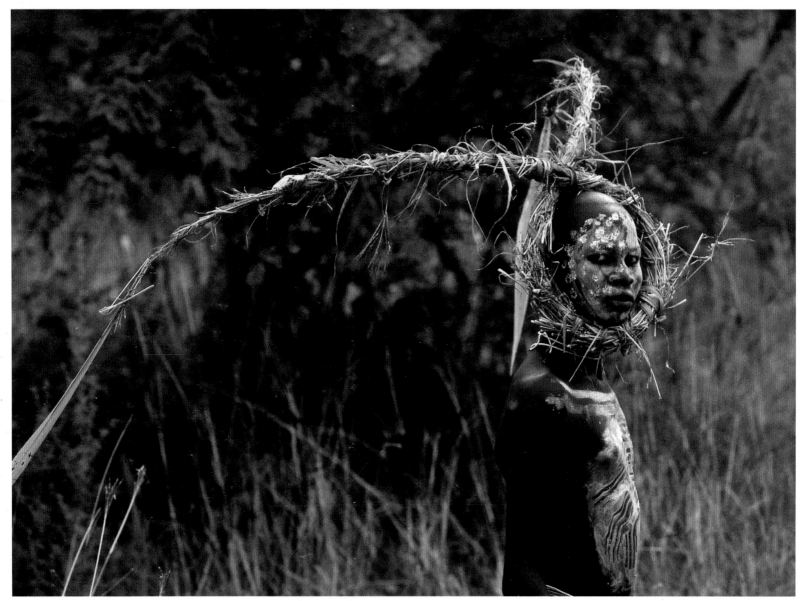

Translated from the French *Les habits de la nature* by David H. Wilson

First published in the United Kingdom in 2008 by
Thames & Hudson Ltd, 181A High Holborn, London WC1V 7QX

www.thamesandhudson.com

First published in 2008 in hardcover in the United States of America by
Thames & Hudson Inc., 500 Fifth Avenue, New York, New York 10110

thamesandhudsonusa.com

Reprinted in 2009, 2010

First published in paperback in 2009

Original edition © 2007 Éditions de La Martinière, Paris
This edition © 2009 Thames & Hudson Ltd, London

SAN JUAN ISLAND LIBRARY
1010 Guard Street
Friday Harbor, WA 98250

All Rights Reserved. No part of this publication may be reproduced or transmitted in any form or by any means, electronic or mechanical,
including photocopy, recording or any other information storage and retrieval system, without prior permission in writing from the publisher.

British Library Cataloguing-in-Publication Data
A catalogue record for this book is available from the British Library

Library of Congress Catalog Card Number 2007905738

ISBN: 978-0-500-28805-4

Printed and bound in China